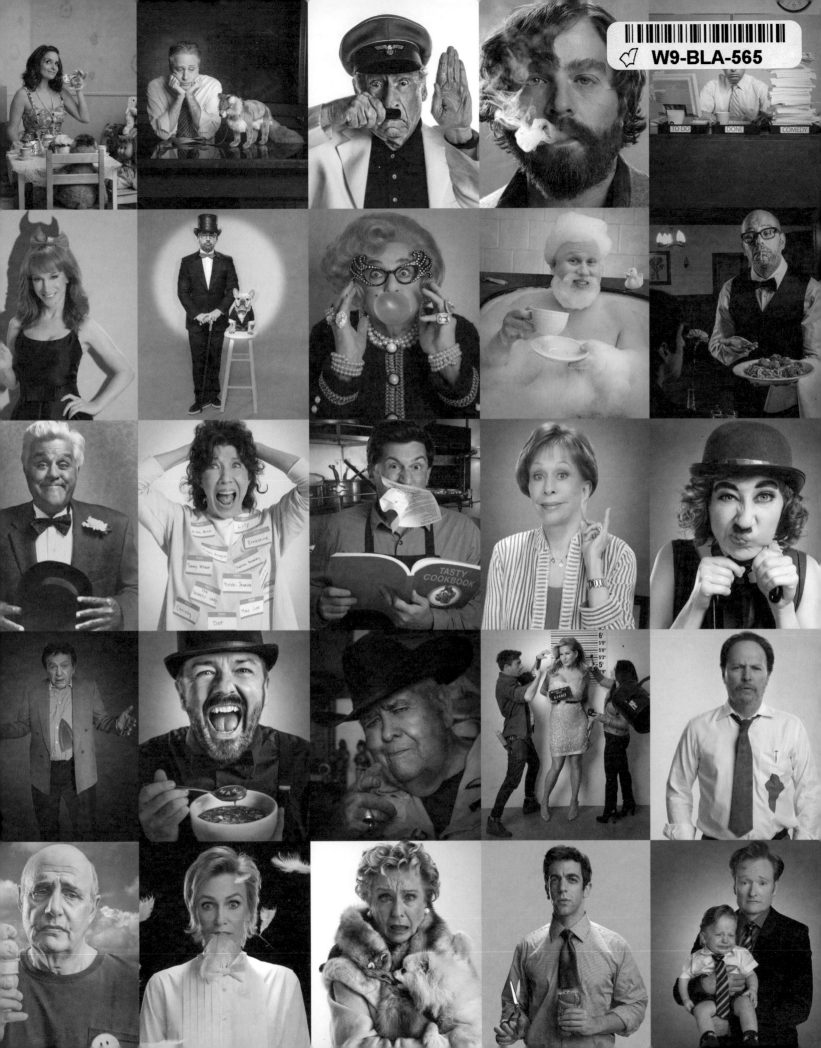

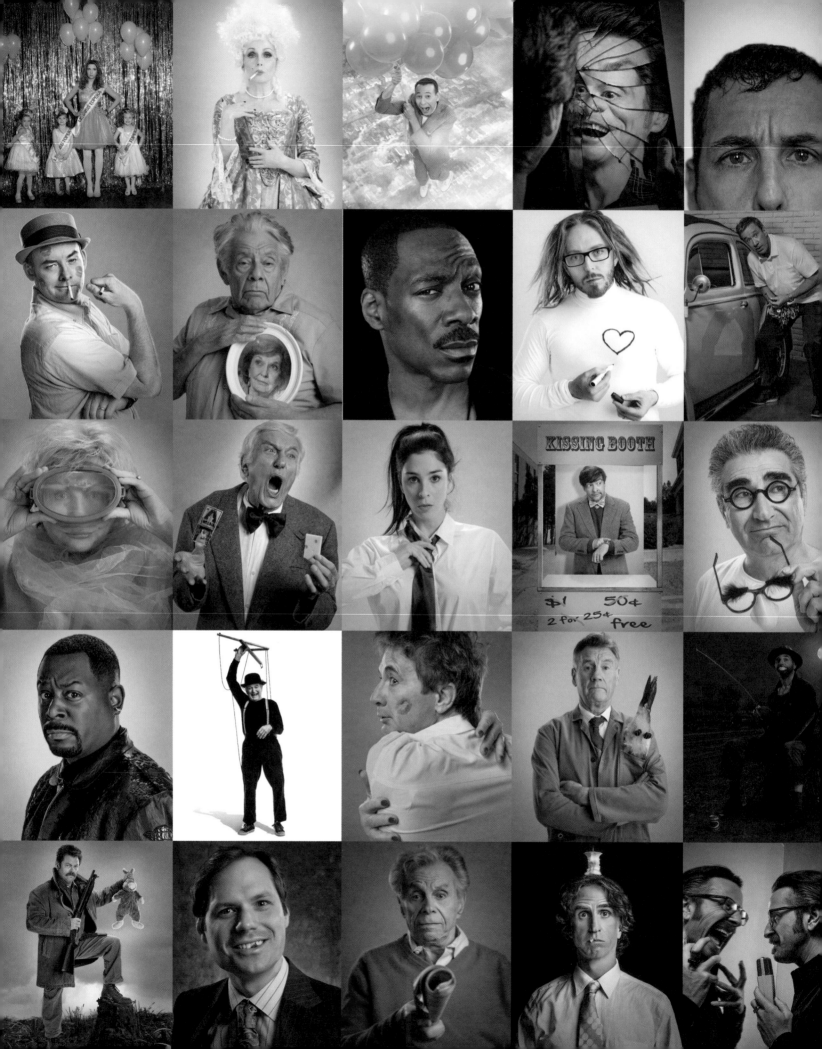

COMIC GENIUS

PORTRAITS OF FUNNY PEOPLE

MATT HOYLE

Introduction by
MEL BROOKS

CHRONICLE BOOKS

SAN FRANCISCO

For my soon-to-be-born son or daughter whom I've yet to know.

Life is serious enough, here's to always seeing the funny side.

— DAD

Hello

First of all, thank you for buying this book. Or receiving it as a gift. Or browsing through it in the bookstore before purchasing it. If you like to laugh, it really is worth it.

This series of portraits happened because I wanted to meet and honor the people who have been making me laugh all my life. At least the professional ones who get paid for it.

So I made a wish list. It was big and naive, but that's how I roll. And I truly believe it took this sort of blind optimism to take on what turned out to be the largest book of its kind ever shot. More than 125 portraits of the biggest names in the funny business, from the earliest comedy pioneers to the stars making us laugh today. All sitting before my camera. I was in heaven.

For each comic icon, I set out to create visual concepts that either said a little bit about their character or revealed a completely different side, which would make for a great portrait. I would come up with about ten concepts per person for their shoot, and if any struck a chord with them, that would be great. And if any of my concepts inspired their own thoughts, I was honored to turn their idea into a striking portrait. Sometimes we would come together and collaborate on a new concept—imagine spitballing ideas with Mel Brooks ("Matt, those ideas stink."), John Cleese ("Yes, I think playing a big fish like a cello would be funny, but it would have to be quite a big fish."), Carol Burnett ("How about when I tug my ear it goes down to my shoulder?") or Steve Martin ("You want me to play the banjo with Kermit the Frog? Ummmm, OK.").

To be honest, once we had Mel Brooks it was a little easier to get a response from others. Once we had Kermit the Frog, no one wanted to be left out.

After a year and a half of shooting in cities from Los Angeles to Edinburgh, and getting the vast majority of the people on my wish list, certainly the biggest collection of these icons in one project, I am proud to now invite you to grin, smile, laugh, guffaw, chuckle, reminisce, admire, and gaze at a book full of true comic geniuses.

—MATT HOYLE

P.S. With this book I'm proud to support Save the Children—there's something so fitting when you connect these talented comedians with children who really need to smile.

Contents

Introduction:

 Comedy is like an egg 7

Mel Brooks 8
Tim Allen 11
Bob Balaban 12
Jason Bateman 15
Michael Ian Black 17
Carol Burnett 19
Steve Carell 21
Jim Carrey 24
Chevy Chase 27
Andrew Dice Clay 30
John Cleese 31
Billy Connolly 34
Jennifer Coolidge 36
David Cross 37
Billy Crystal 39
Rhys Darby 42
Dame Edna Everage 44
Tina Fey 47
Zach Galifianakis 50
Janeane Garofalo 53
Ricky Gervais 55
"Bobcat" Goldthwait 57
Tom Green 61
Kathy Griffin 62
Neil Patrick Harris 64
Tim Heidecker and
 Eric Wareheim 66
Ed Helms 67
John Hodgman 69
David Koechner 70
Martin Lawrence 72
Cloris Leachman 73
Denis Leary 75
Jay Leno 76
Eugene Levy 78
George Lopez 79
Jon Lovitz 82
Matt Lucas 83
Joanna Lumley 86
Joanna Lumley and
 Jennifer Saunders 87
Jane Lynch 88
Marc Maron 91
Steve Martin 92
Jackie Mason 96
Adam McKay 99

Stephen Merchant 100
Bette Midler 101
Tim Minchin 104
Eugene Mirman 105
Tracy Morgan 106
Eddie Murphy 107
Mike Myers 109
Bob Newhart 110
B. J. Novak 113
Conan O'Brien 114
Catherine O'Hara 118
Bob Odenkirk 119
Nick Offerman 120
John Oliver 122
Patton Oswalt 123
Michael Palin 125
Carl Reiner 128
Paul Reubens 130
Michael Richards 132
Don Rickles 135
Joan Rivers 136
Jay Roach 139
Mort Sahl 141
Andy Samberg 142
Adam Sandler 144
Jennifer Saunders 147
Kristen Schaal 149
Martin Short 150
Michael Showalter 153
Sarah Silverman 155
Tommy Smothers 156
David Steinberg 158
Jon Stewart 159
Jerry Stiller 162
Eric Stonestreet 164
Jeffrey Tambor 165
Lily Tomlin and
 Jane Wagner 168
Lily Tomlin 169
Dick Van Dyke 170
Kristen Wiig 172
Fred Willard 173
Robin Williams 175
Rainn Wilson 178
Jonathan Winters 180
"Weird Al" Yankovic 183

Biographies 186
Acknowledgments 202

Comedy is like an egg

It can be hard-boiled

It can be scrambled

Or it can be raw.

If you don't break comedy

If you don't break the egg

You'll always have it.

But in time, if you don't take a chance and break the egg

It will spoil.

Therefore. Break the egg.

Poach it

Sunnyside up it

Scramble it

Or make an omelette like the French say . . . with three eggs . . .

With some truffles.

Make it *baveuse*

That's French . . .

It means, well done on the outside

Soft in the middle

And that's the way I like my comedy.

—MEL BROOKS

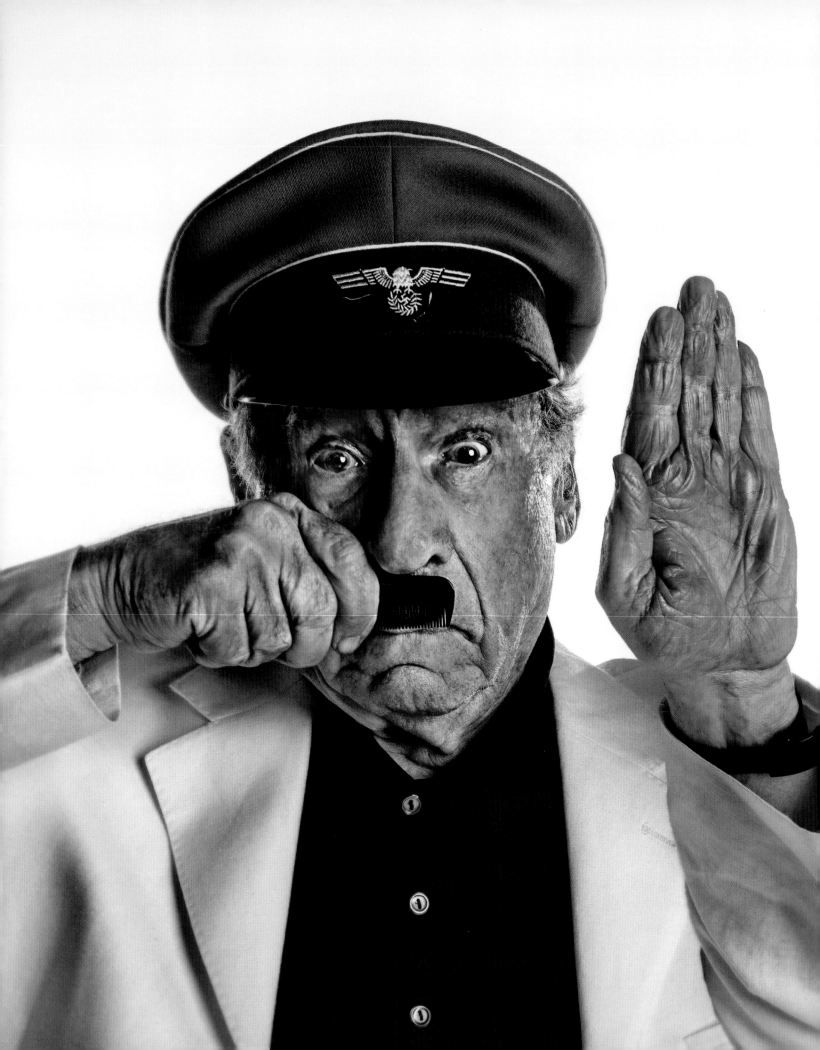

Tragedy is when I cut my finger . . .

Comedy is when you fall into an open sewer and die.

MEL BROOKS

Electricity can be dangerous.

My nephew tried to stick a penny into a plug. Whoever said
a penny doesn't go far didn't see him shoot across that floor.
I told him he was grounded.

TIM ALLEN

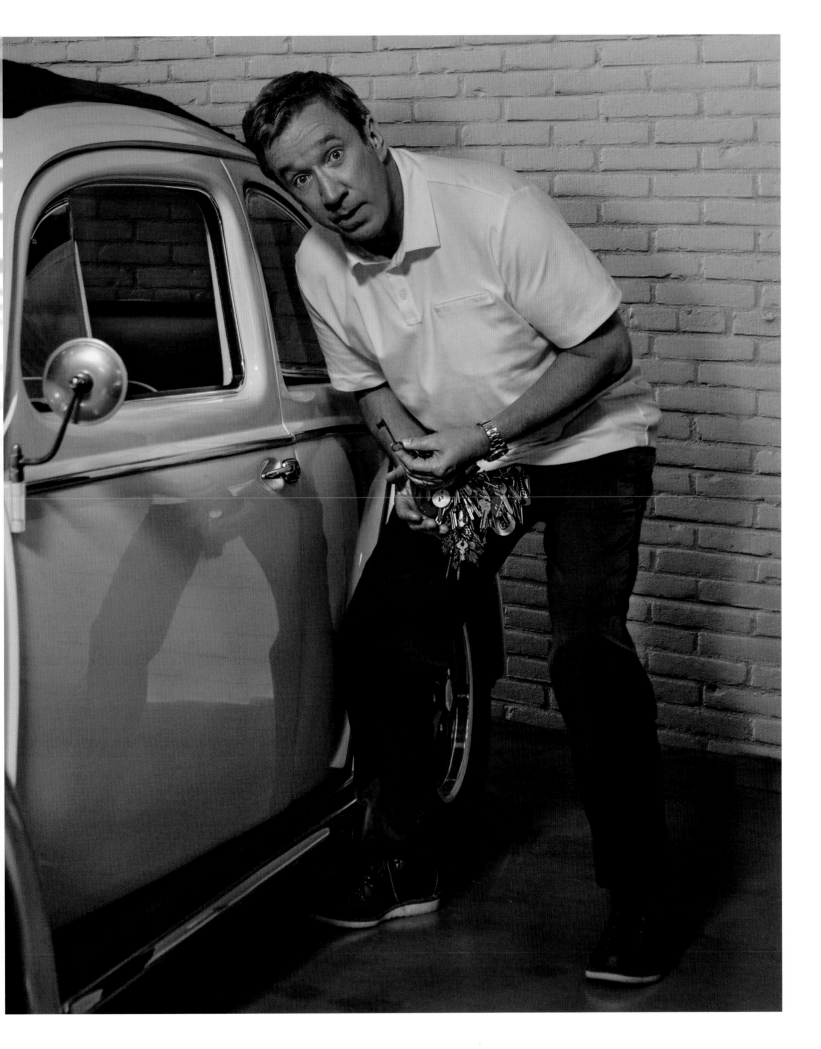

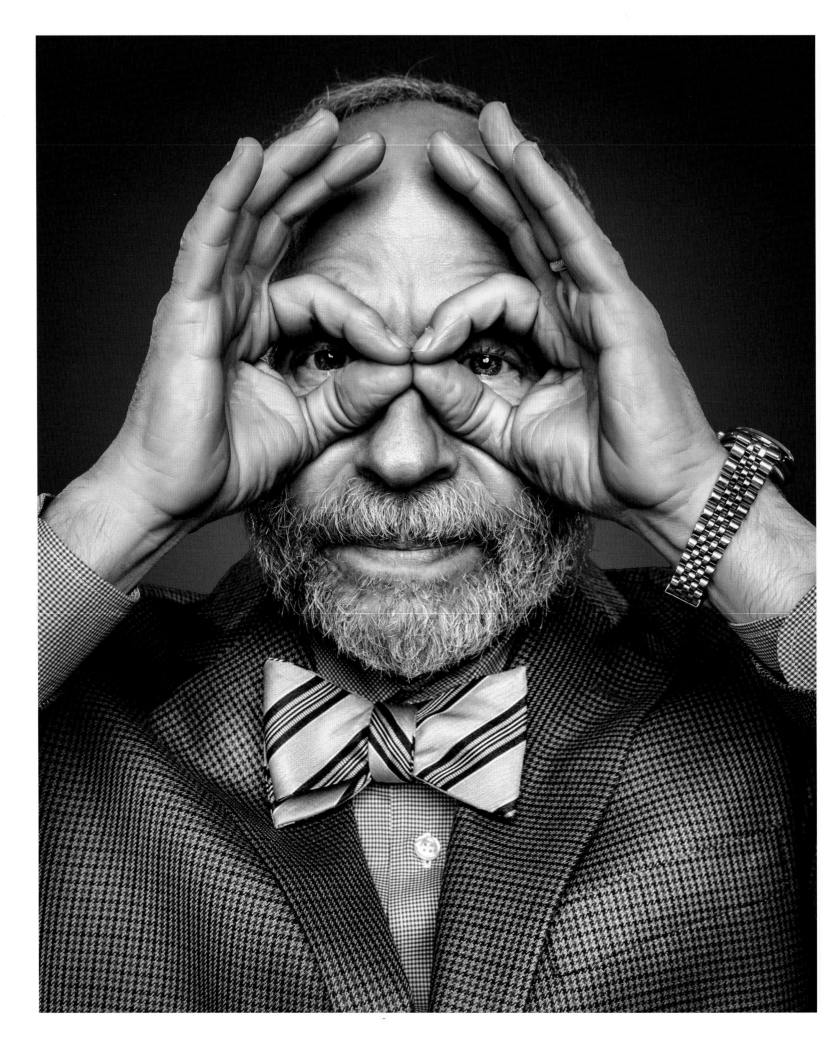

I try to do everything I can . . .

not to fail hideously.

BOB BALABAN

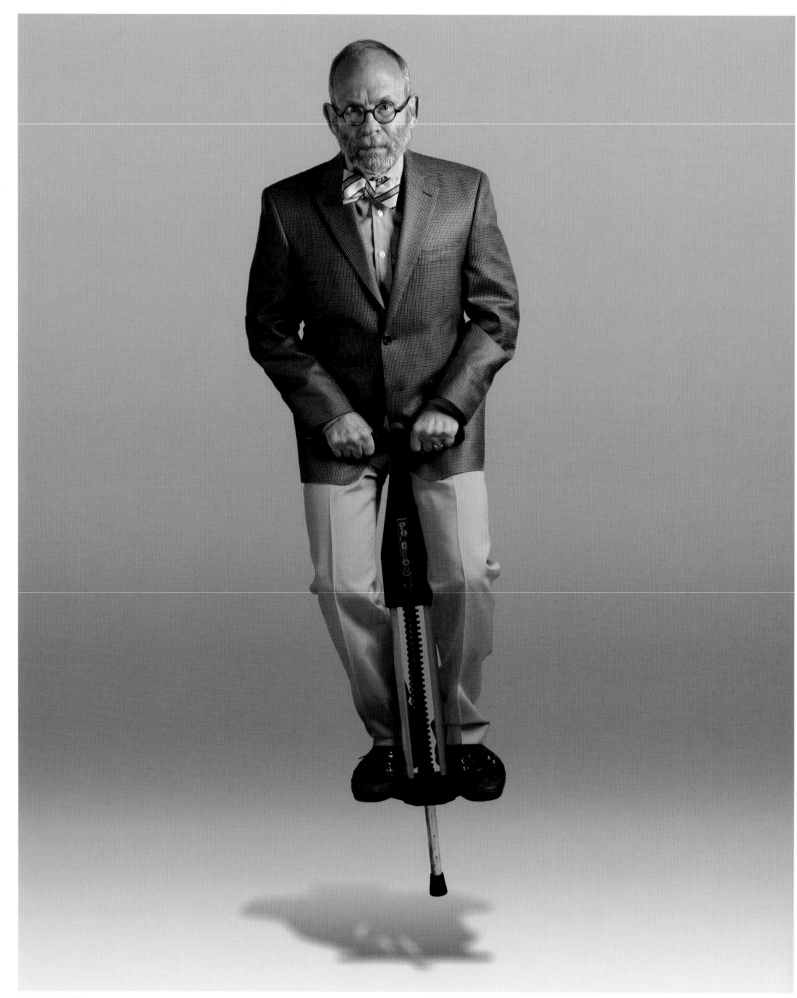

BOB BALABAN

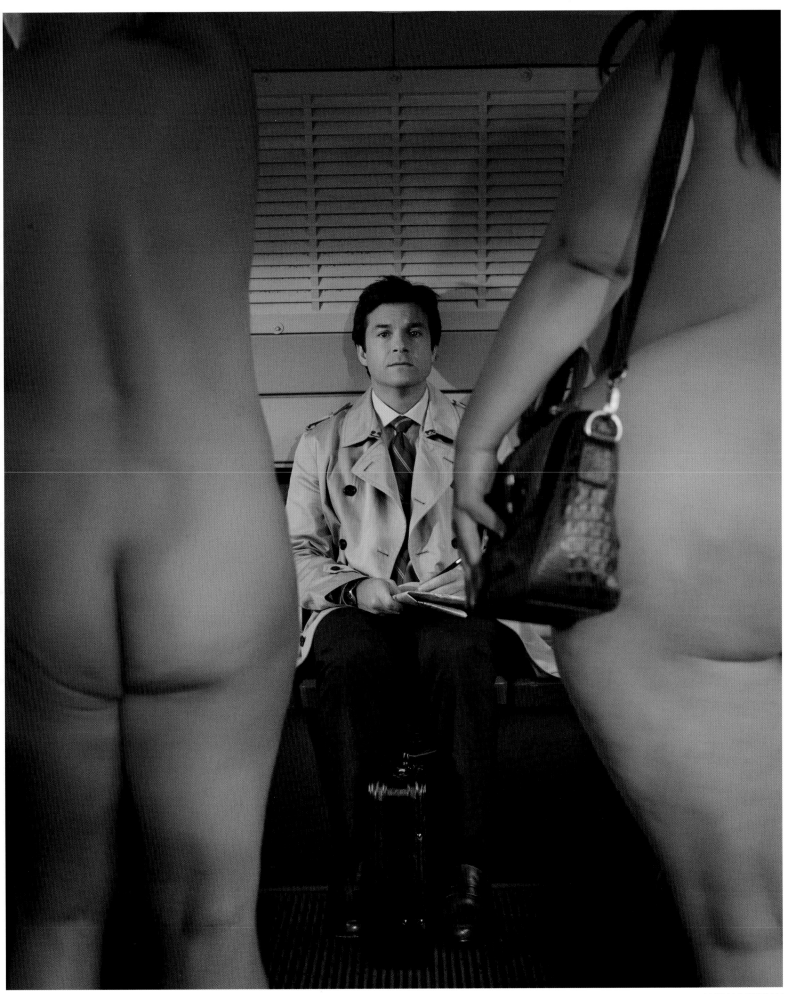

JASON BATEMAN

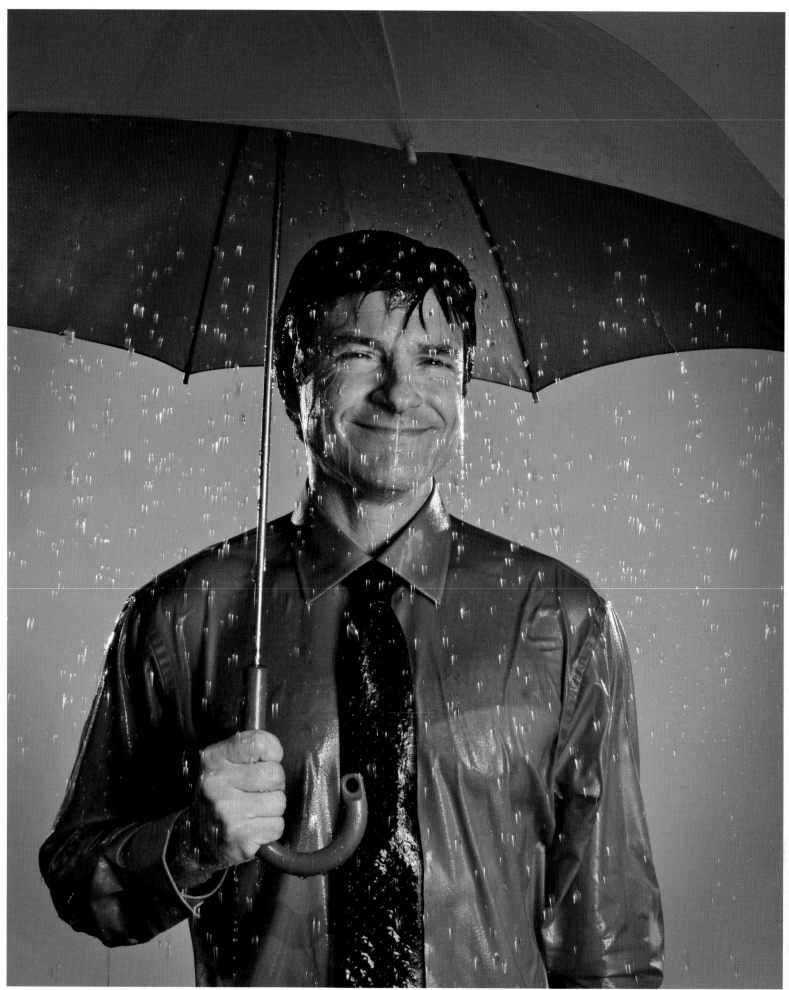

JASON BATEMAN

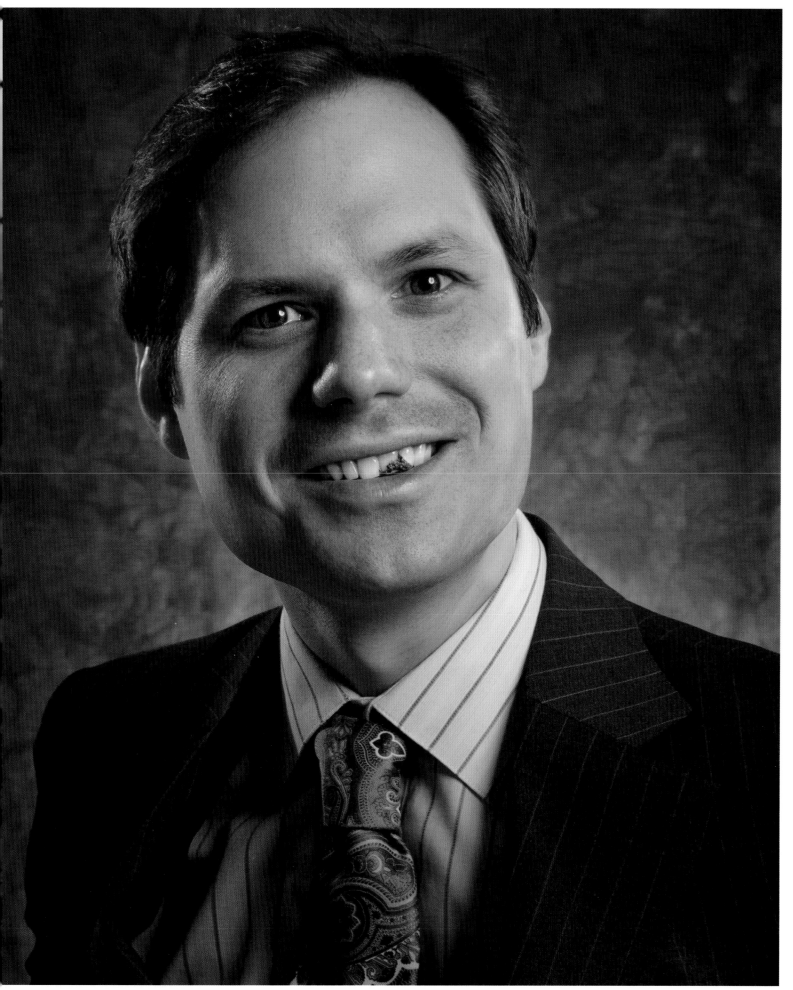

MICHAEL IAN BLACK

When I was little, I would always stand in front of a mirror and cross my eyes.

Then my mother would come in and say, "Stop that! Nothing will ever come of it!"

CAROL BURNETT

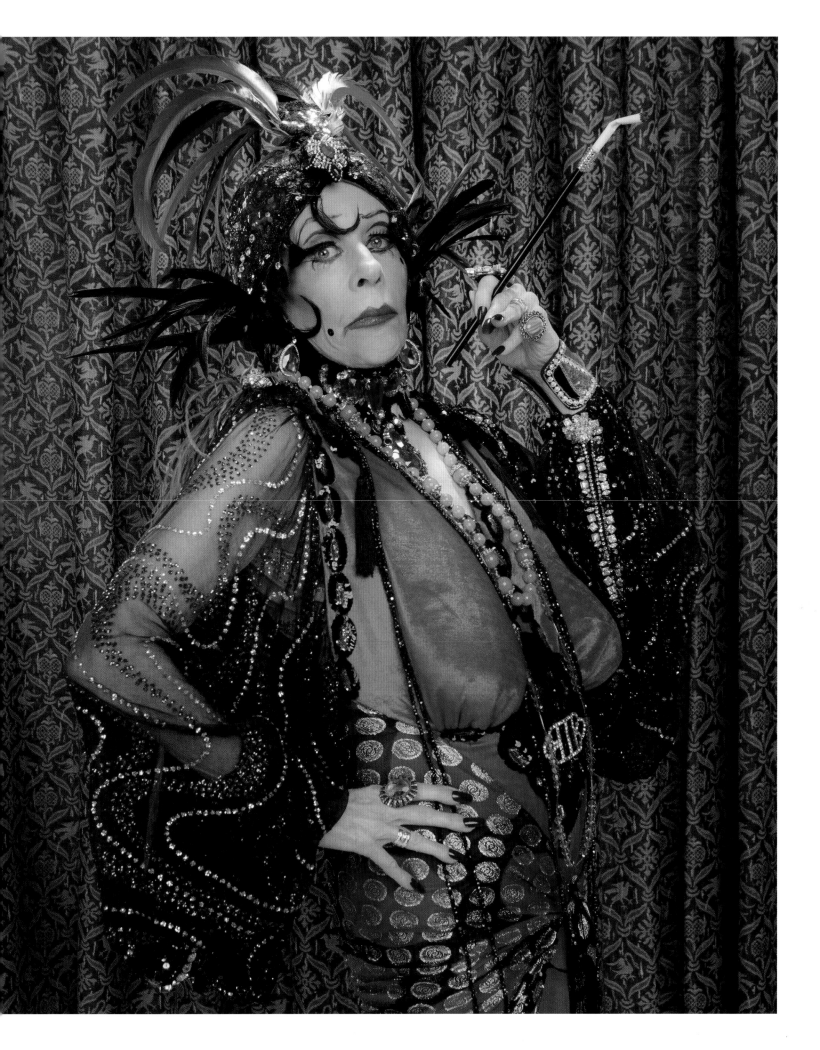

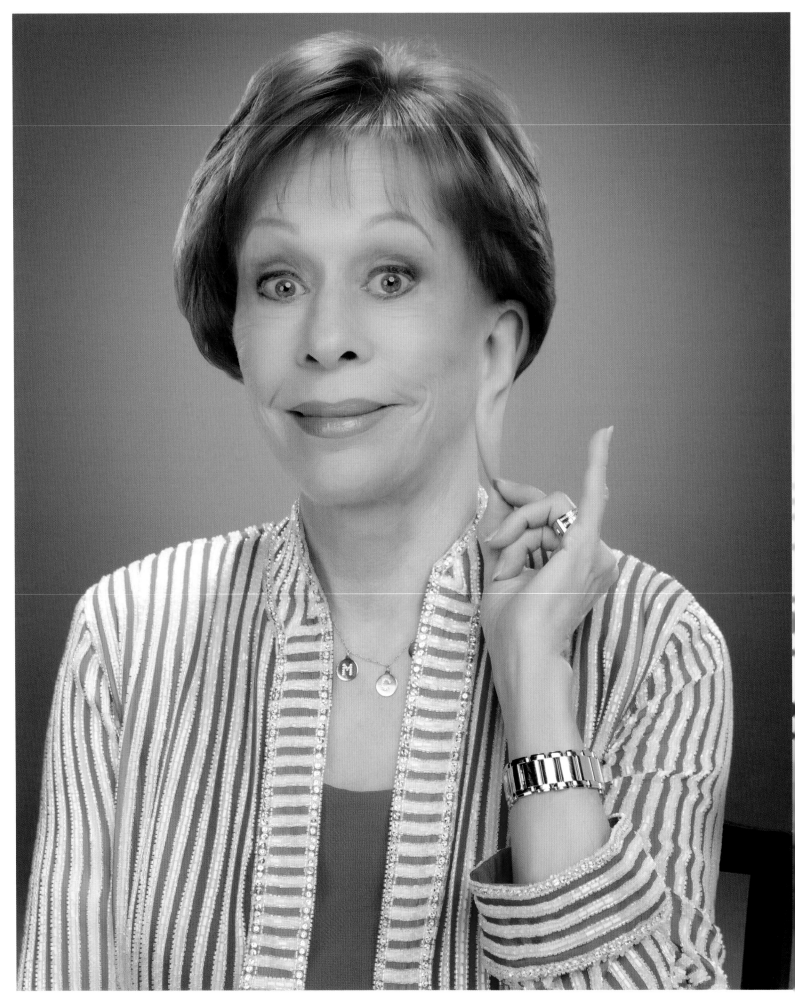

CAROL BURNETT

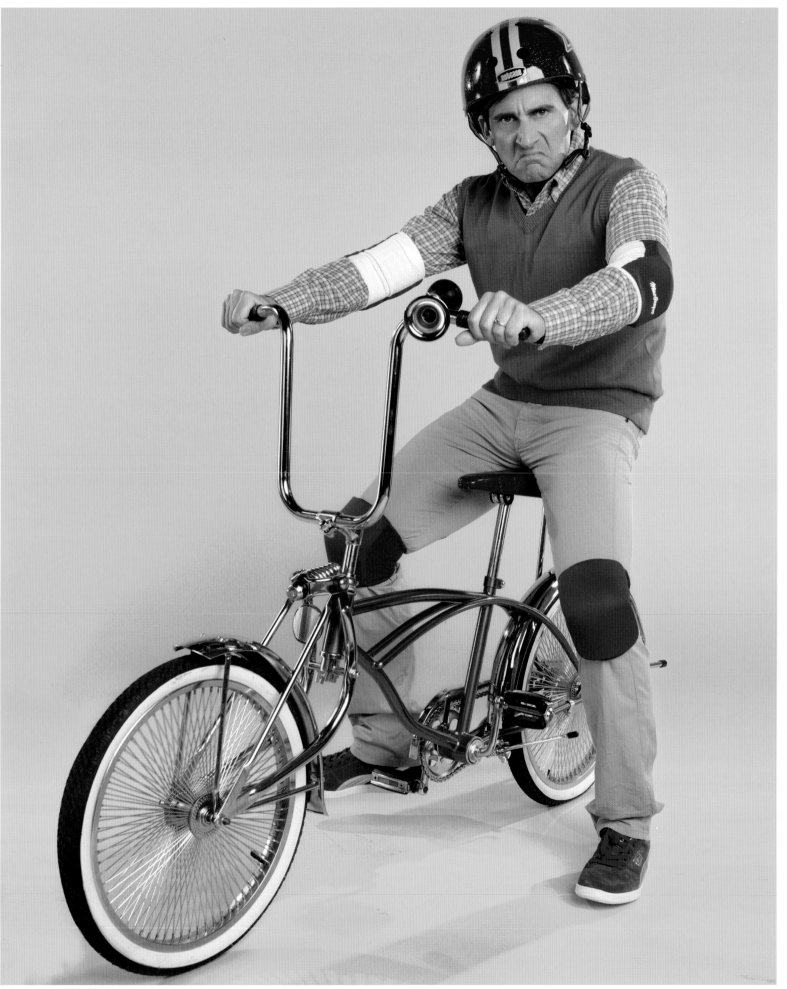

STEVE CARELL

I'm not funny.

I'm actually quite a boring person to meet one-on-one. That seems to shock quite a few people who I run into, but I can't help it. I really suck as a guest at cocktail parties. I have no idea where my pathetic nature comes from. If I thought about it too long, it would depress me.

STEVE CARELL

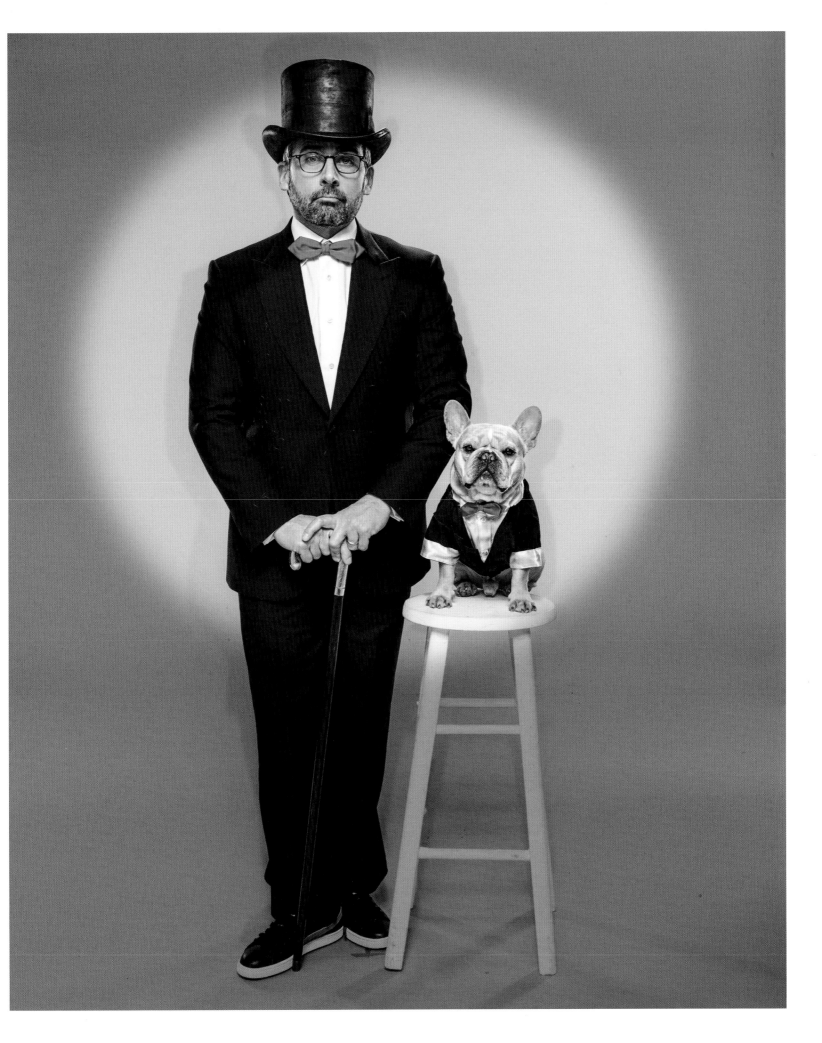

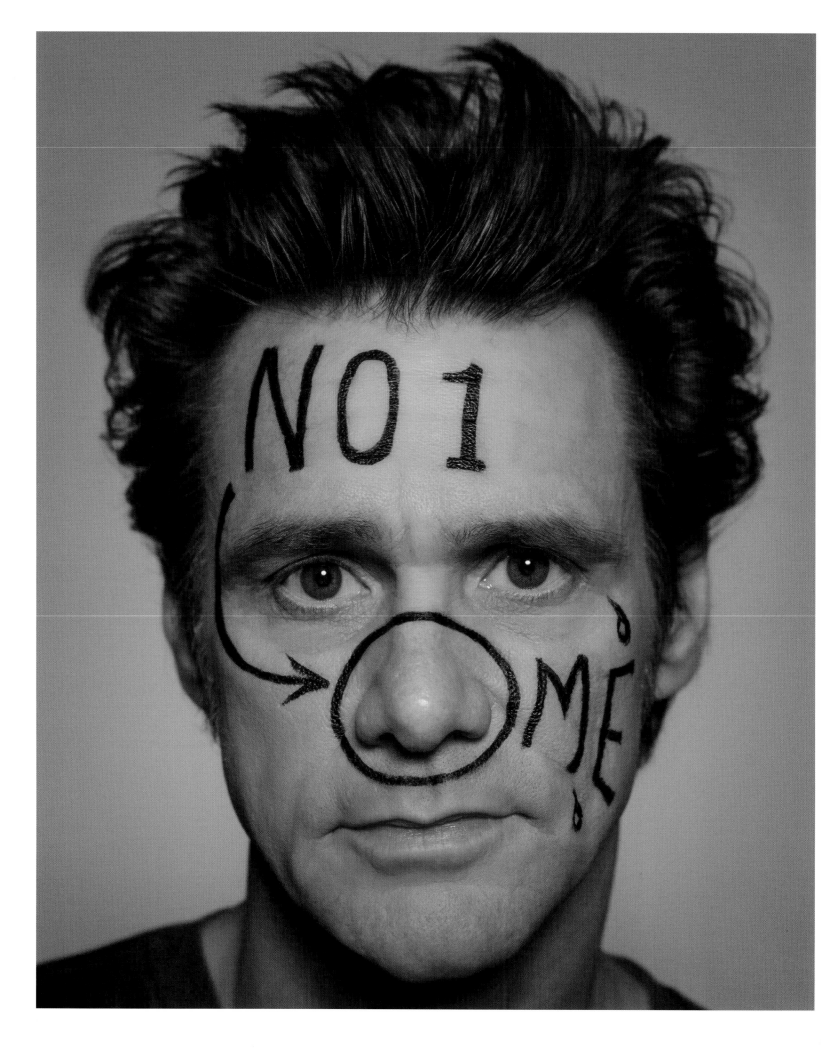

One thing I hope I'll never be . . .

is drunk with my own power. And anybody who says I am
will never work in this town again.

JIM CARREY

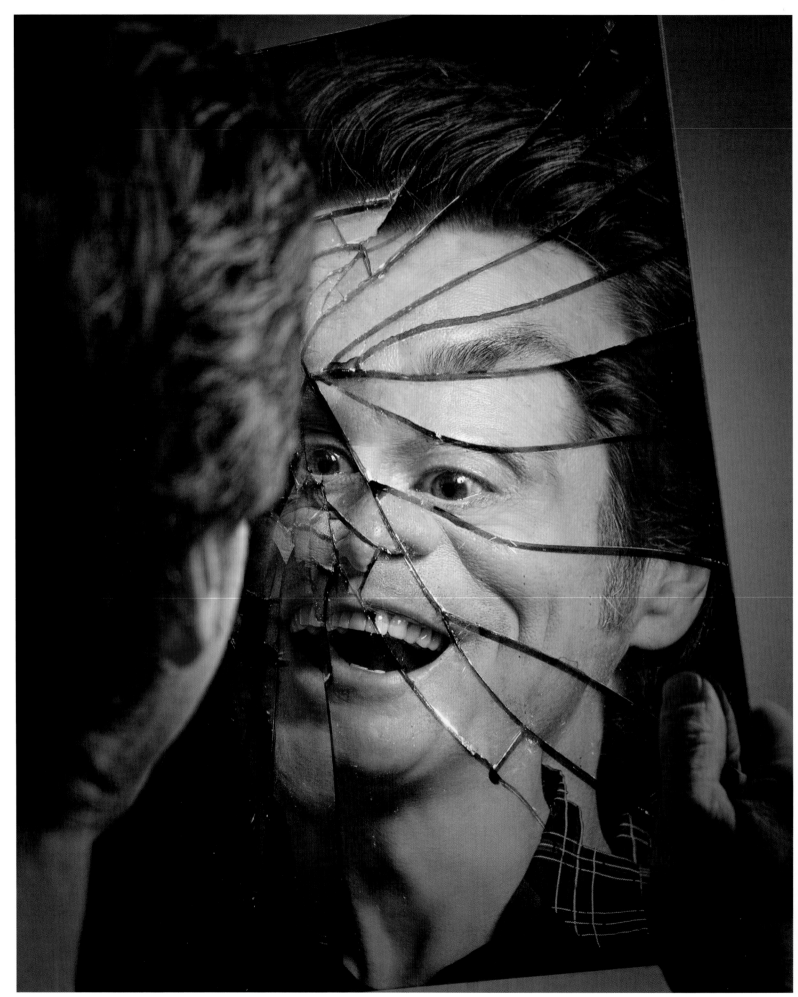

JIM CARREY

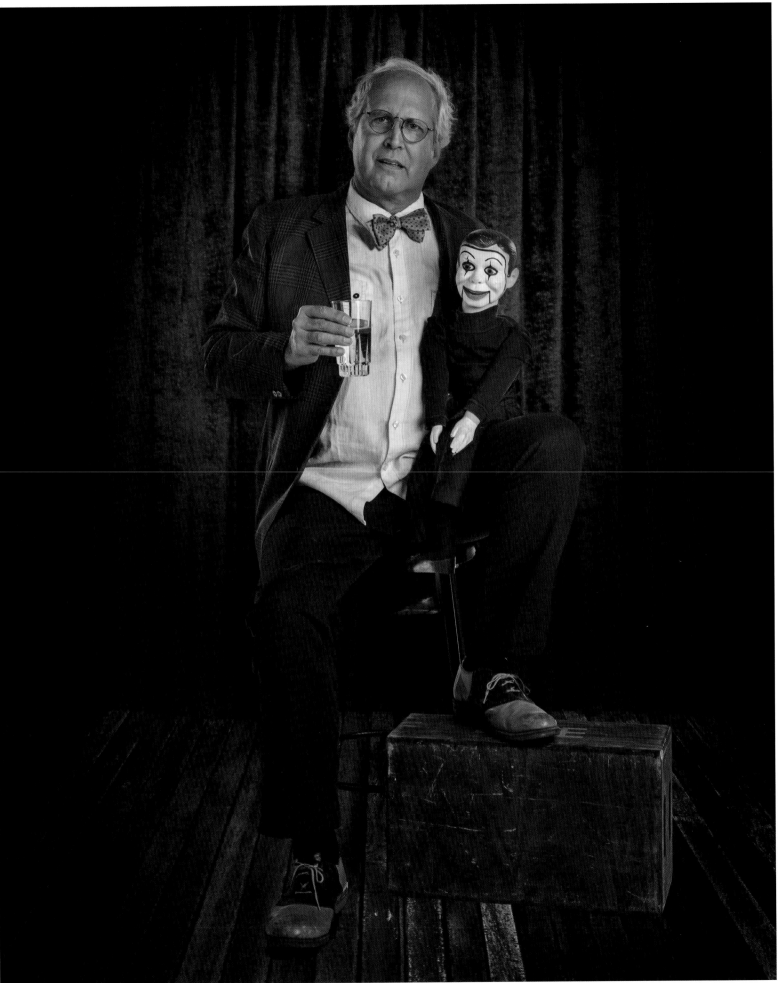

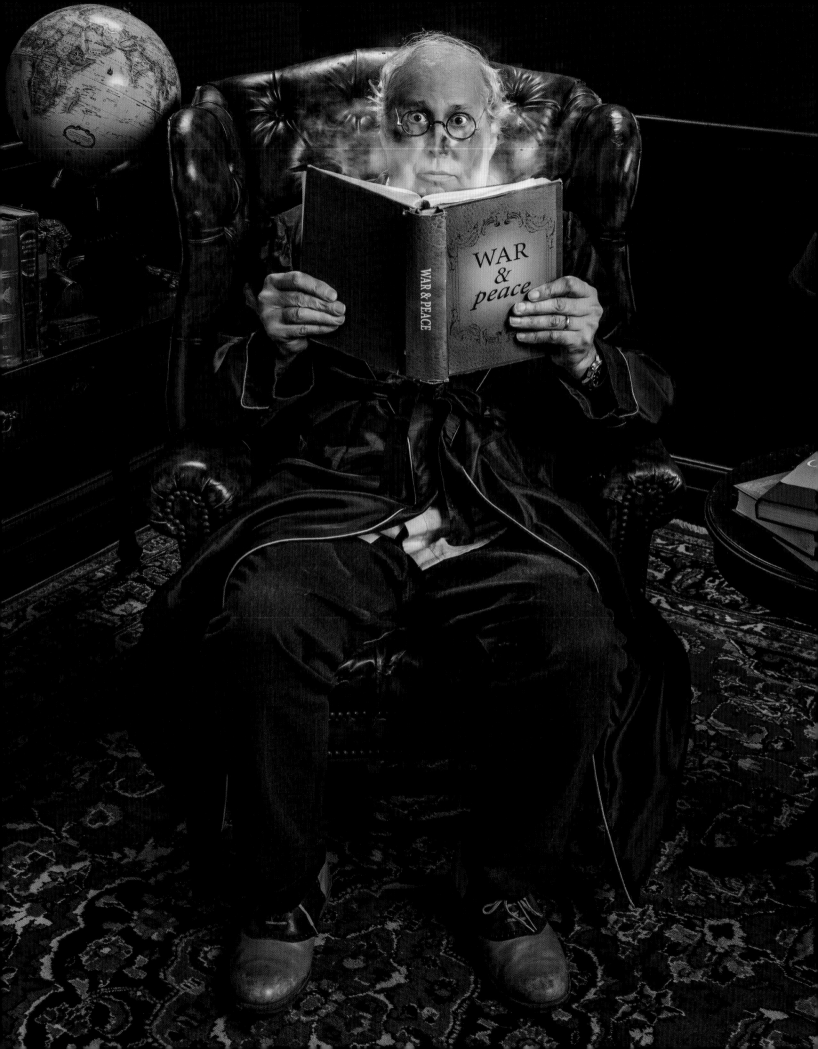

The best comedy I ever did was when people didn't know who I was.

Fame is a very unnatural human condition. When you stop to realize that Abraham Lincoln was probably never seen by more than 400 people in a single evening, and that I can enter over 40 *million* homes in a single evening due to the power of television, you have to admit the situation is not normal.

CHEVY CHASE

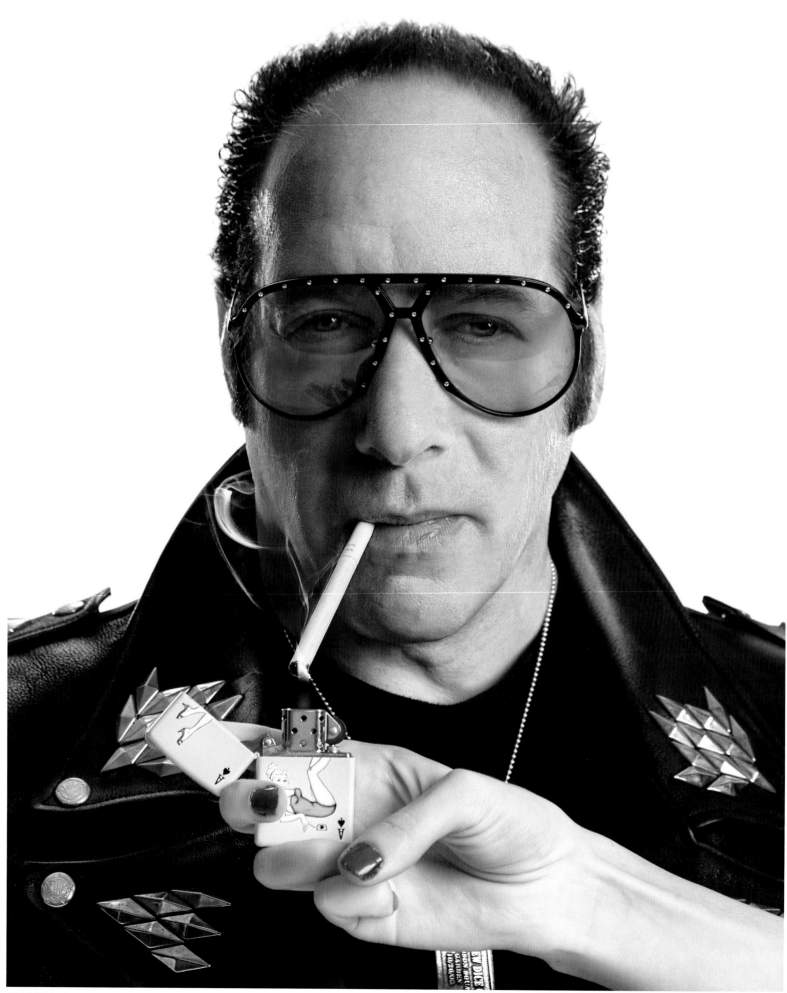

ANDREW DICE CLAY

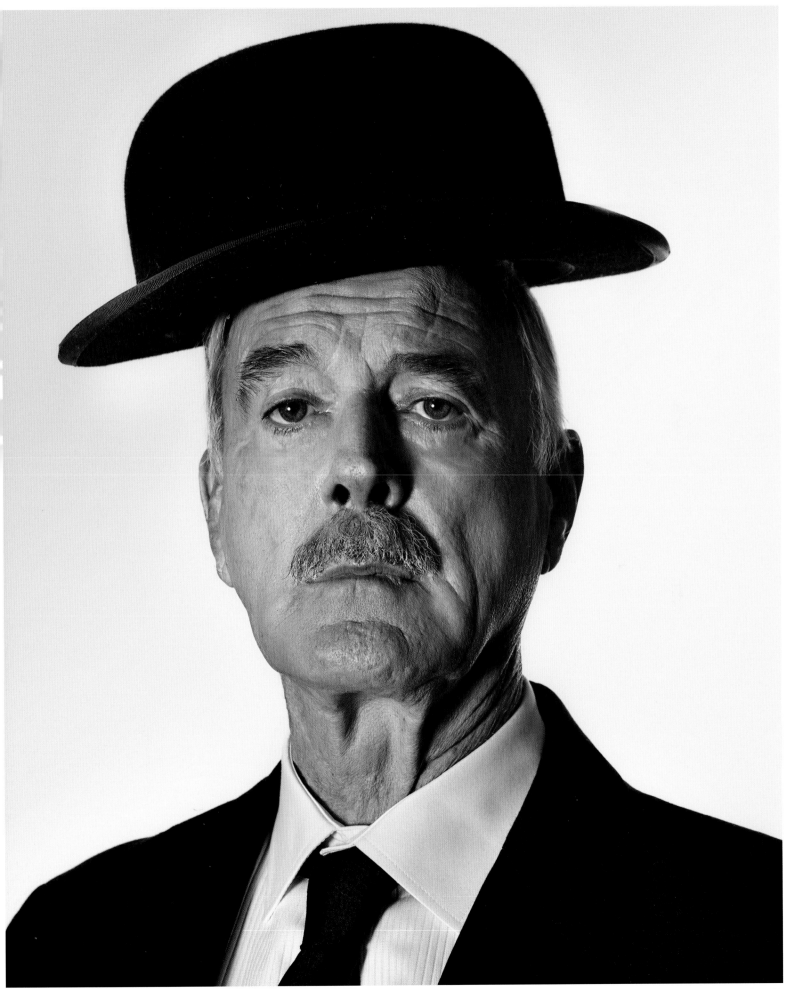

JOHN CLEESE

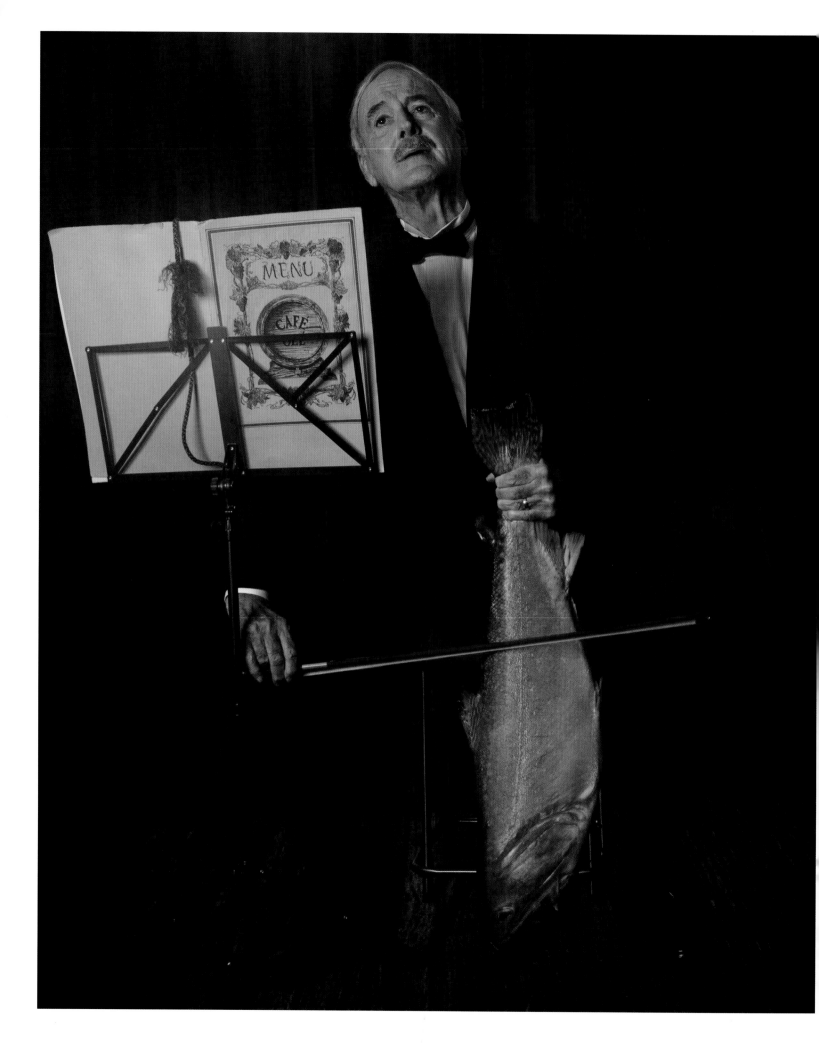

Acting is all about faking things . . .

so the best training is having a difficult parent.

JOHN CLEESE

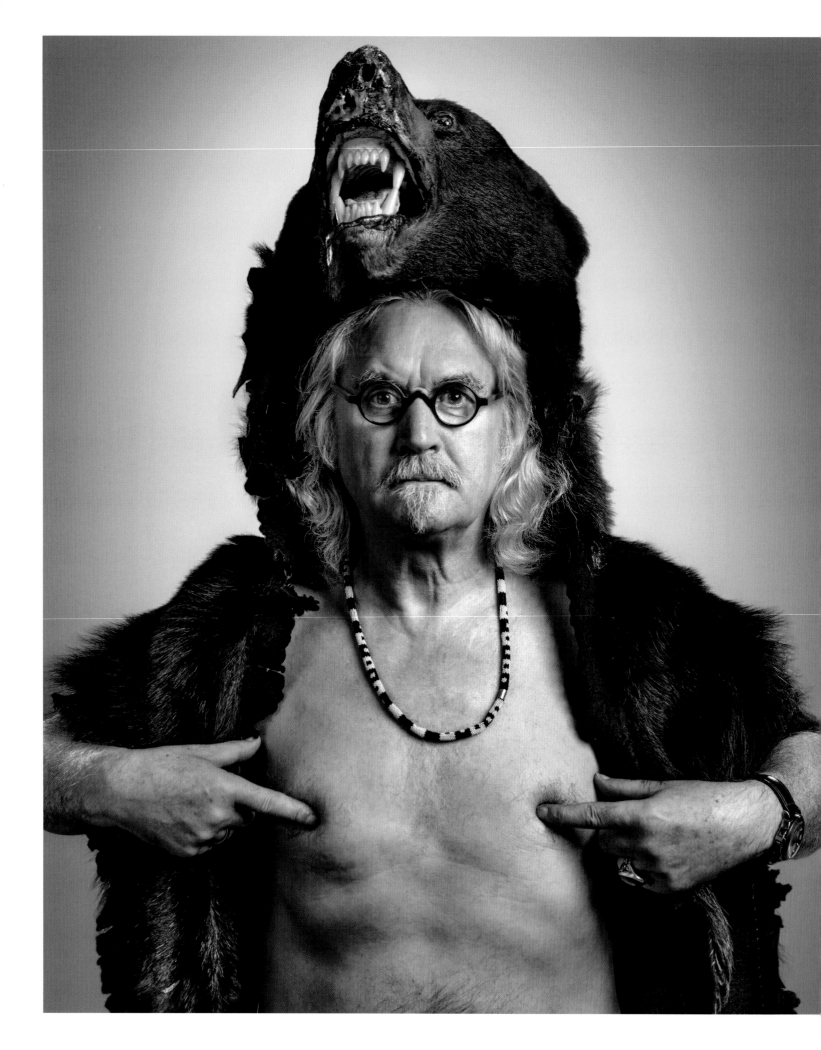

Never trust a man, who,
when left alone with a tea cozy,
doesn't try it on.

JENNIFER COOLIDGE

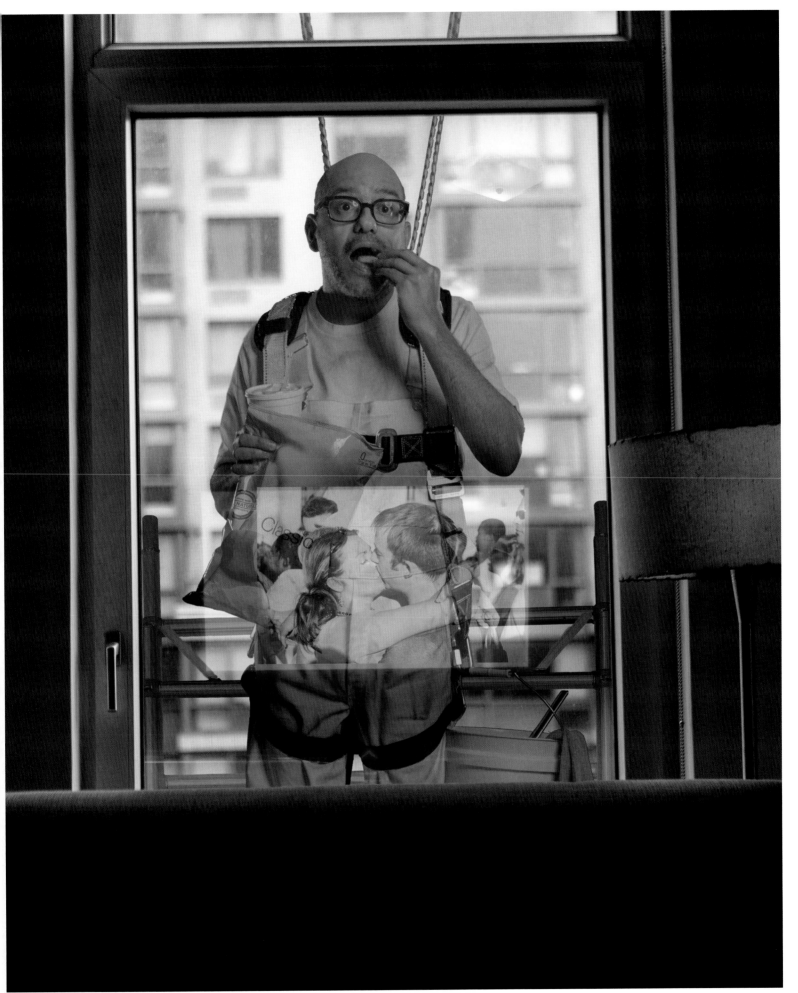

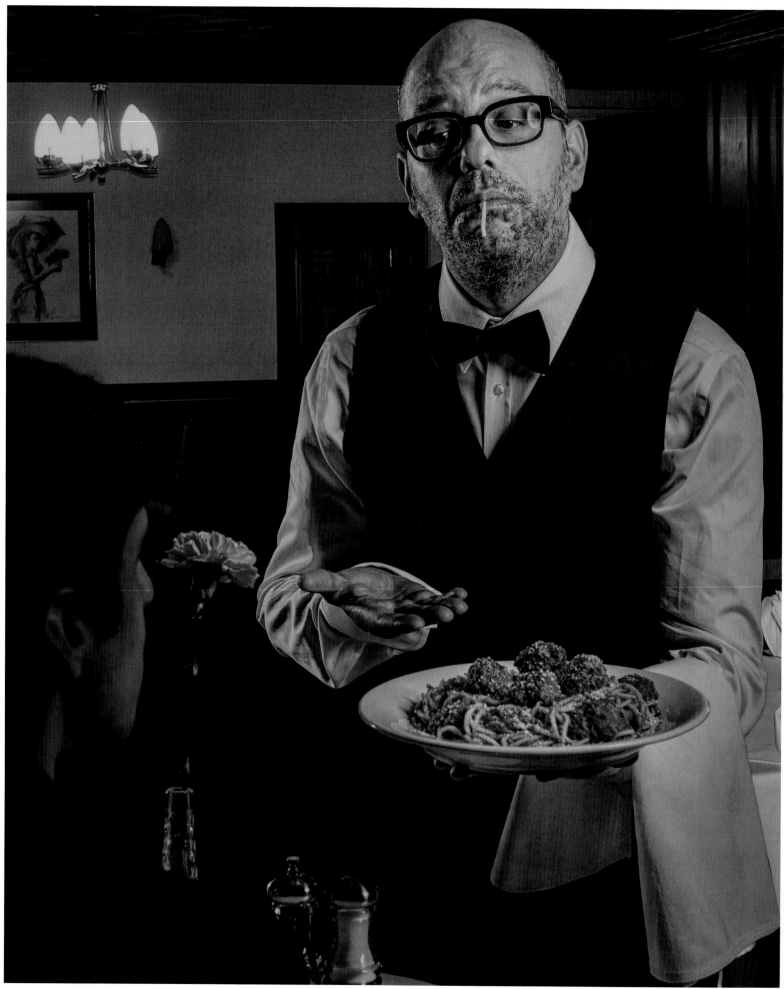

DAVID CROSS

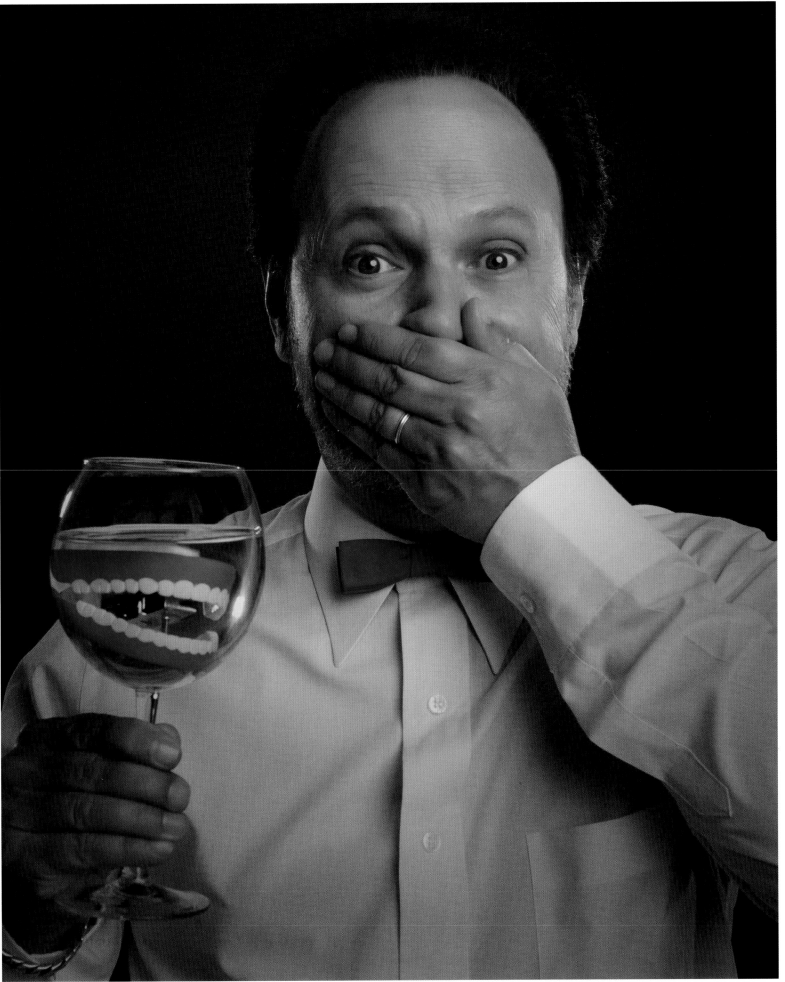

BILLY CRYSTAL

I could always improvise.

Some of my elementary school teachers remember me standing in front of the class with a flower on my head, talking about photosynthesis. I'd stop and say, "Is this working for any of you?"

BILLY CRYSTAL

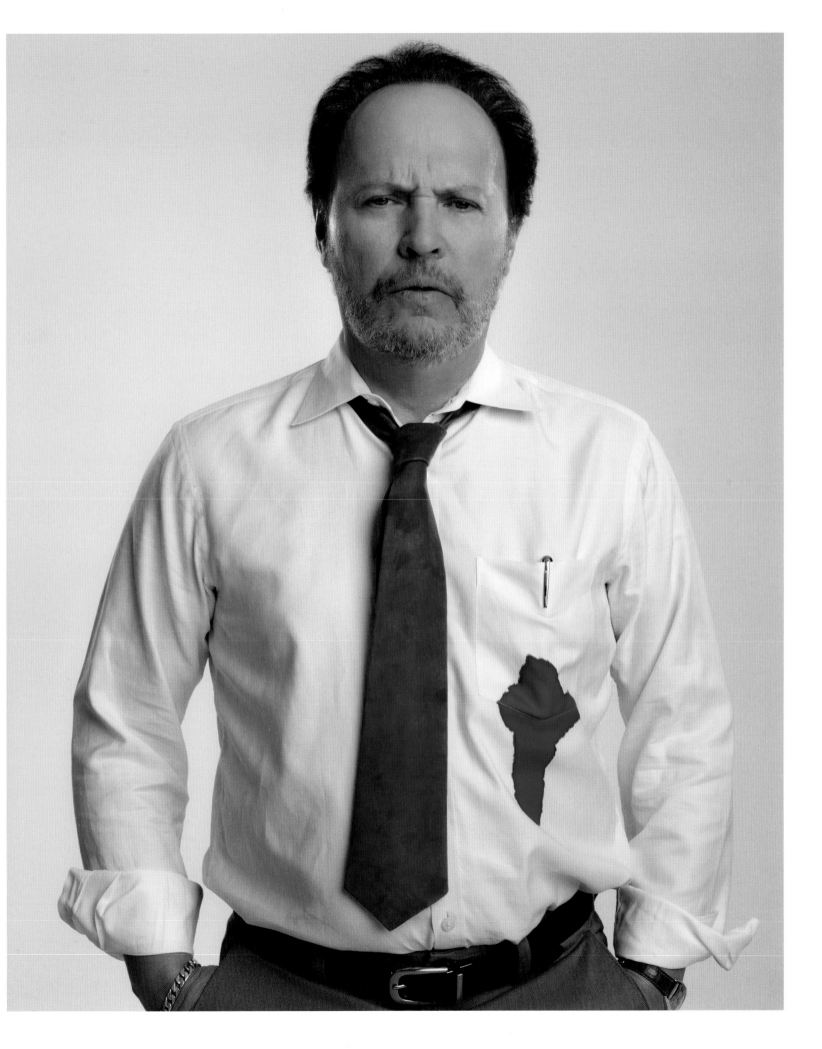

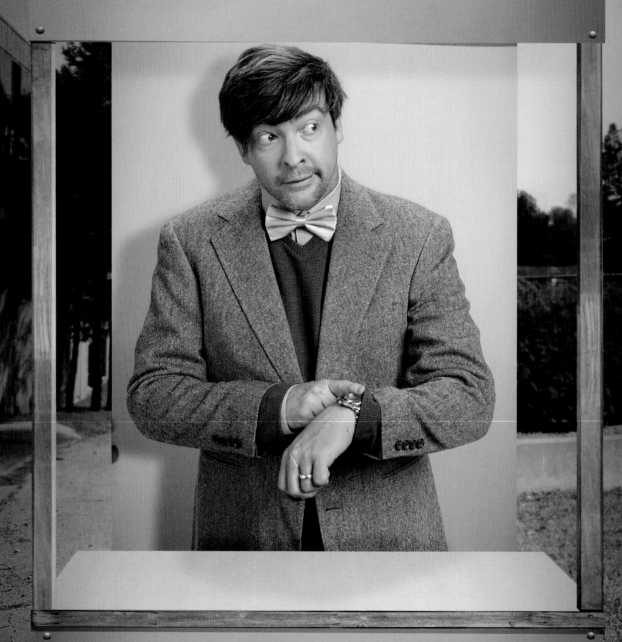

I'm a yes-man . . .

living in a no-man's land.

RHYS DARBY

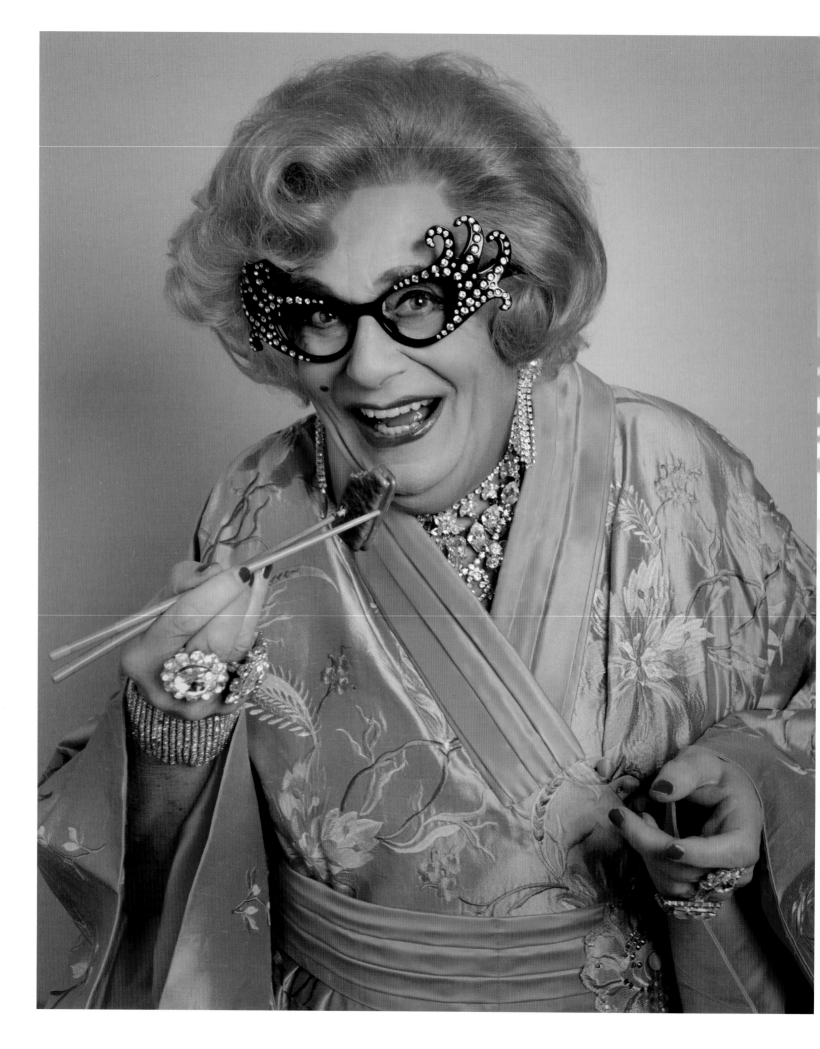

I was born in Melbourne with a precious gift.

Dame Nature stooped over my cot and gave me this gift.

It was the ability to laugh at the misfortunes of others.

DAME EDNA EVERAGE

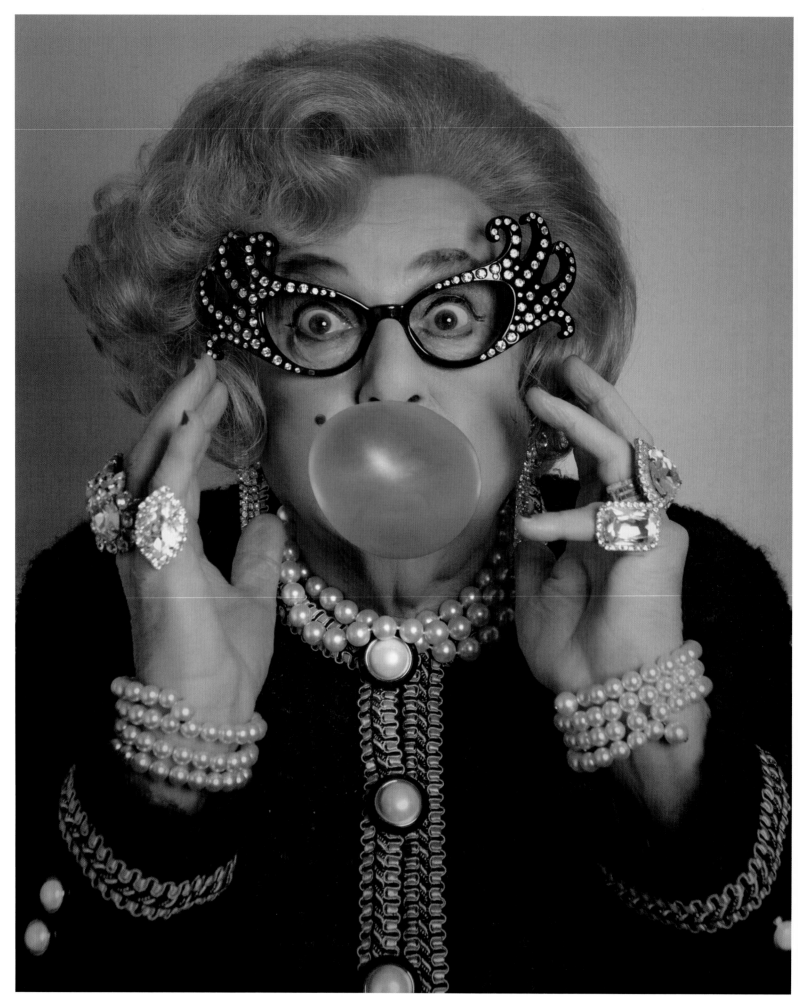

DAME EDNA EVERAGE

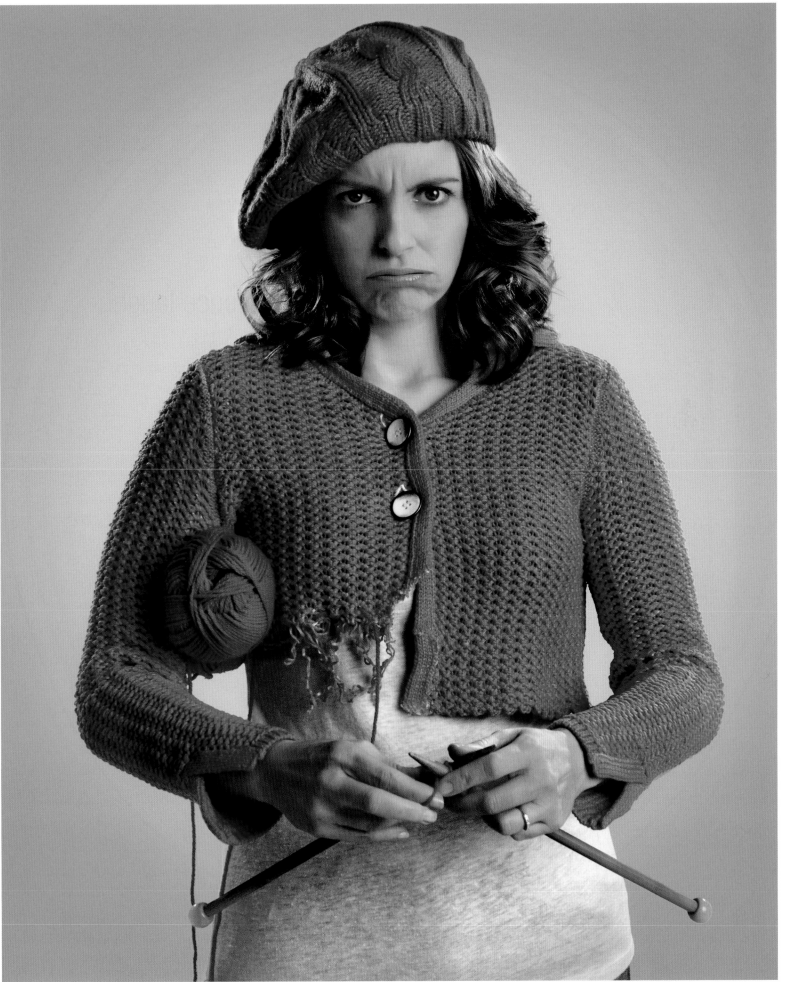

TINA FEY

If you want to make an audience laugh . . .

you dress a man up like an old lady and push her down the stairs. If you want
to make comedy writers laugh, you push an actual old lady down the stairs.

TINA FEY

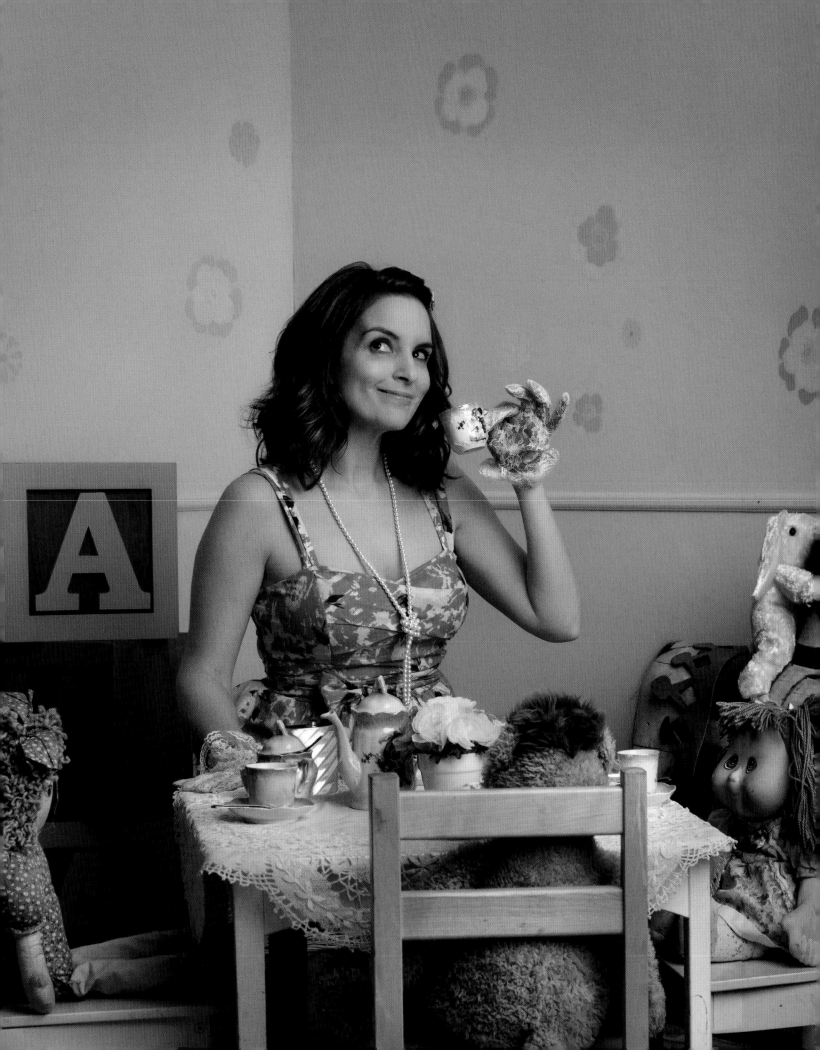

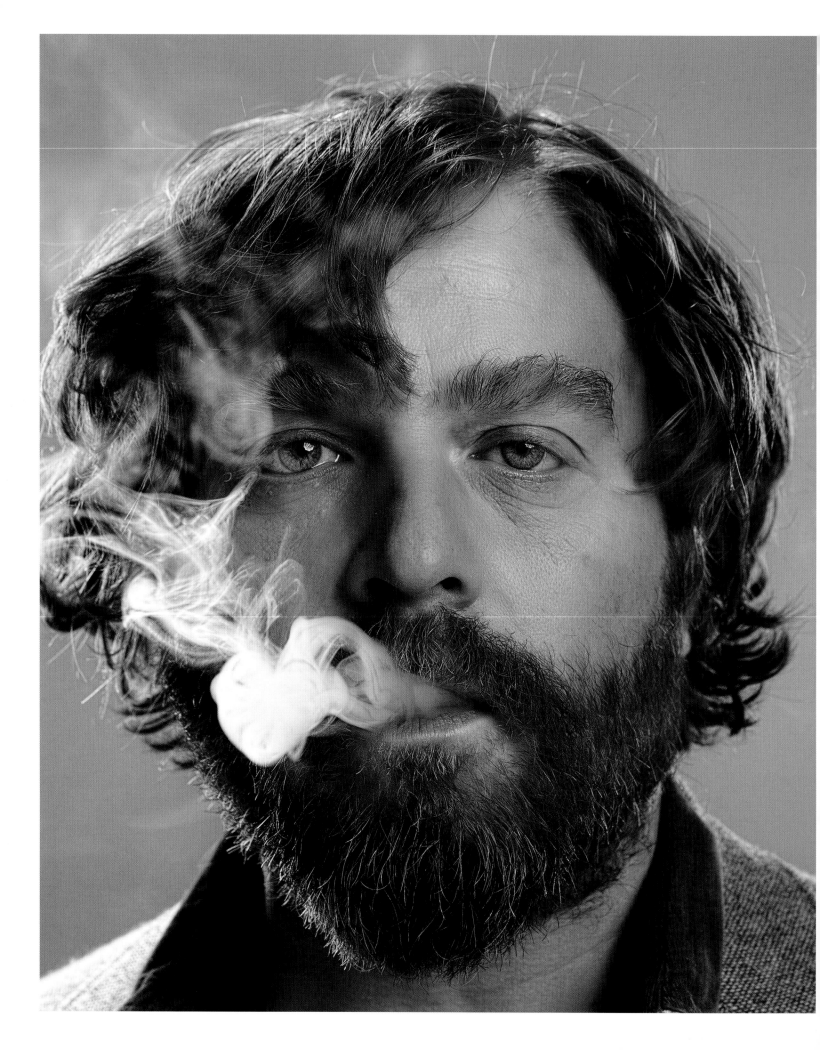

I have a lot of growing up to do.

I realized that the other day inside my fort.

ZACH GALIFIANAKIS

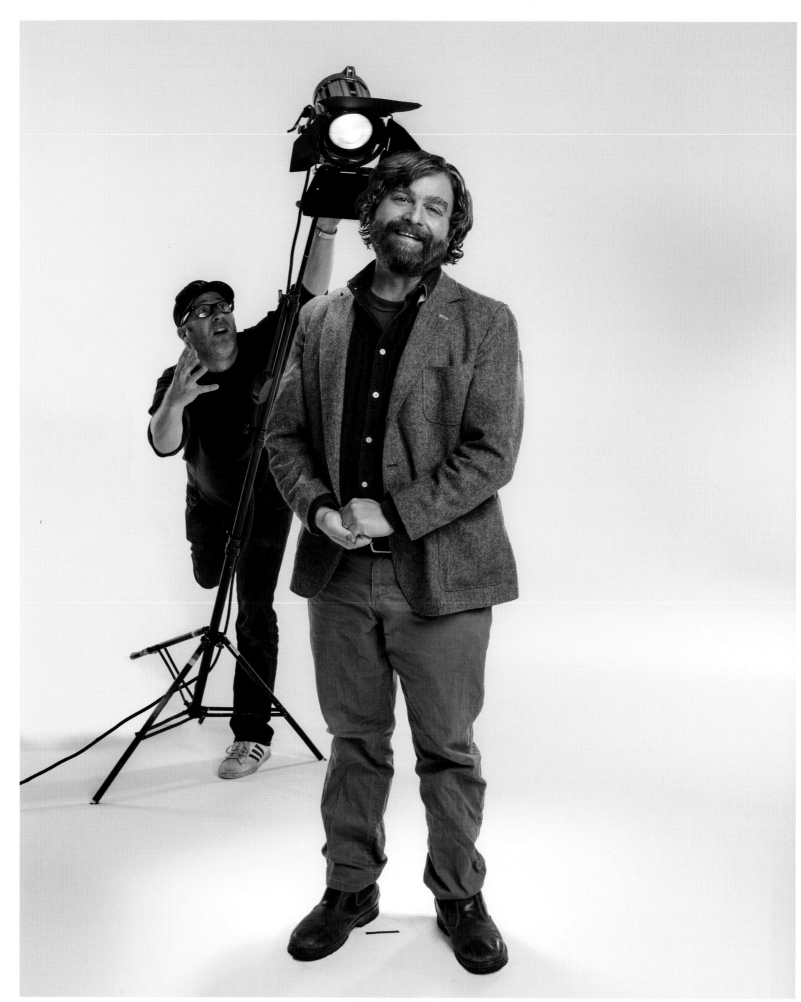

ZACH GALIFIANAKIS

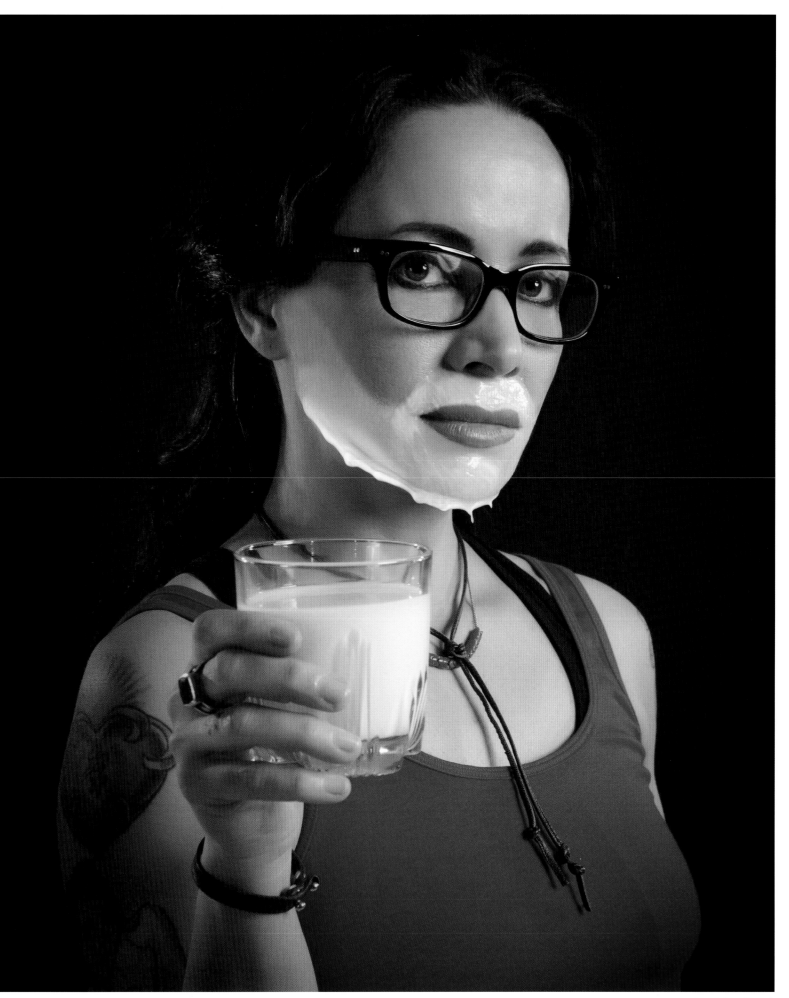

JANEANE GAROFALO

In the beginning God created the heavens and the earth . . .

Then he said, "Let there be light." And there was light.

Which means he made the entire universe in the dark!

How fucking good is that? He's brilliant.

RICKY GERVAIS

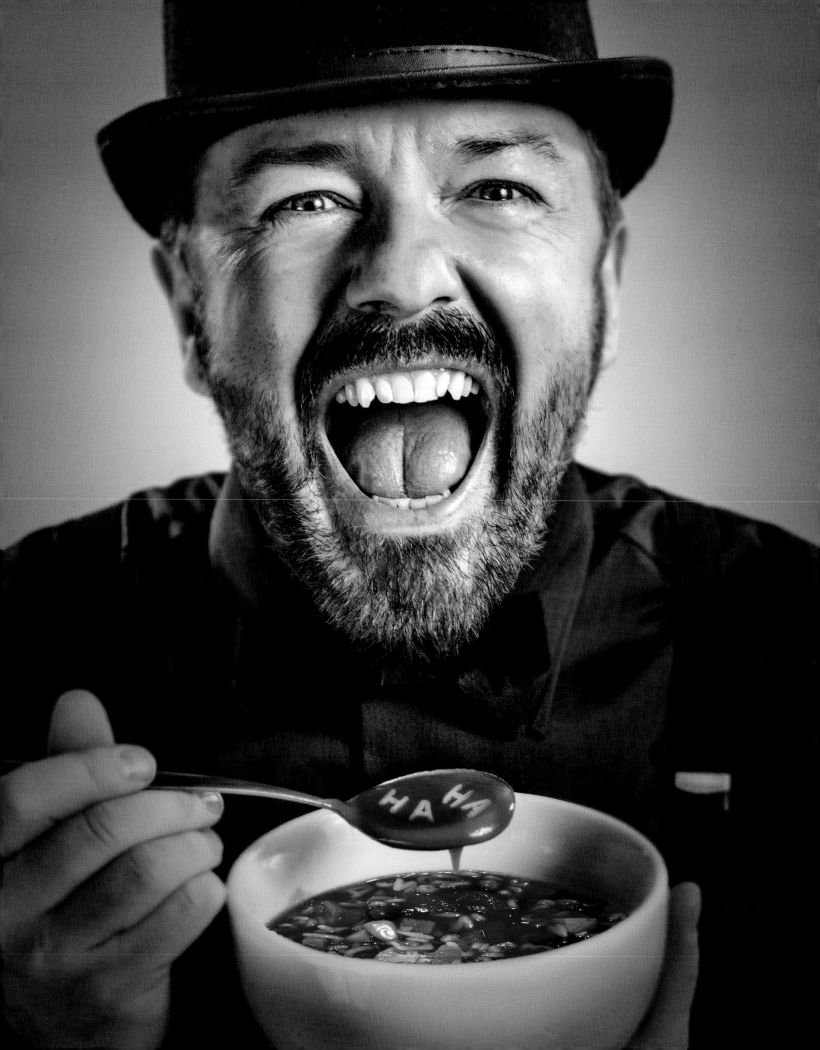

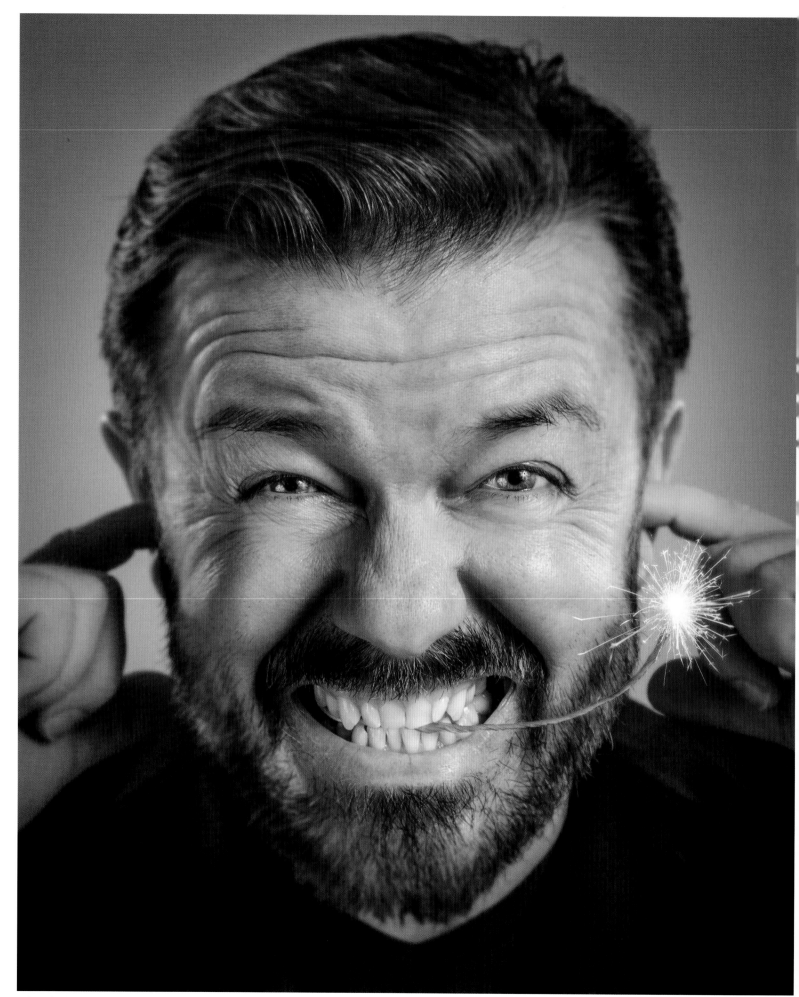

RICKY GERVAIS

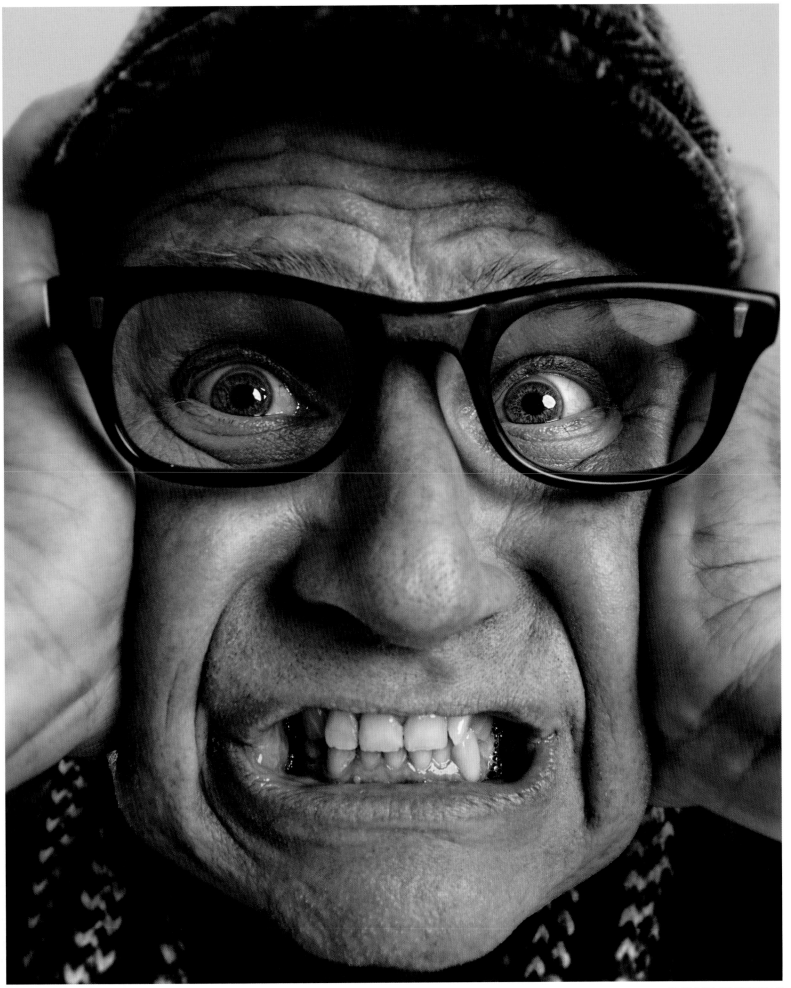

"BOBCAT" GOLDTHWAIT

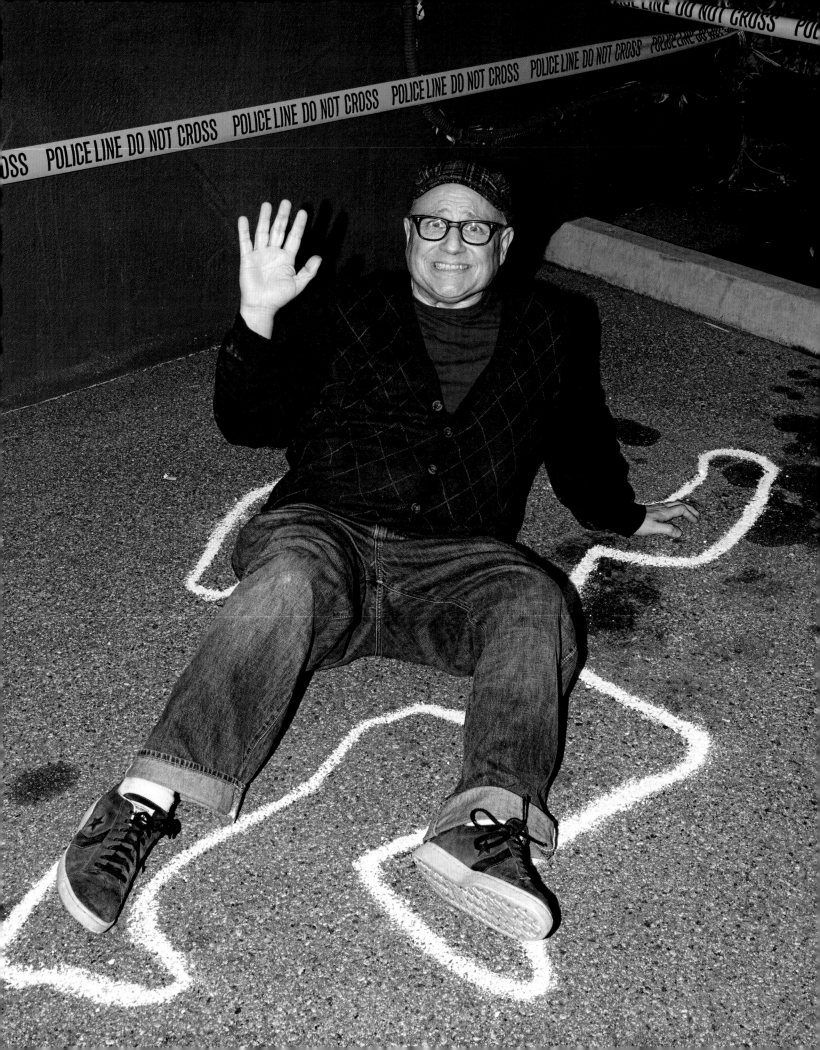

I'm all for hunters owning guns . . .

It increases the odds of two rednecks blowing each other's heads off.

"BOBCAT" GOLDTHWAIT

When my agent told me I had been asked to host *Canada's Walk of Fame . . .*

I was both surprised and delighted. Surprised that I still had an agent and delighted to be allowed back into Canada.

TOM GREEN

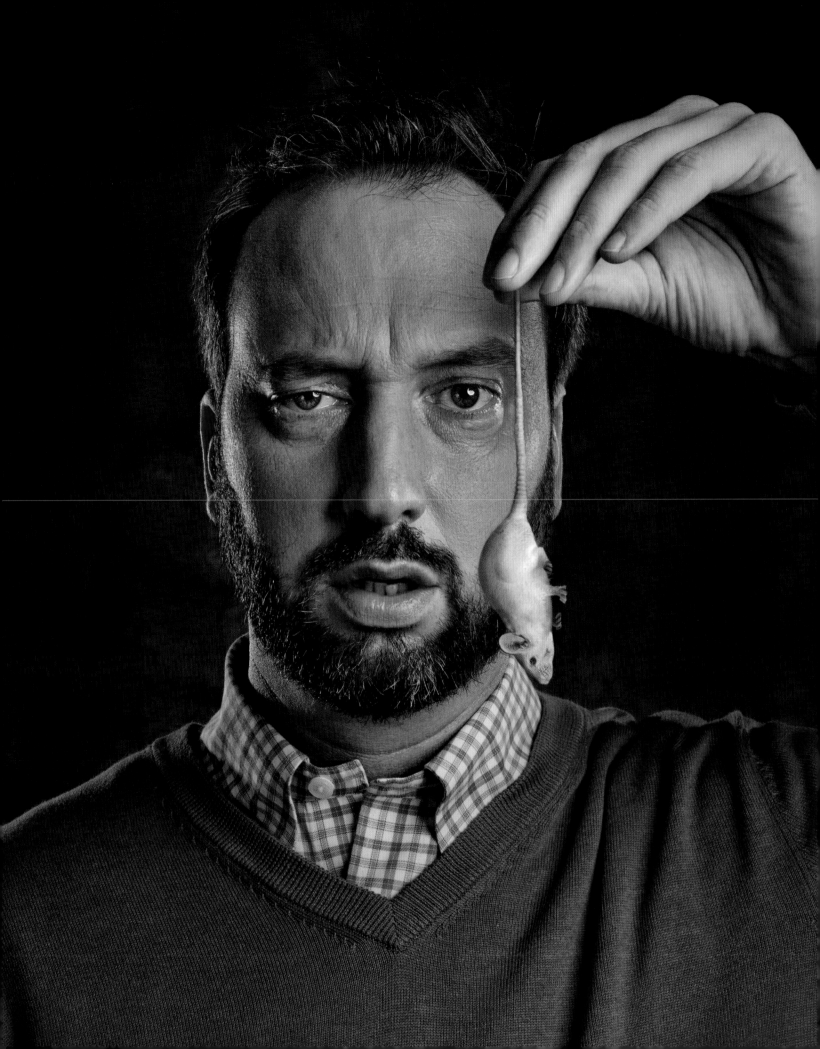

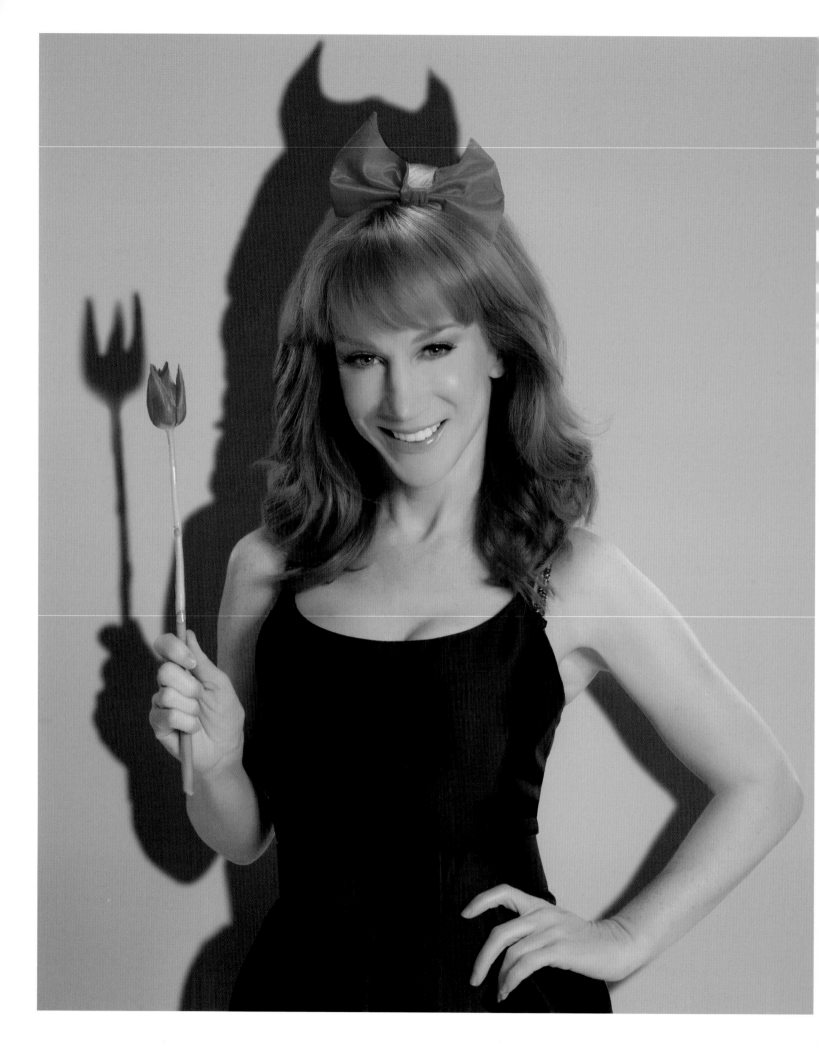

I was a kid who needed to talk all the time.

I'd just go next door to the Bowens' house, where I first learned the power of juicy material. The Bowens would bribe me with Pepperidge Farm Milano cookies, and I'd freely spill our family secrets, all to my mom's horror, of course . . . but to me they were my first live shows.

KATHY GRIFFIN

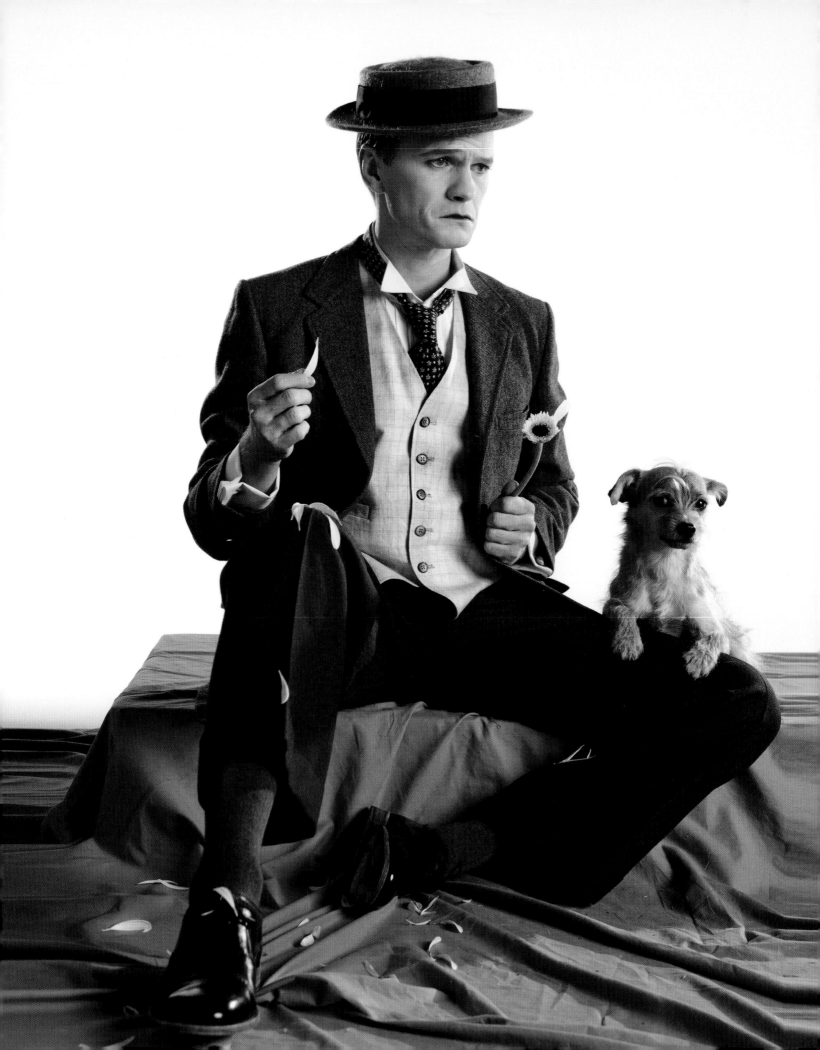

NEIL PATRICK HARRIS

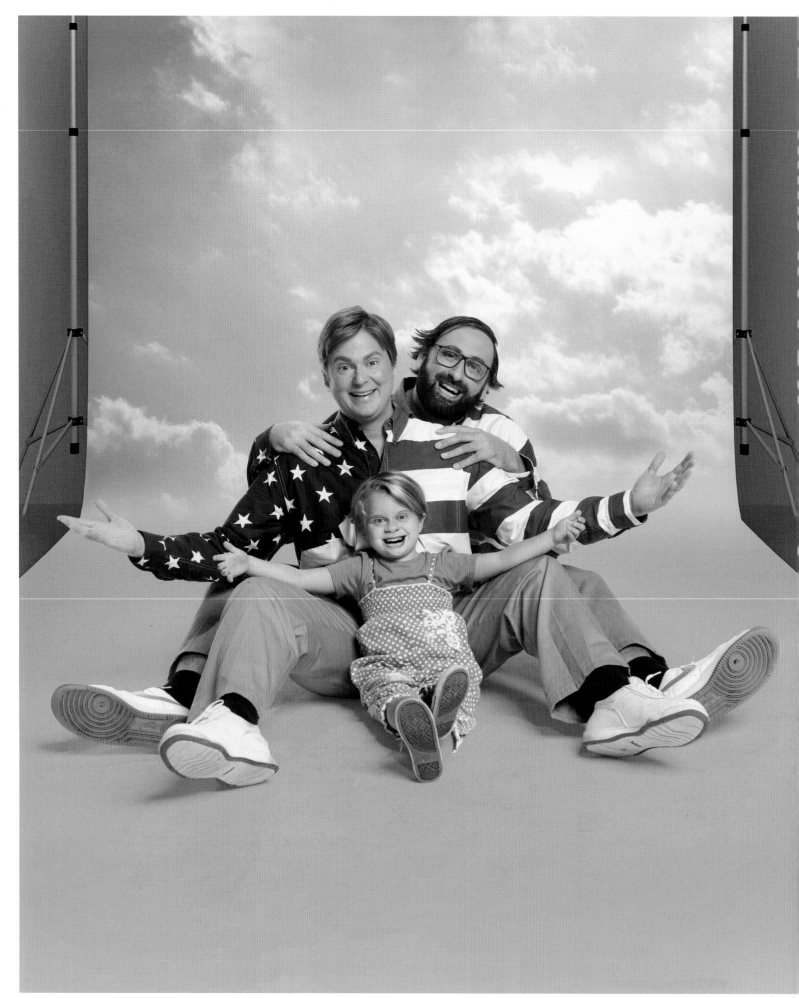

TIM HEIDECKER AND ERIC WAREHEIM

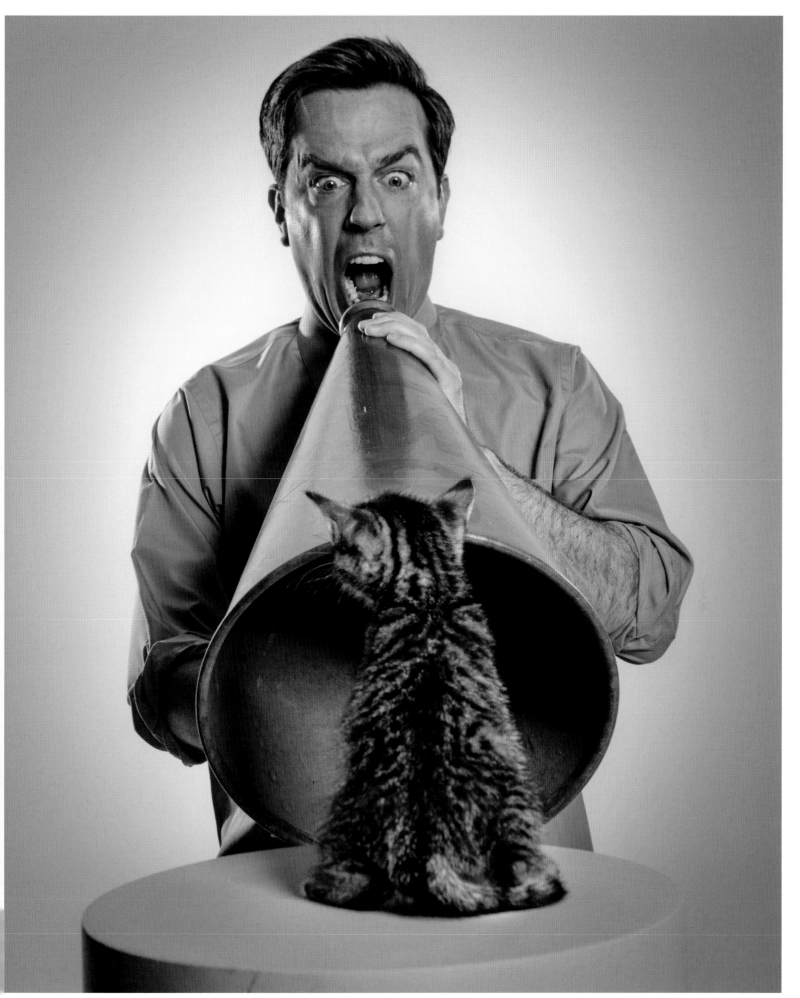

ED HELMS

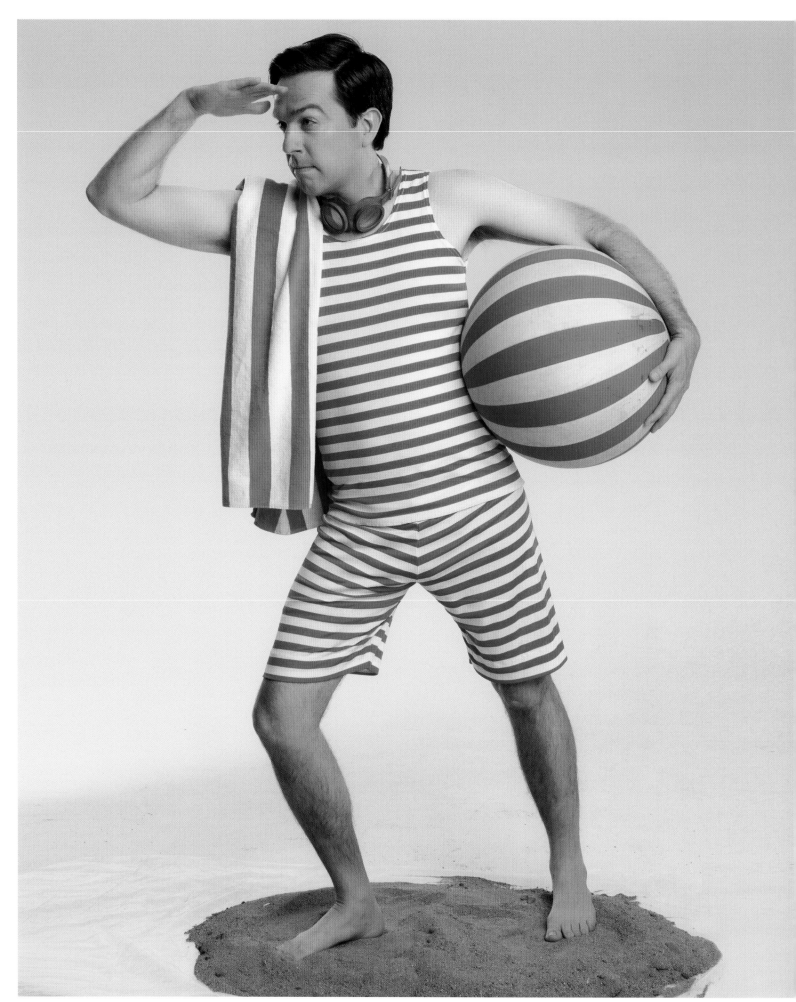

ED HELMS

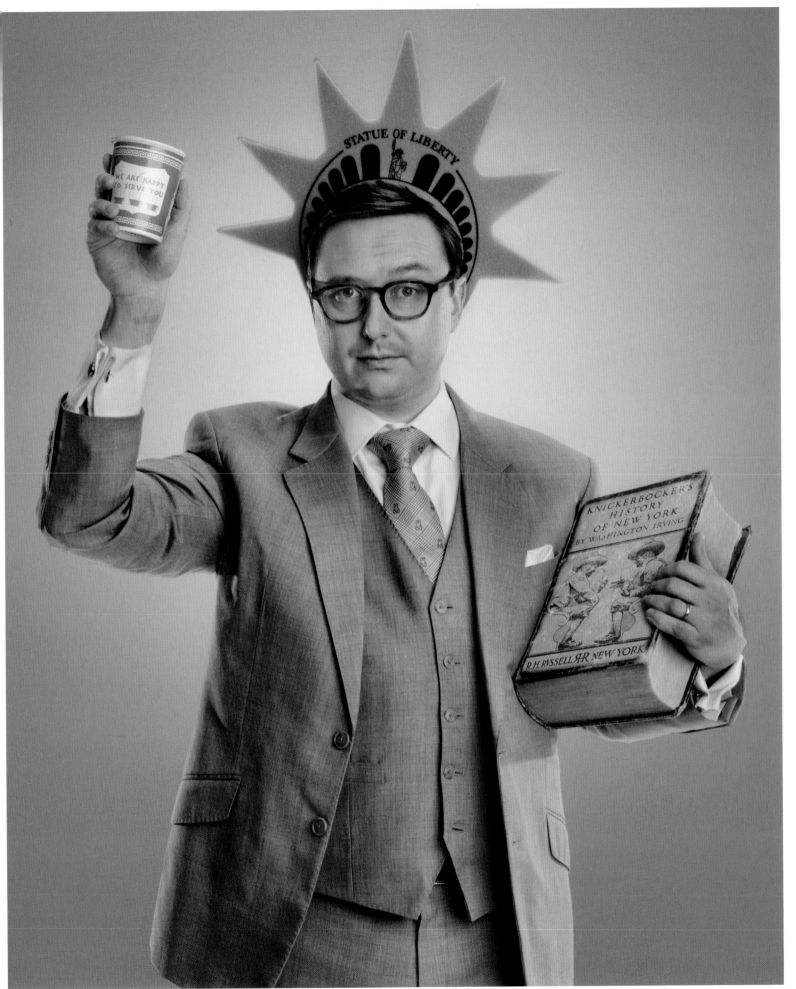

JOHN HODGMAN

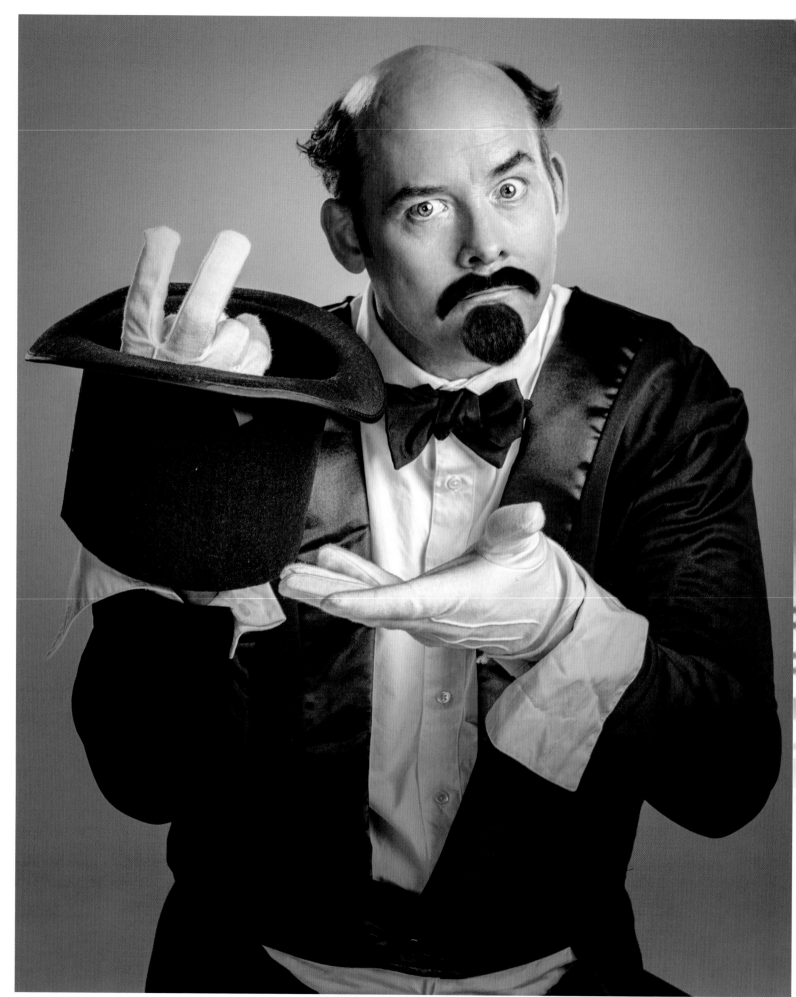

DAVID KOECHNER

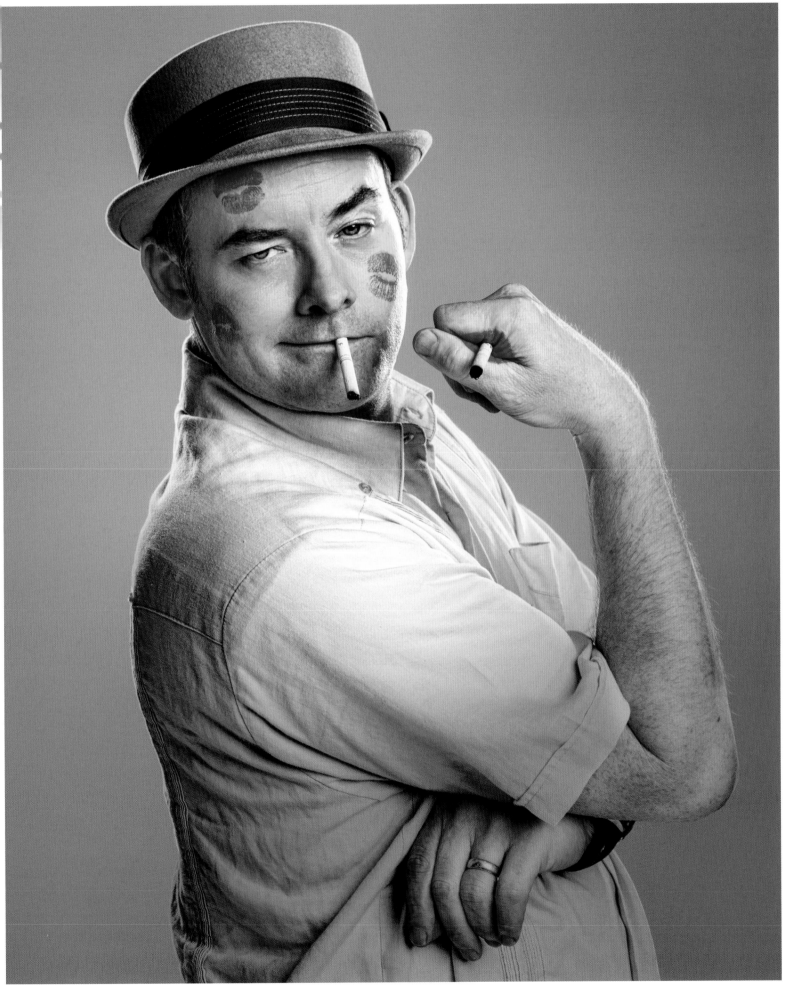

DAVID KOECHNER

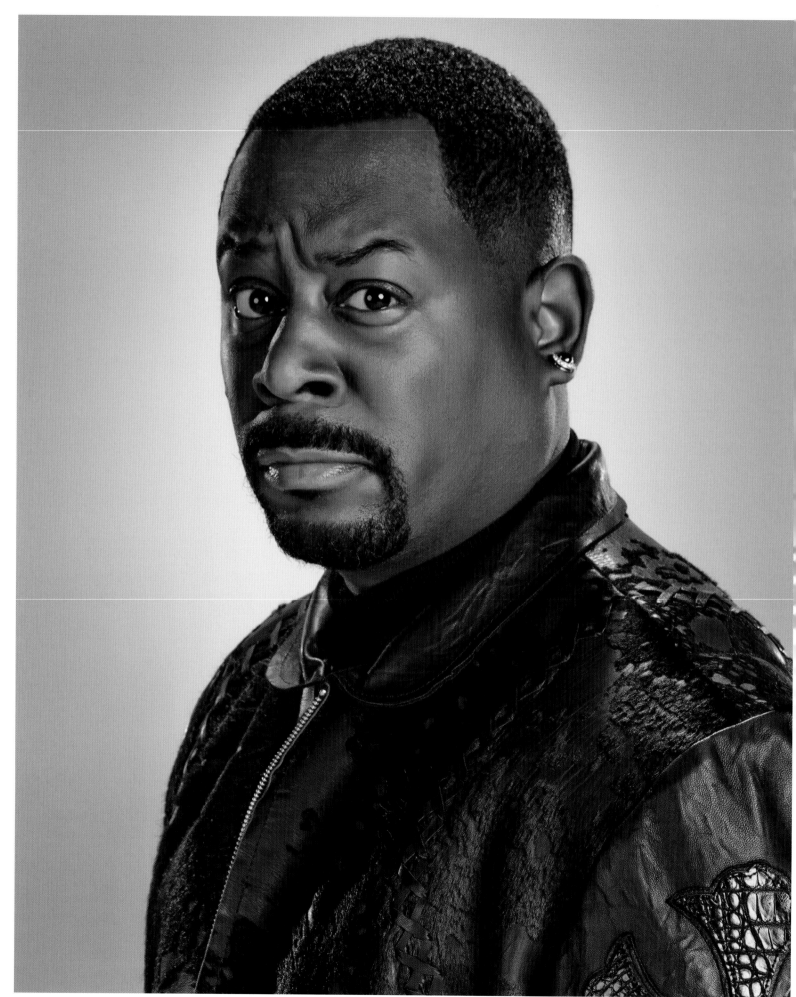

MARTIN LAWRENCE

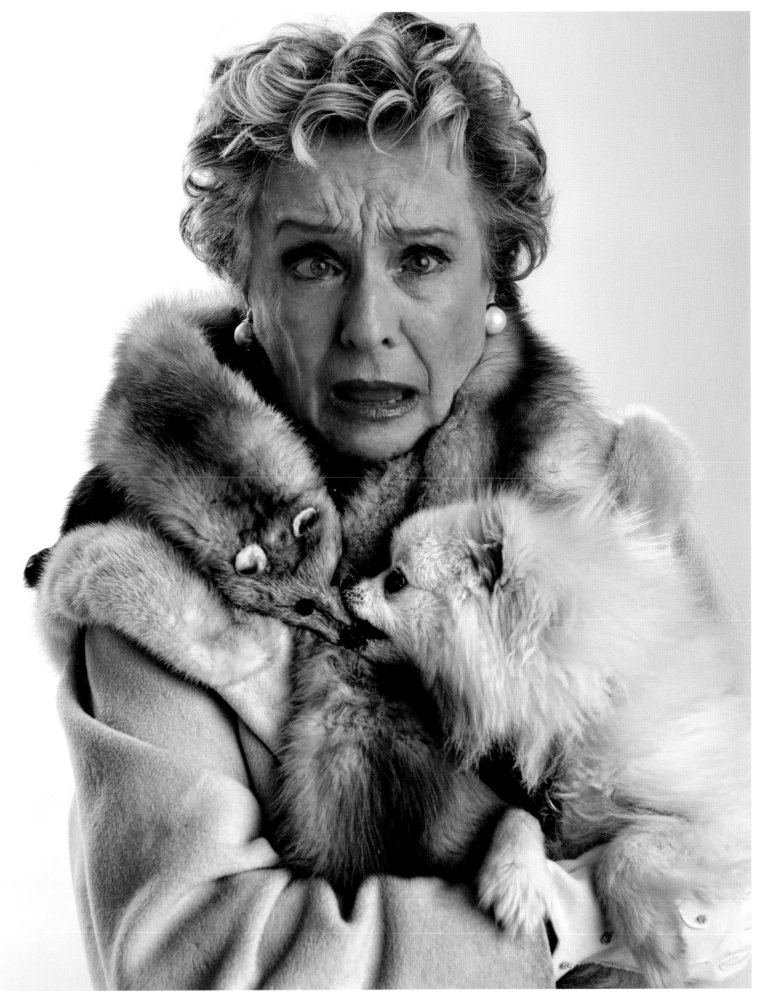

CLORIS LEACHMAN

Racism isn't born, folks . . .

it's taught. I have a two-year-old son.
You know what he hates? Naps! End of list.

DENIS LEARY

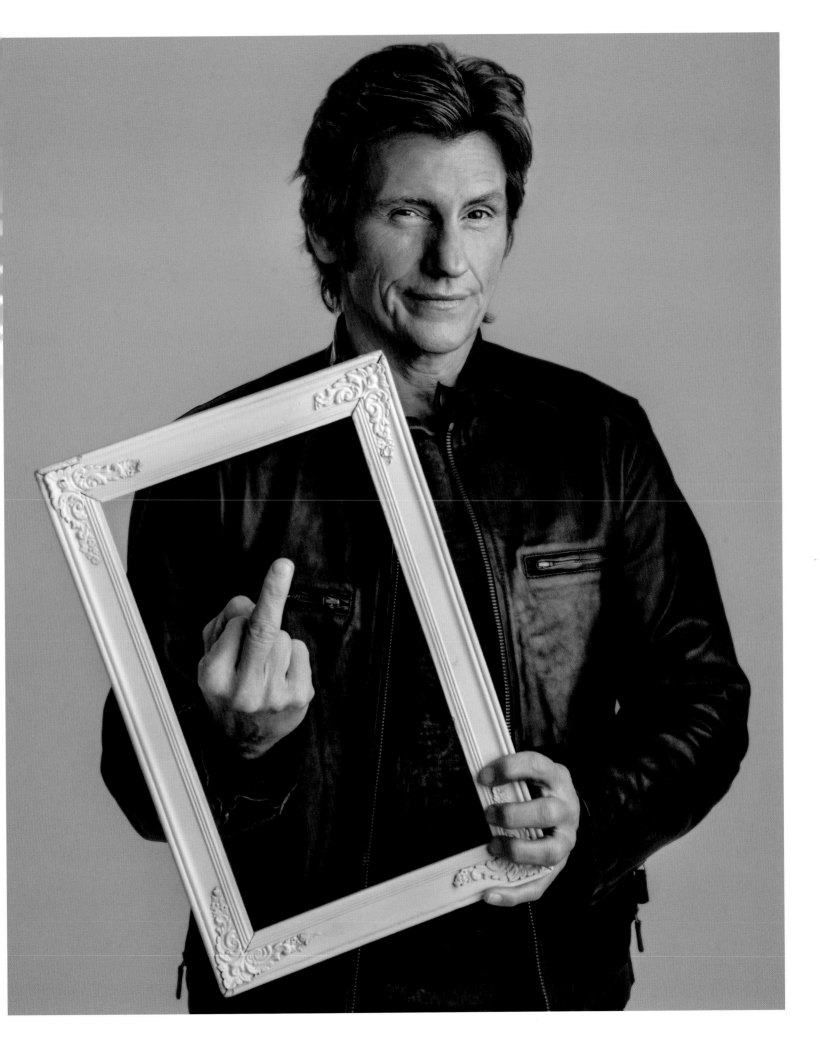

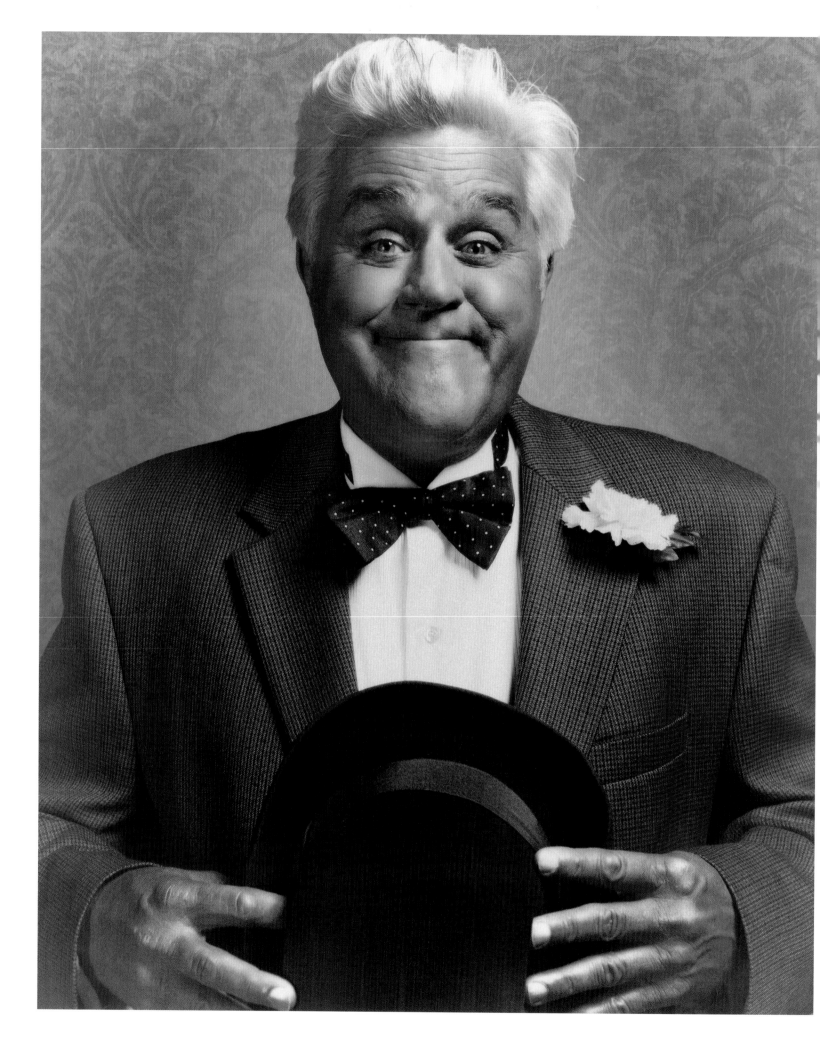

Politics is just show business
for ugly people.

JAY LENO

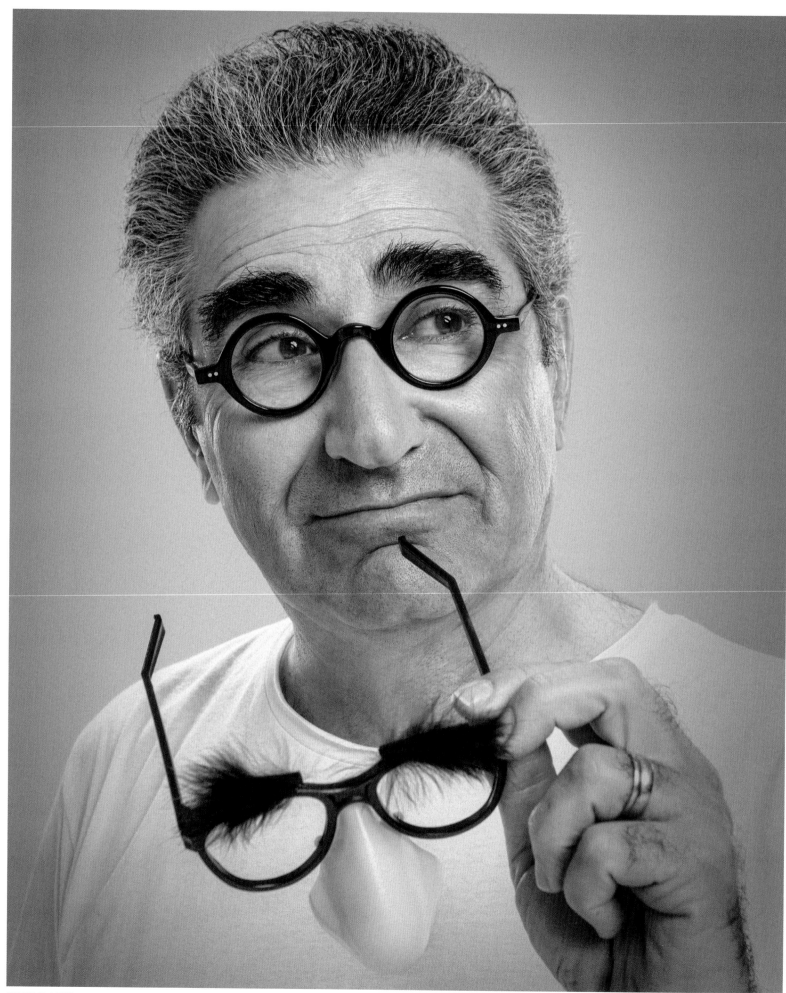

EUGENE LEVY

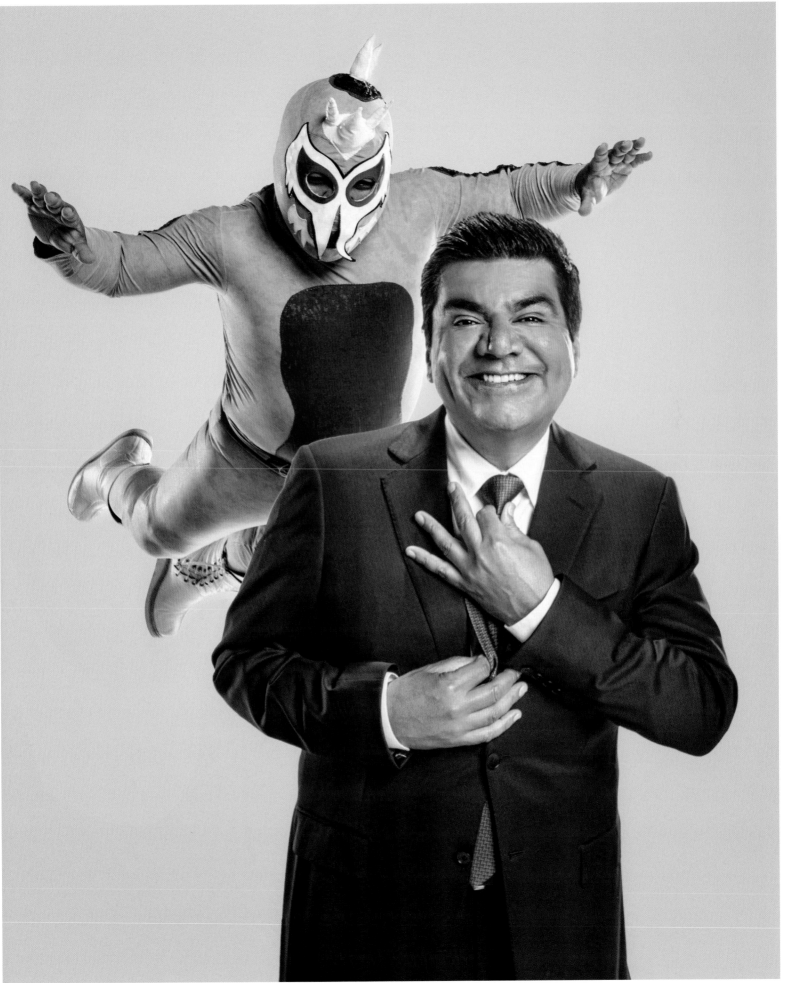

GEORGE LOPEZ

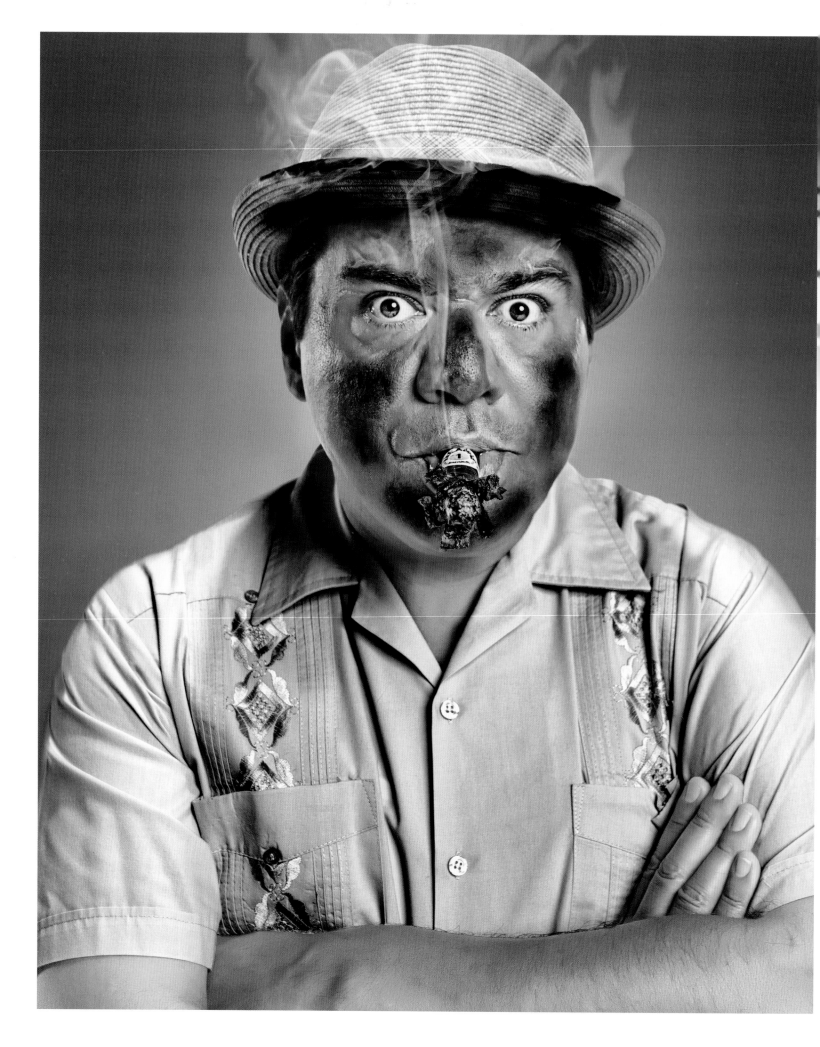

The truth makes people laugh.

You know how Mexican restaurants always have "border" in the name:

Border Grill, Border Cafe. You wouldn't do that to black people:

Kunta's Kitchen or Shackles. They don't do it to white people.

You don't see the Honkey Grill, the Cracker Barrel . . .

Oh, never mind.

GEORGE LOPEZ

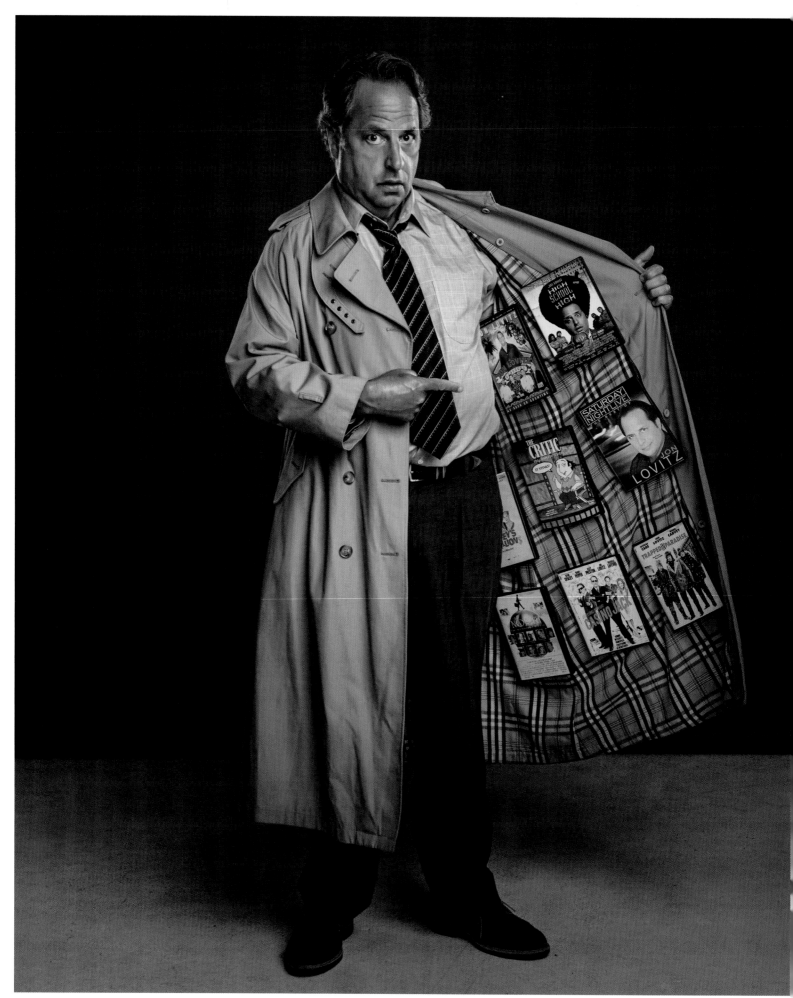

JON LOVITZ

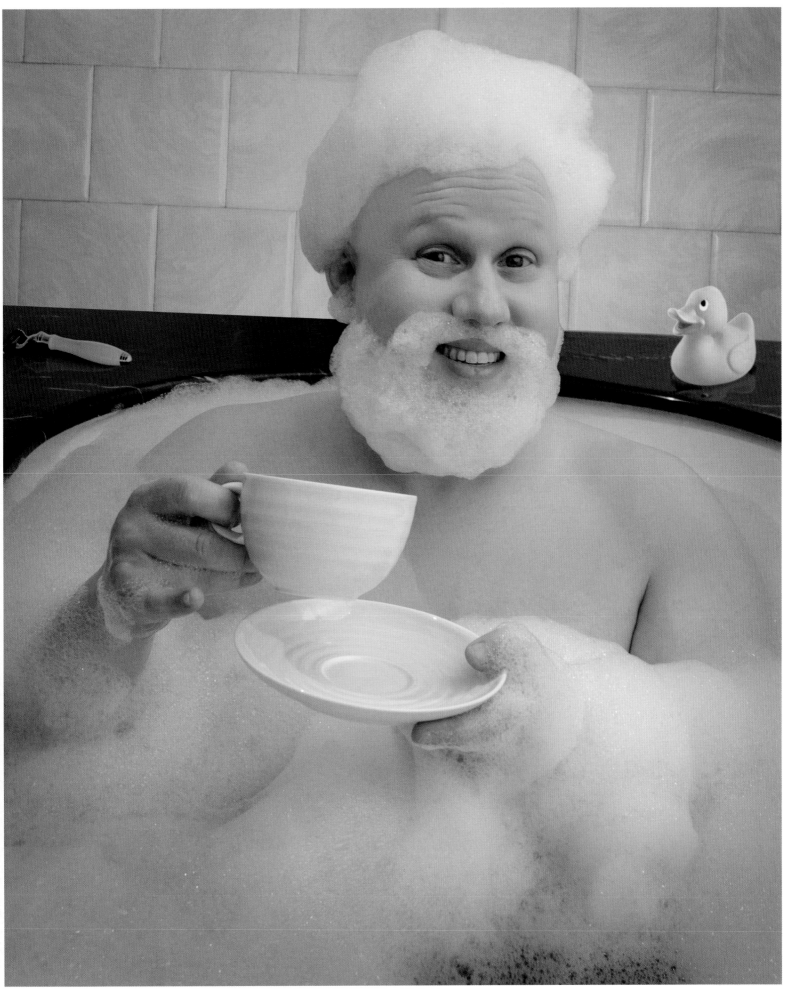

MATT LUCAS

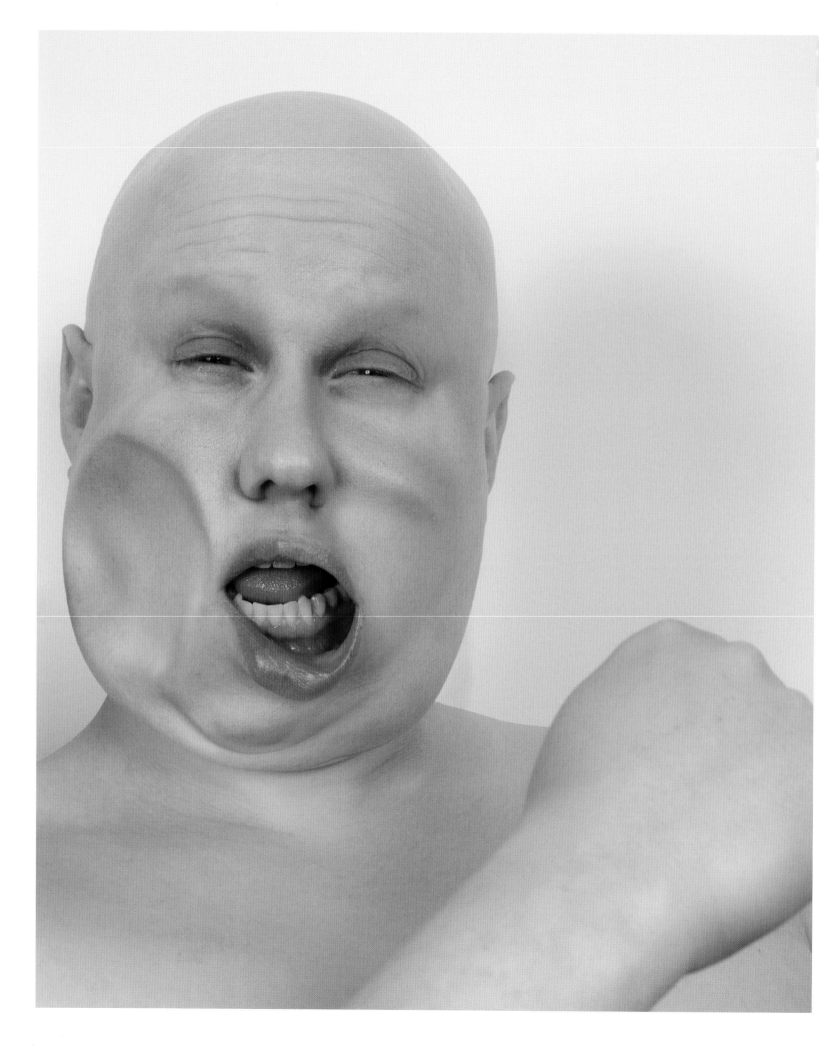

People see my impressions as a great skill . . .

and I'm flattered, but there are things I can't do that everyone else can.
I can do funny voices and funny faces, but I can't drive.

MATT LUCAS

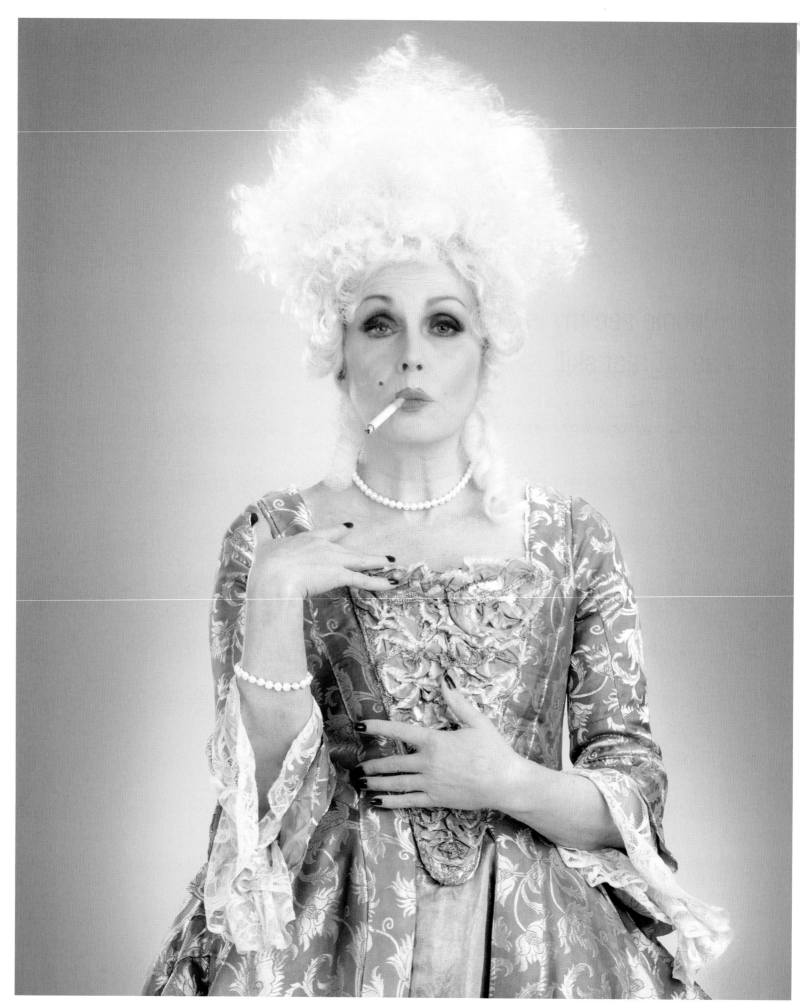

JOANNA LUMLEY

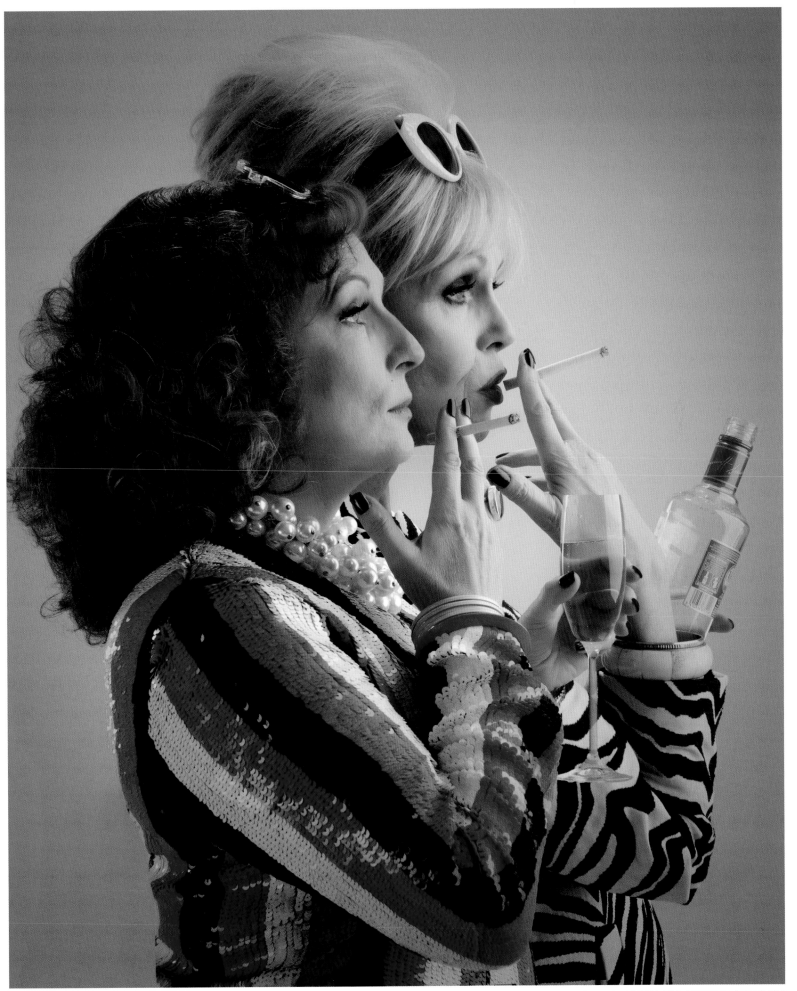

JOANNA LUMLEY AND JENNIFER SAUNDERS

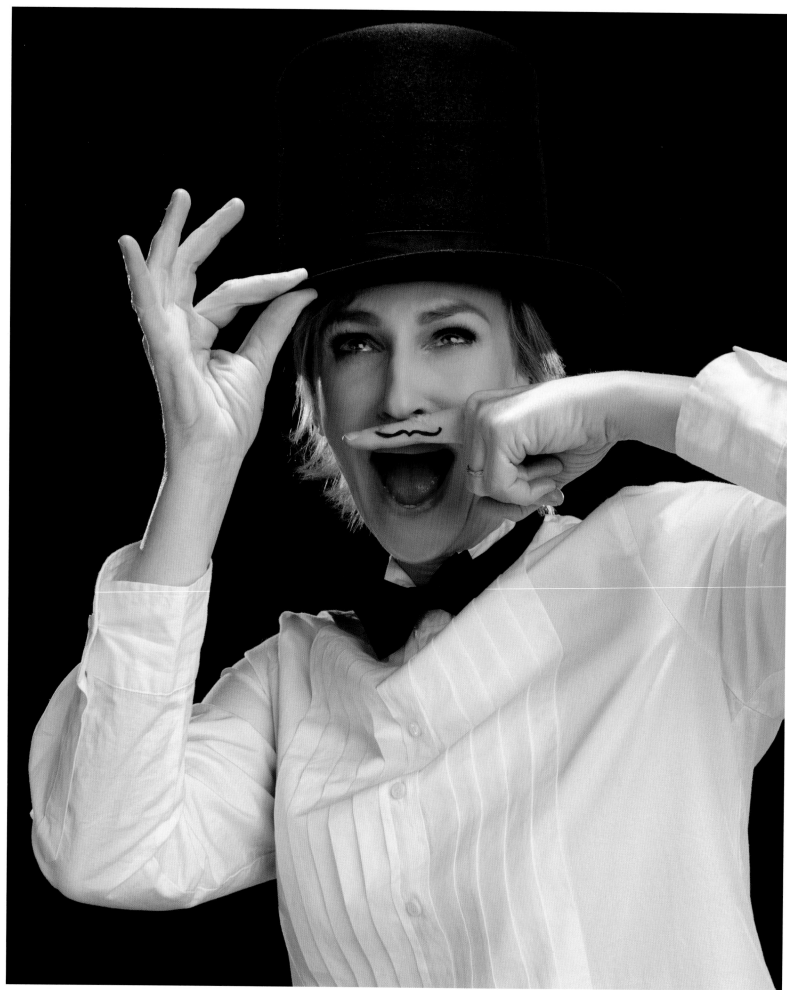

JANE LYNCH

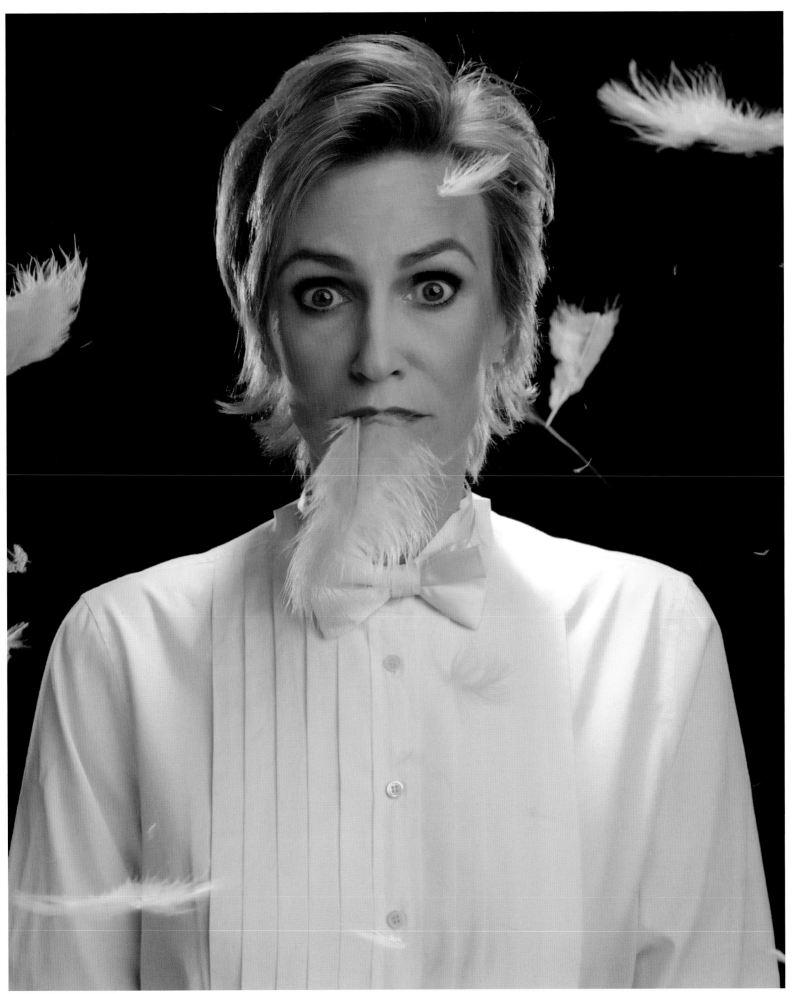

JANE LYNCH

It's easy to maintain your integrity . . .

when no one is offering to buy it out.

MARC MARON

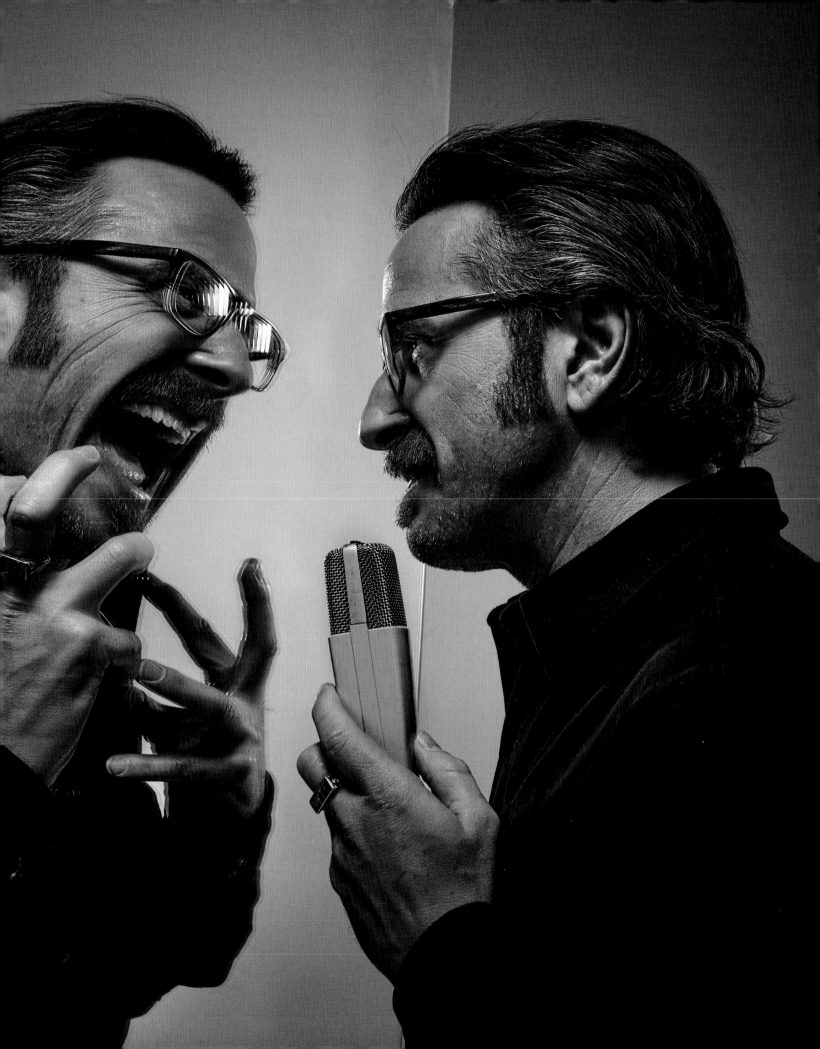

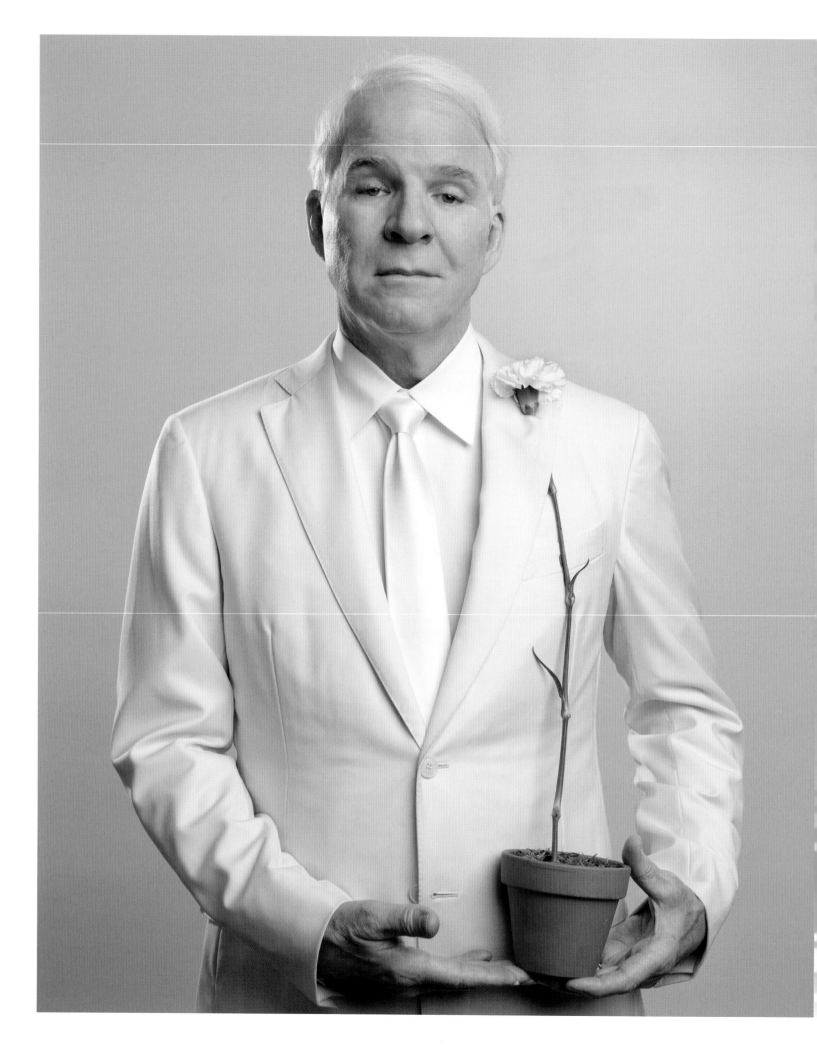

I was not naturally talented . . .

I didn't sing, dance, or act, though working around
that minor detail made me inventive.

STEVE MARTIN

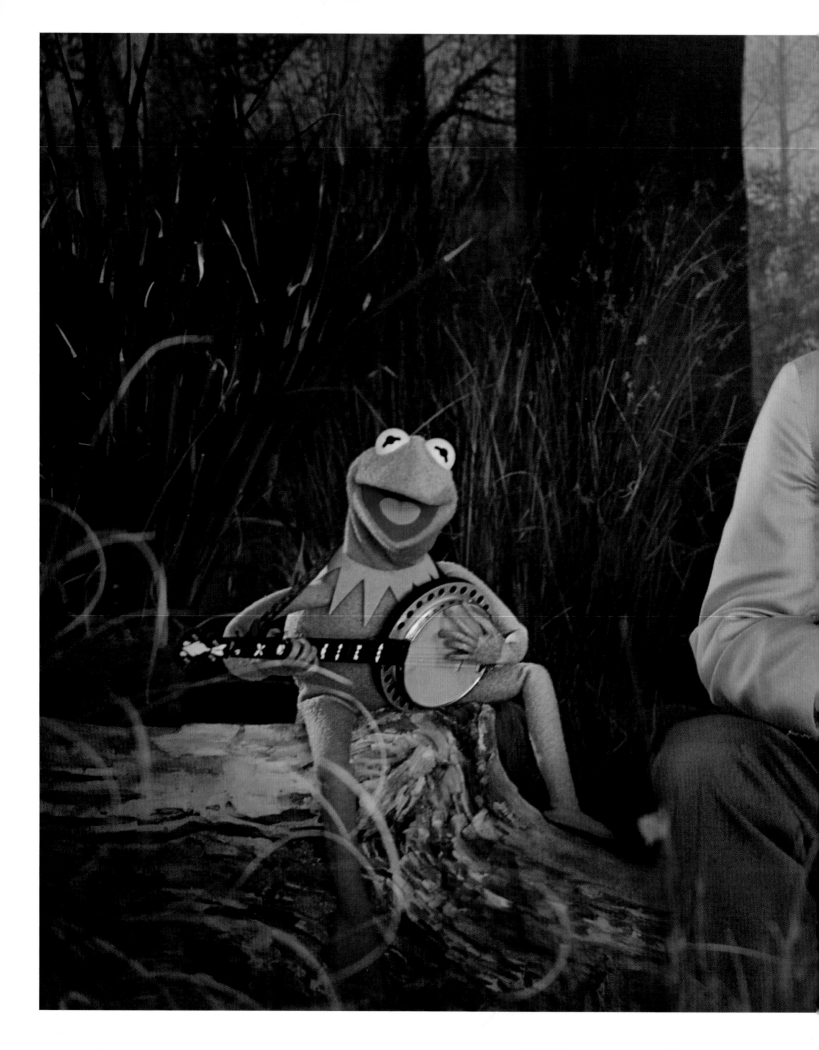

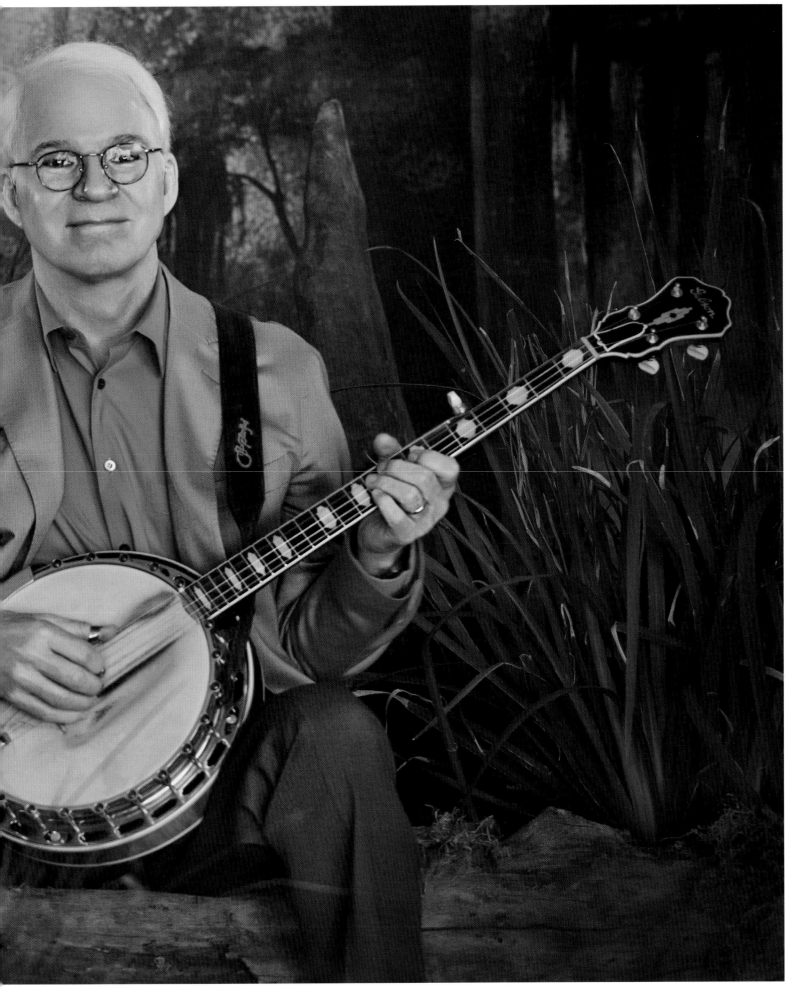

STEVE MARTIN AND KERMIT THE FROG

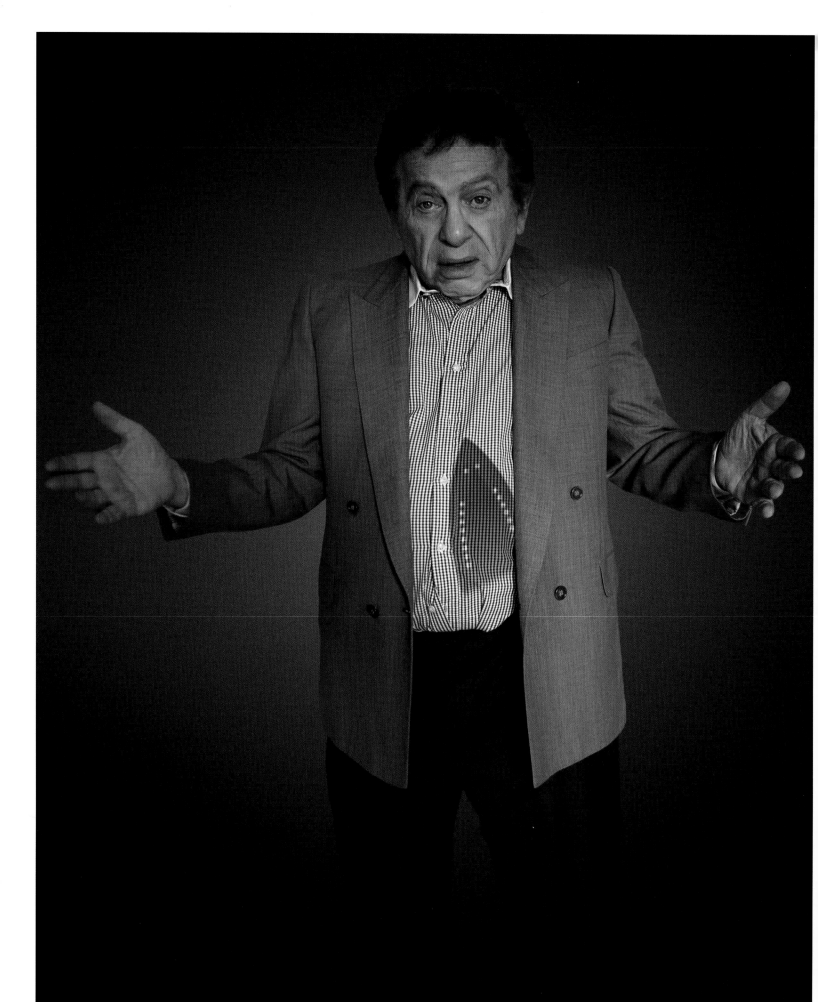

I have enough money to last
me the rest of my life . . .

unless I buy something.

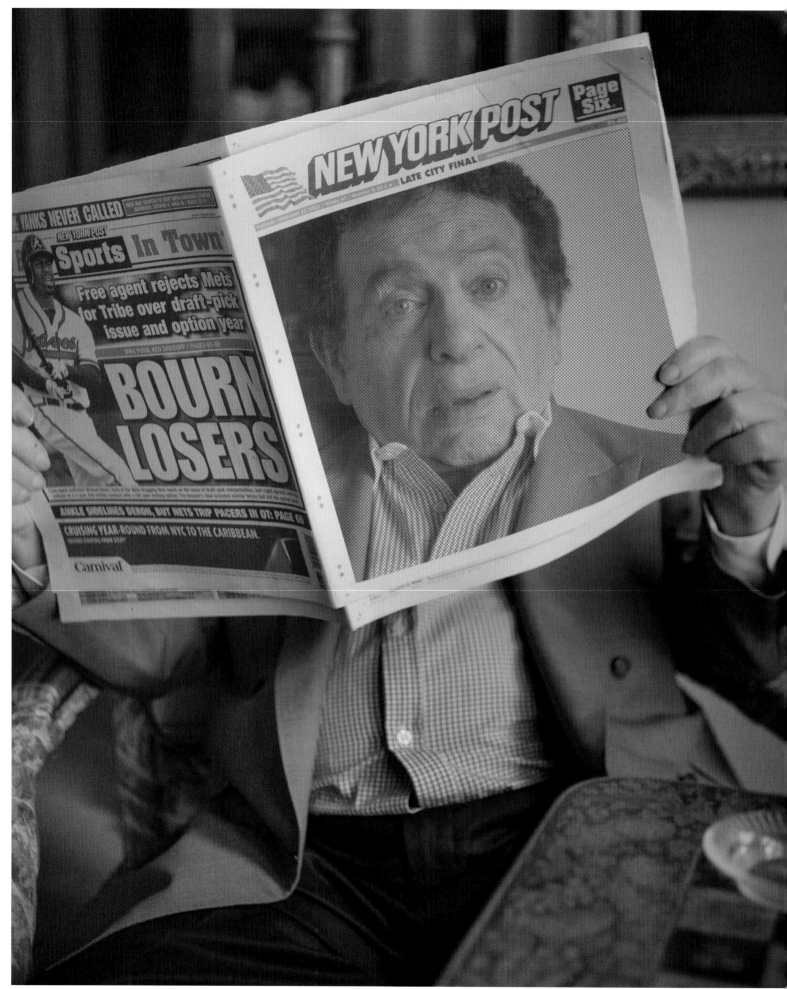

JACKIE MASON

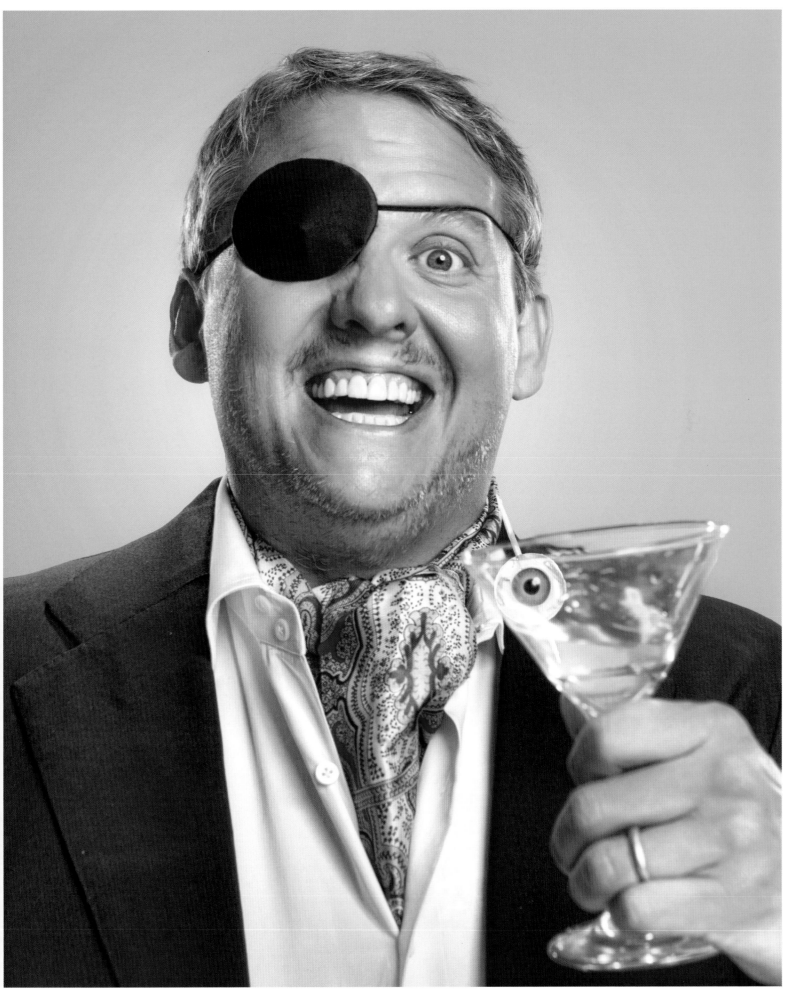

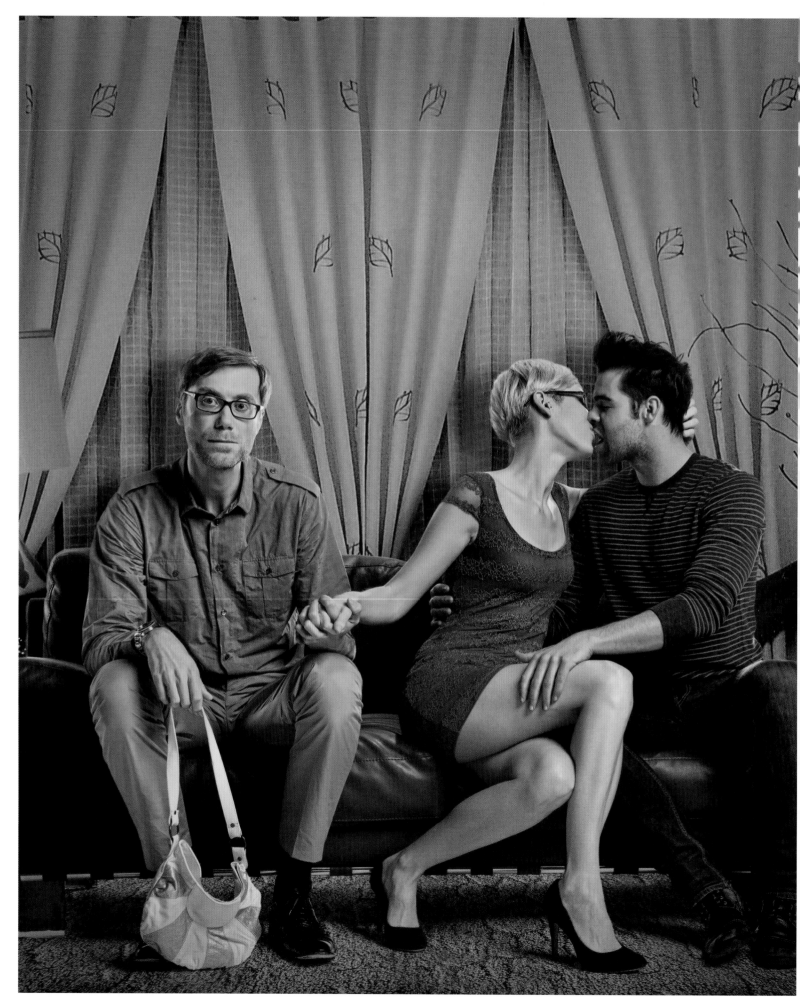

STEPHEN MERCHANT

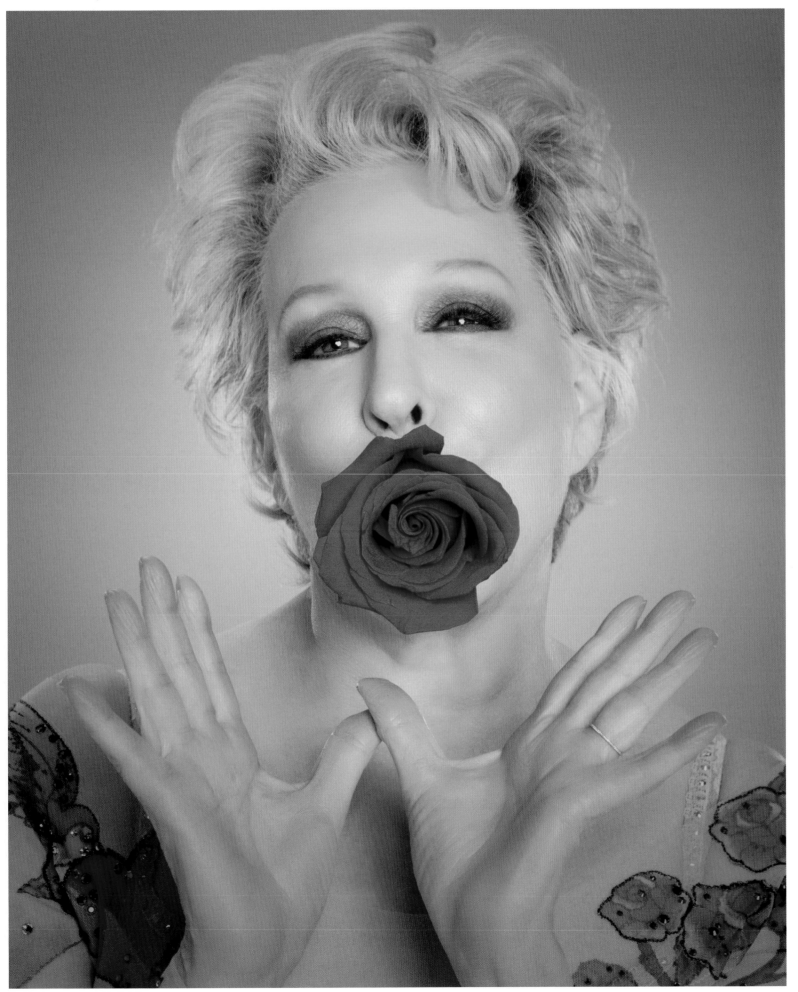

BETTE MIDLER

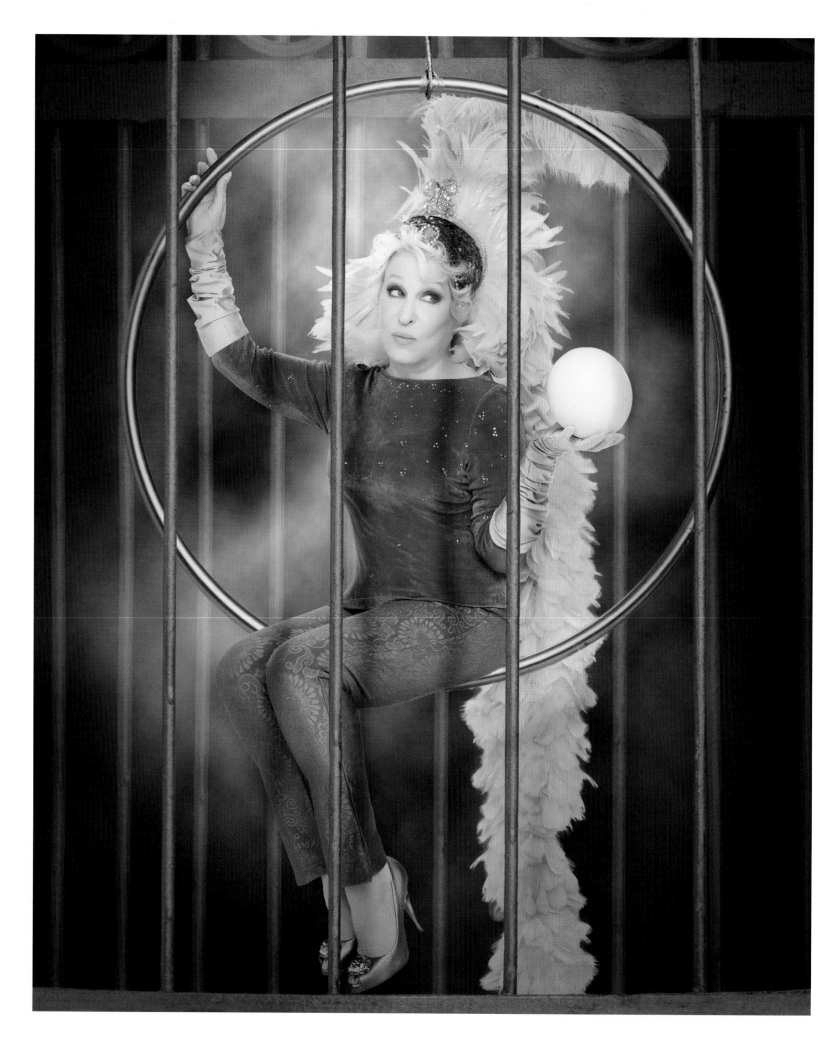

I wouldn't say I invented tacky . . .

but I definitely brought it to its present high popularity.

BETTE MIDLER

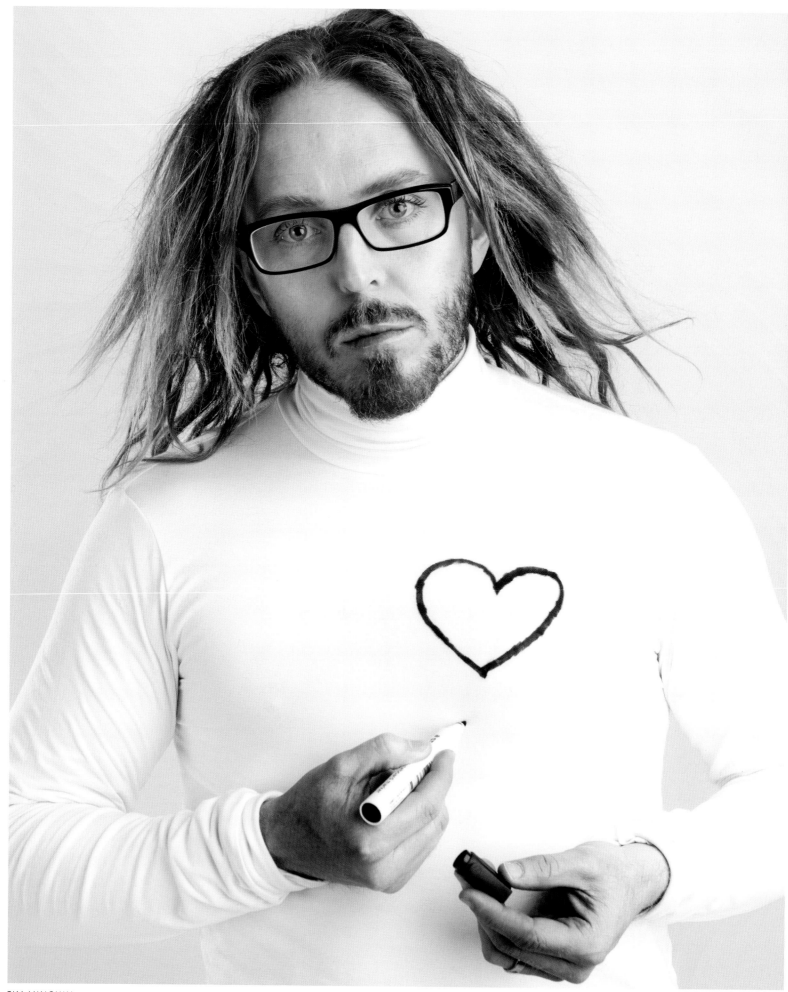

TIM MINCHIN

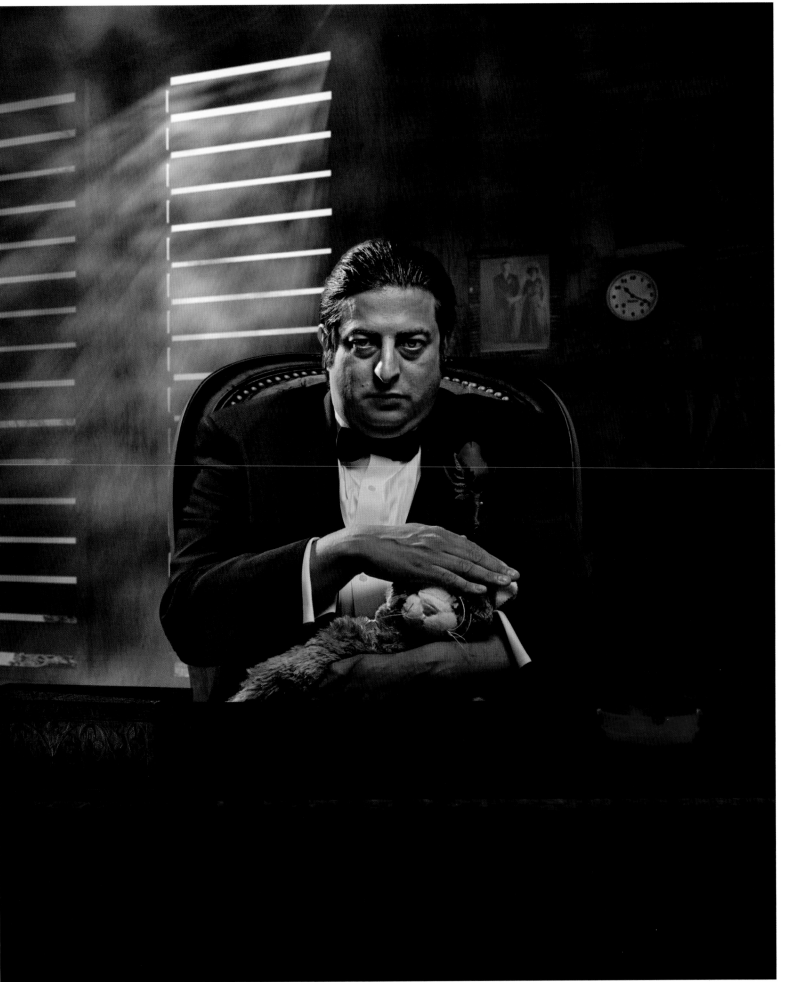

EUGENE MIRMAN

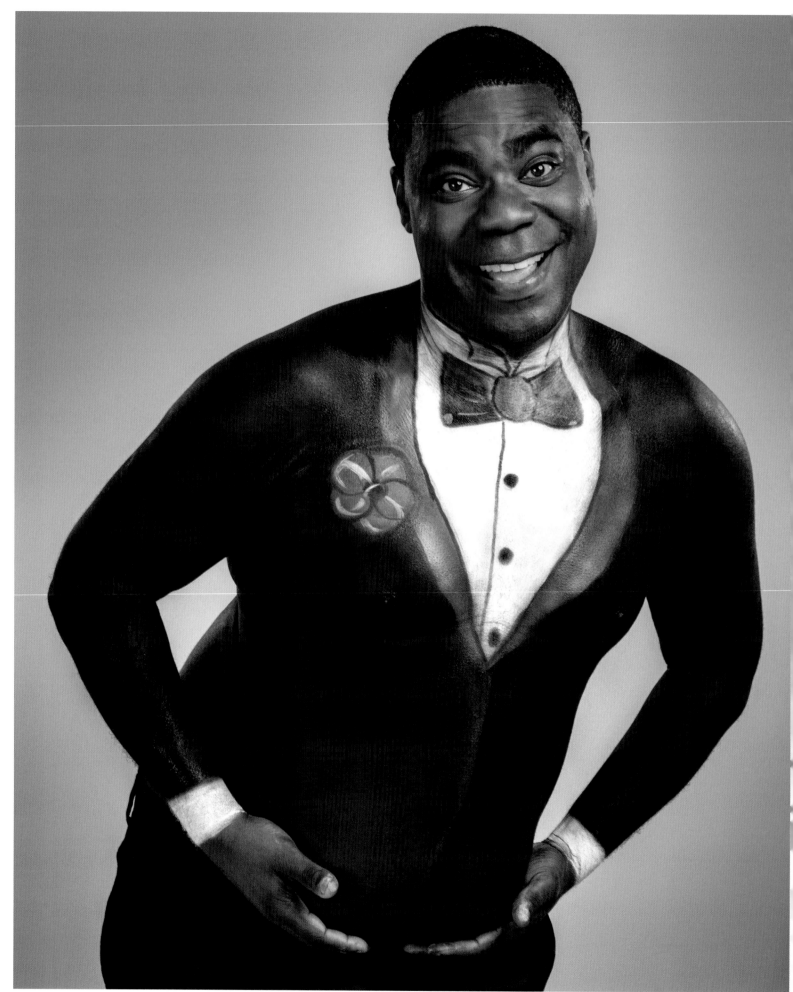

TRACY MORGAN

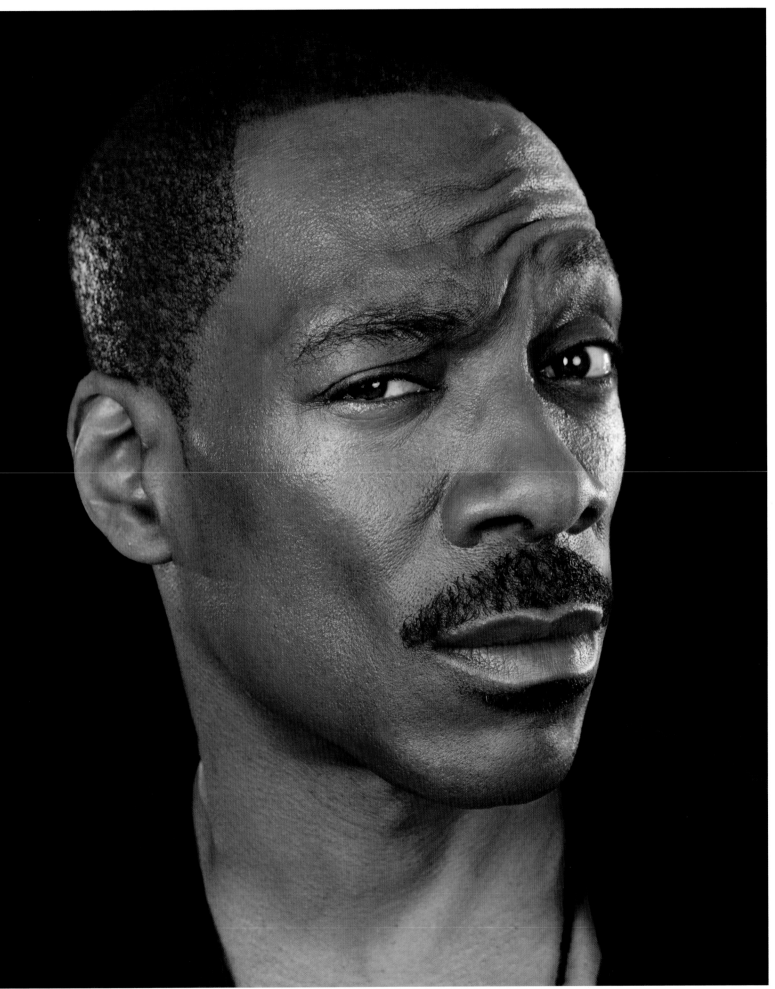

EDDIE MURPHY

I like smart jokes . . .

I like dumb jokes, and I like dumb jokes done smartly.

MIKE MYERS

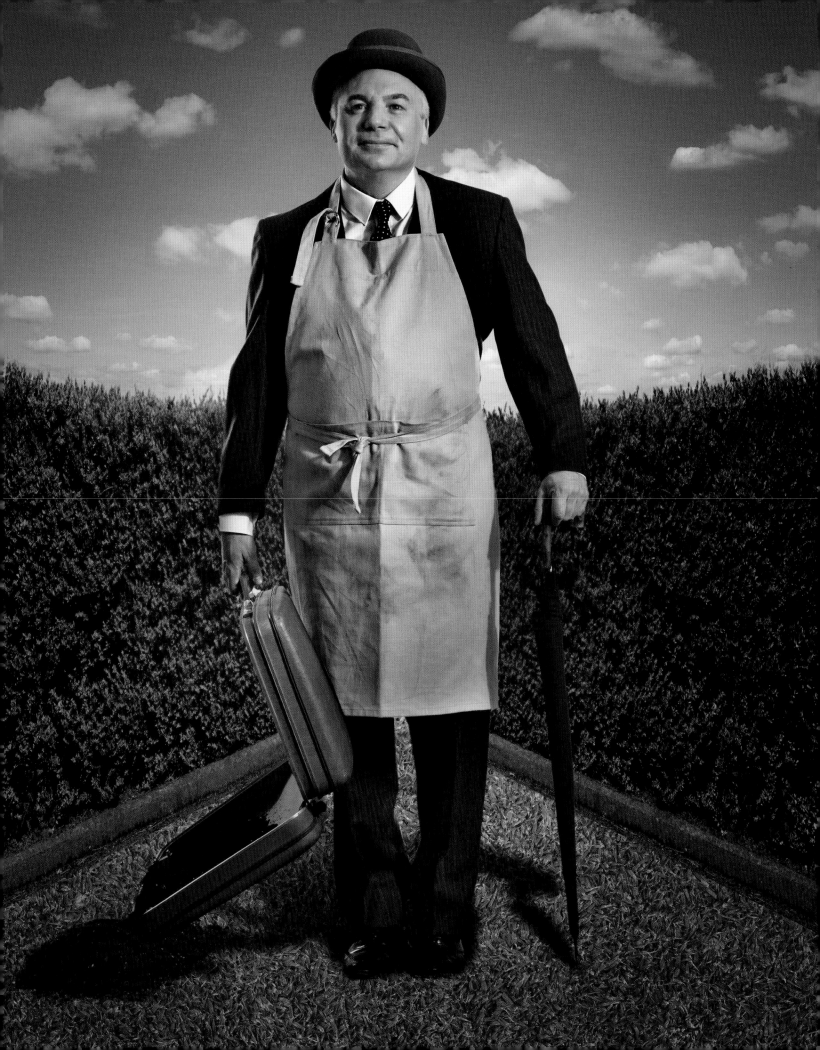

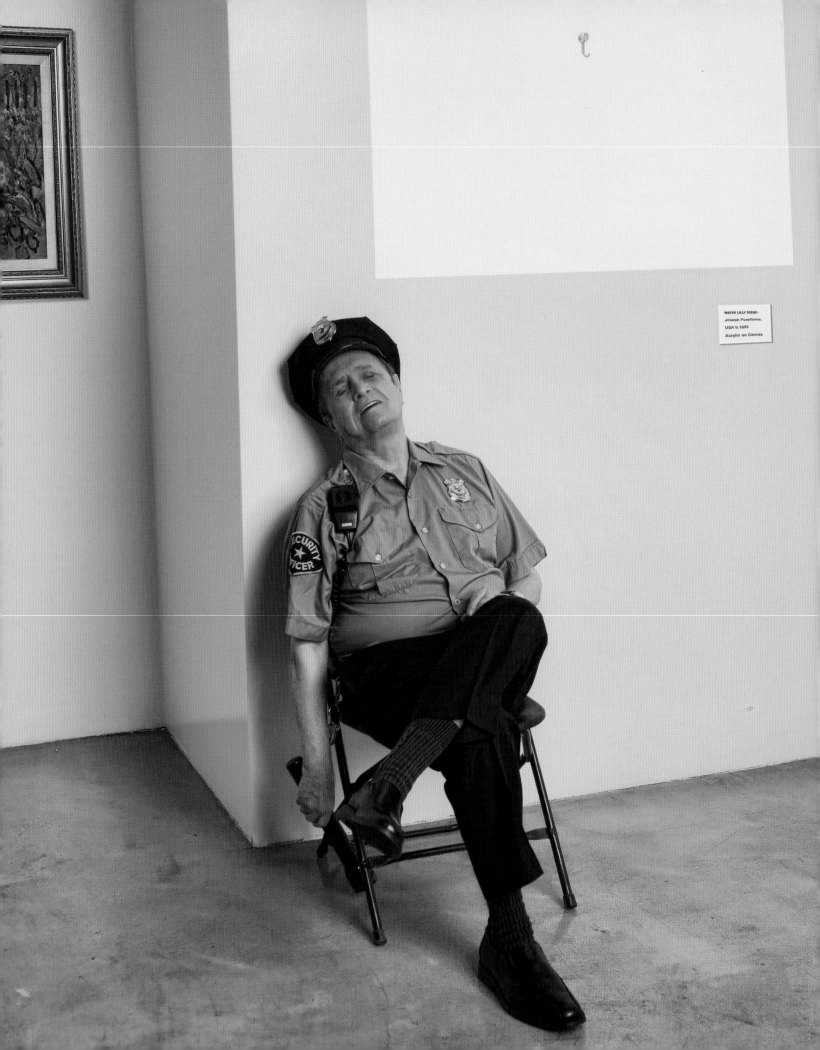

WATER LILLY SCENE-
Joseph Funnibone,
USA b.1893
Acrylic on Canvas

I don't like country music . . .

but I don't mean to denigrate those who do. And for the
people who like country music, denigrate means "put down."

BOB NEWHART

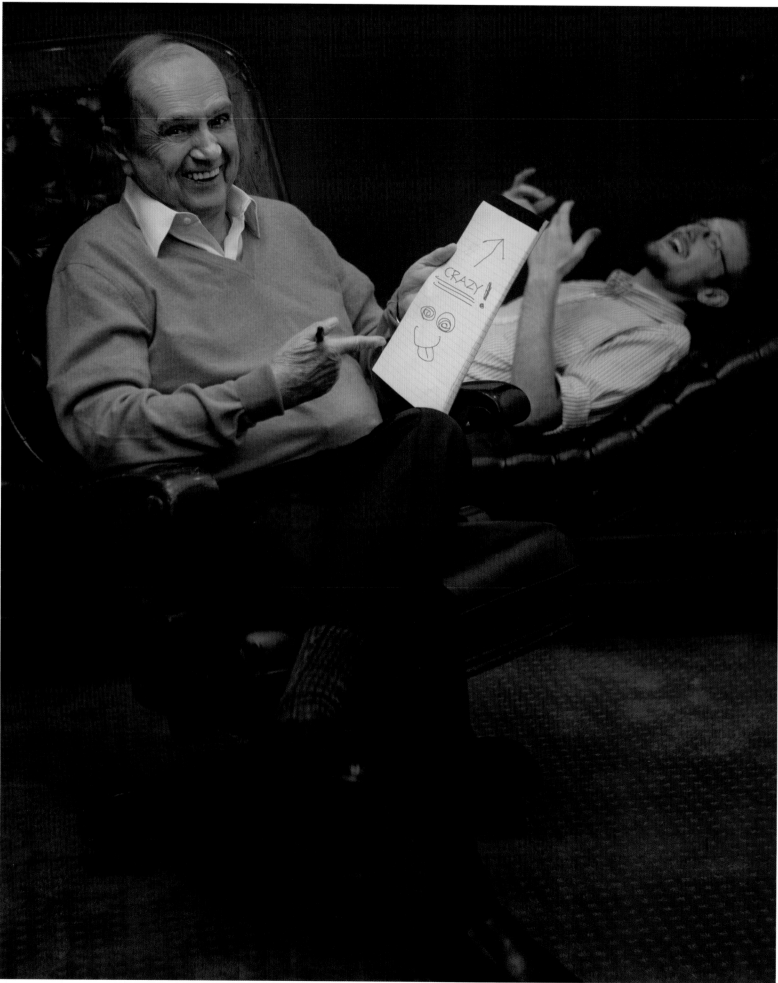

BOB NEWHART

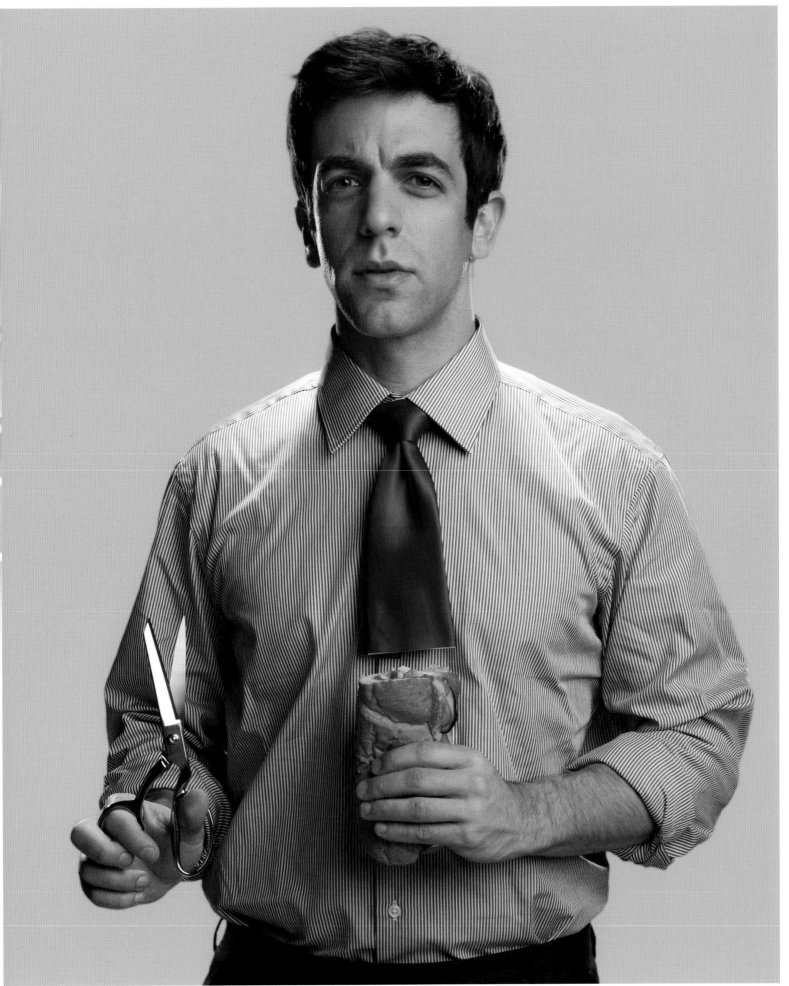

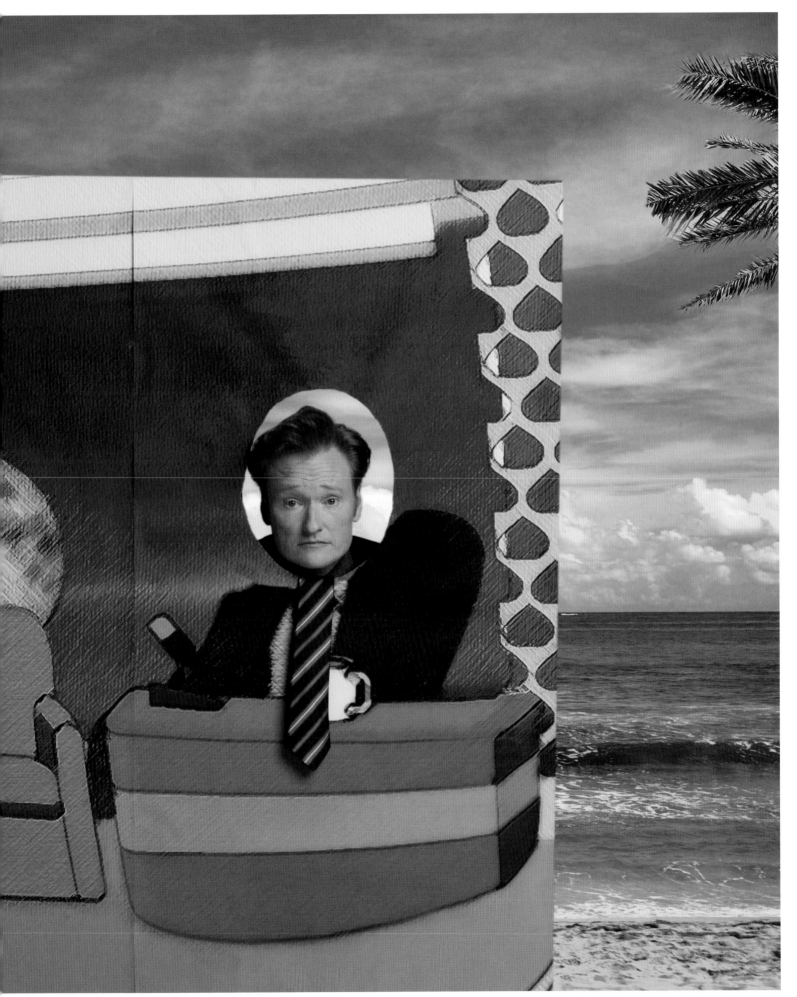

CONAN O'BRIEN

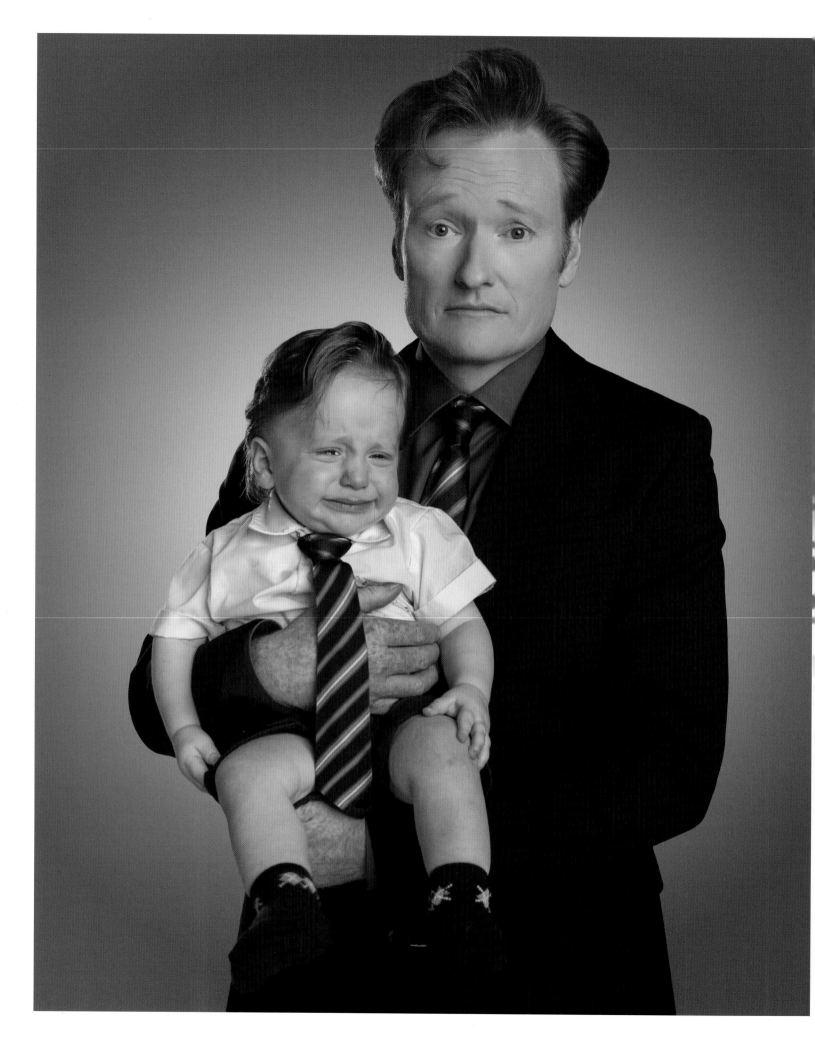

If I existed 200 years ago . . .

all the other farmers in my community would be like, "That guy is worthless! He's sitting on a rock, coming up with weird concepts and ideas, making faces, and combing his hair into a giant pastry." It's a good thing I was born in this century, when superfluous television seems to be part of the economy.

CONAN O'BRIEN

CATHERINE O'HARA

BOB ODENKIRK

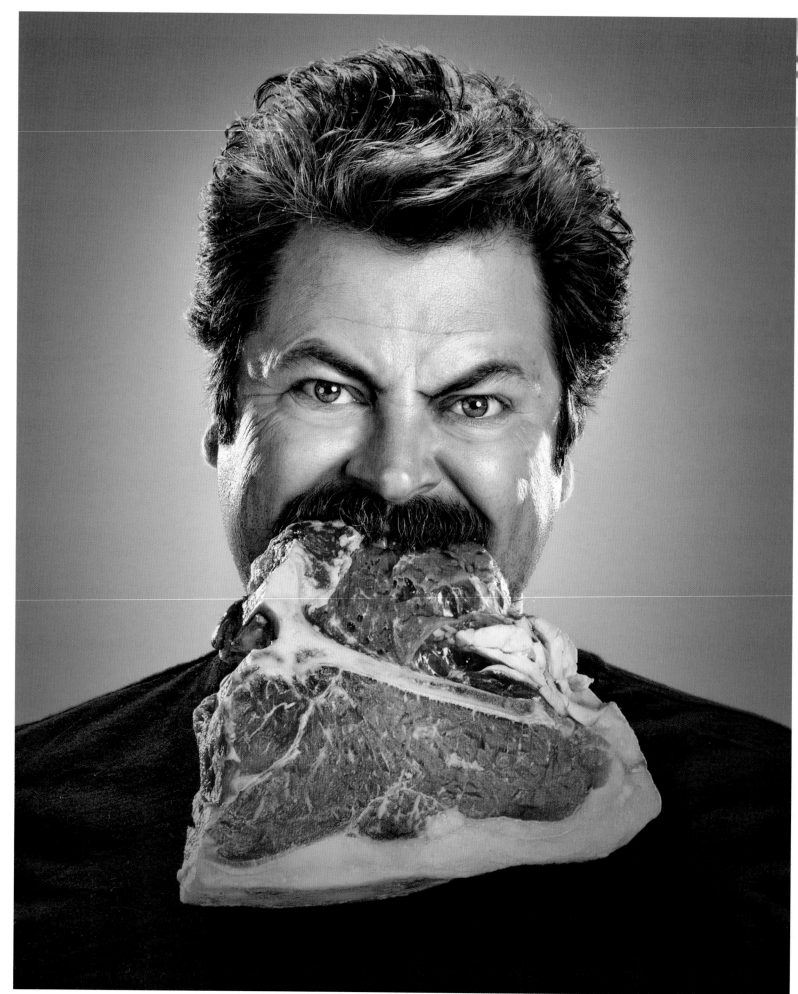

NICK OFFERMAN

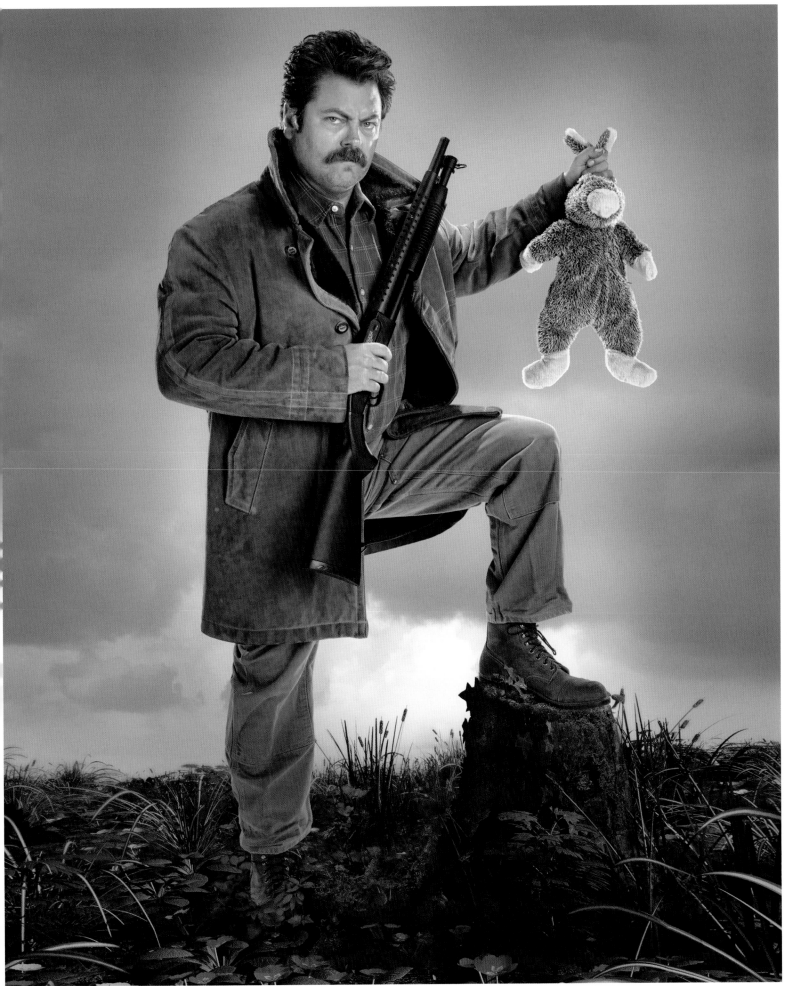

NICK OFFERMAN

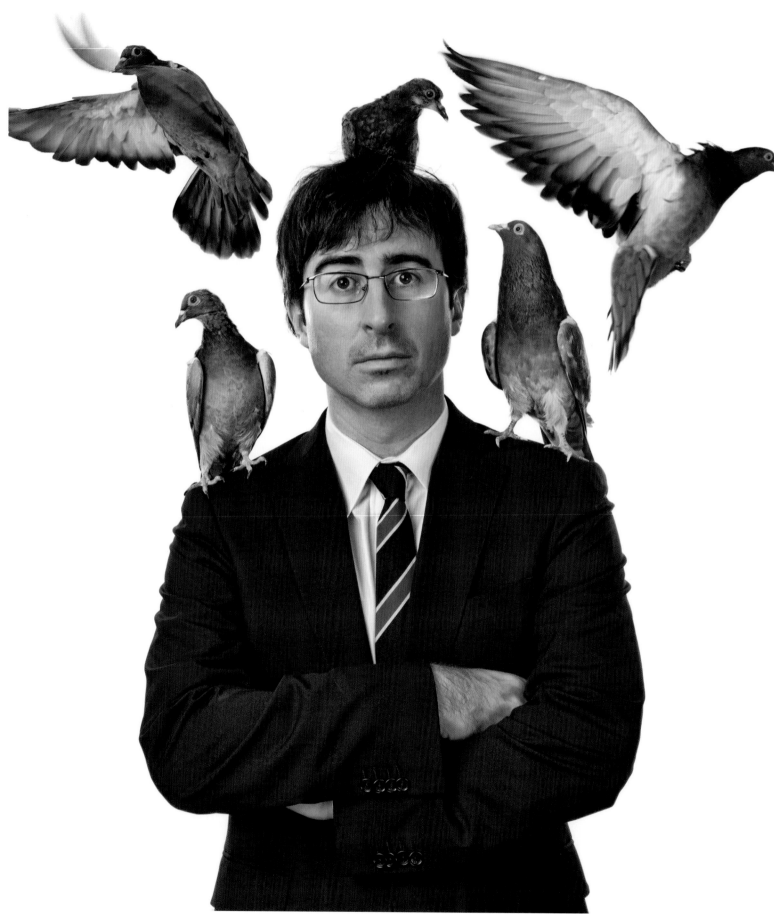

JOHN OLIVER

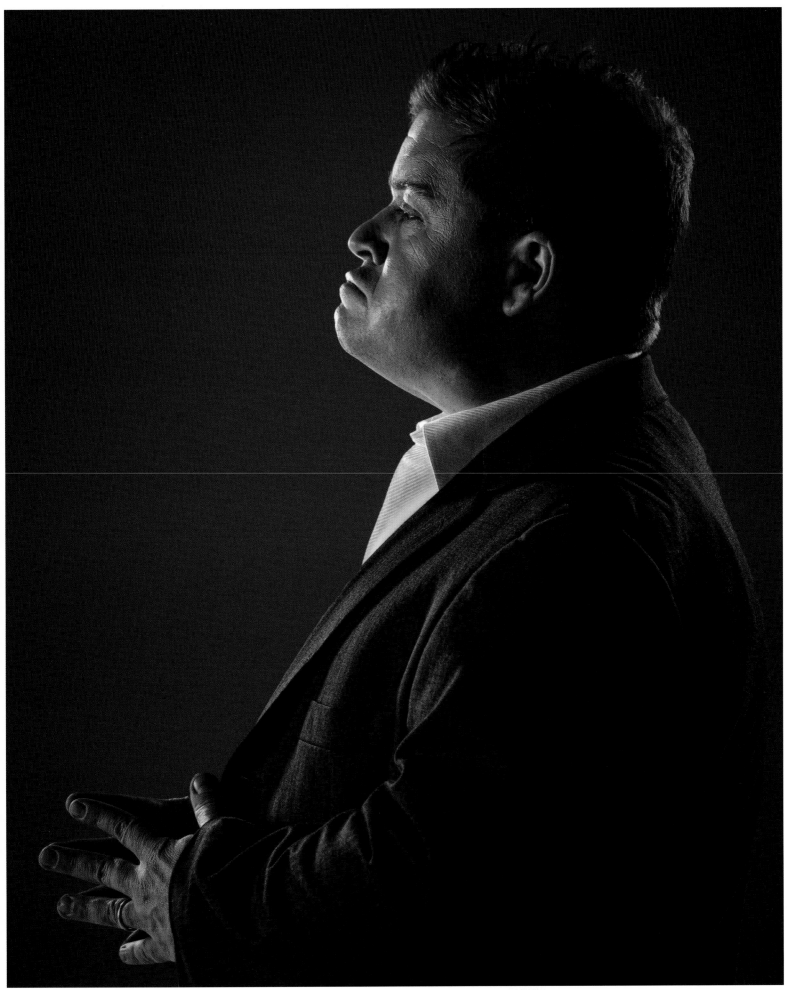

PATTON OSWALT

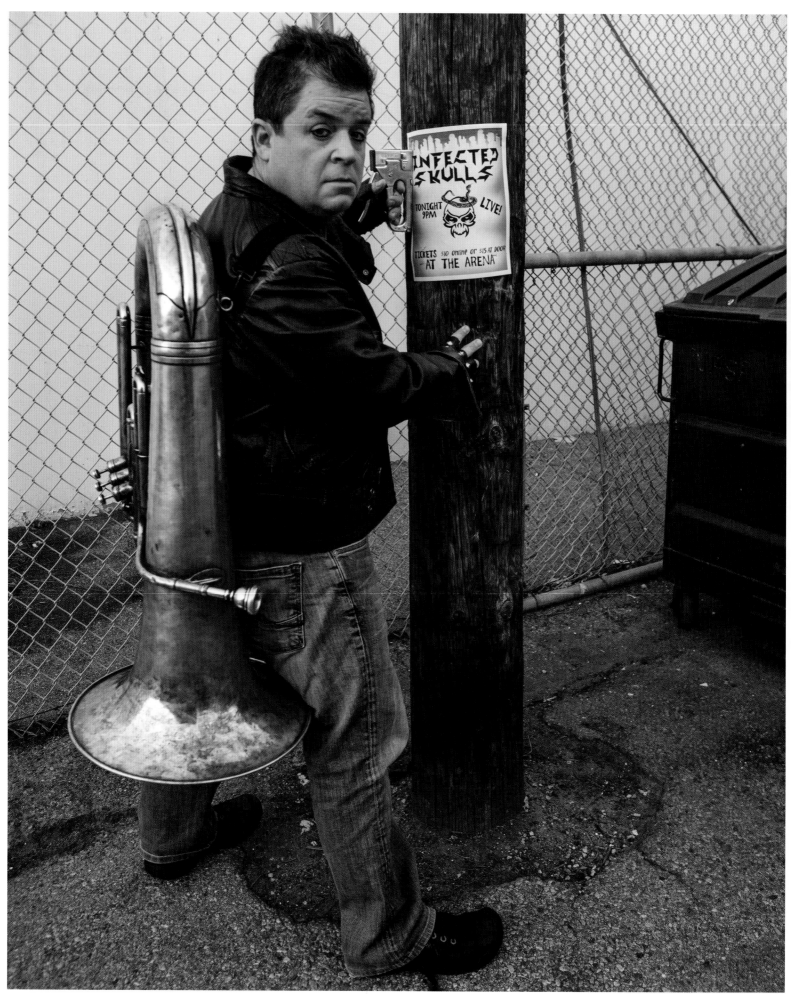

PATTON OSWALT

You can't get a suit of armor and a rubber chicken just like that . . .

You have to plan ahead.

MICHAEL PALIN

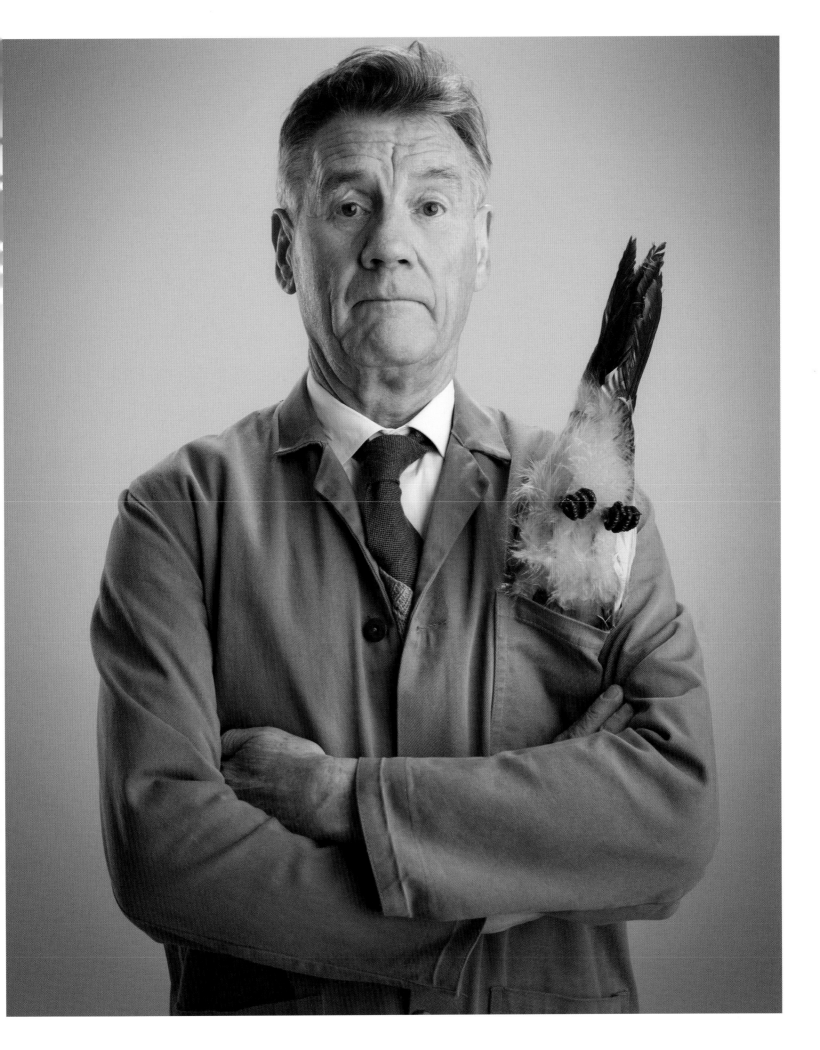

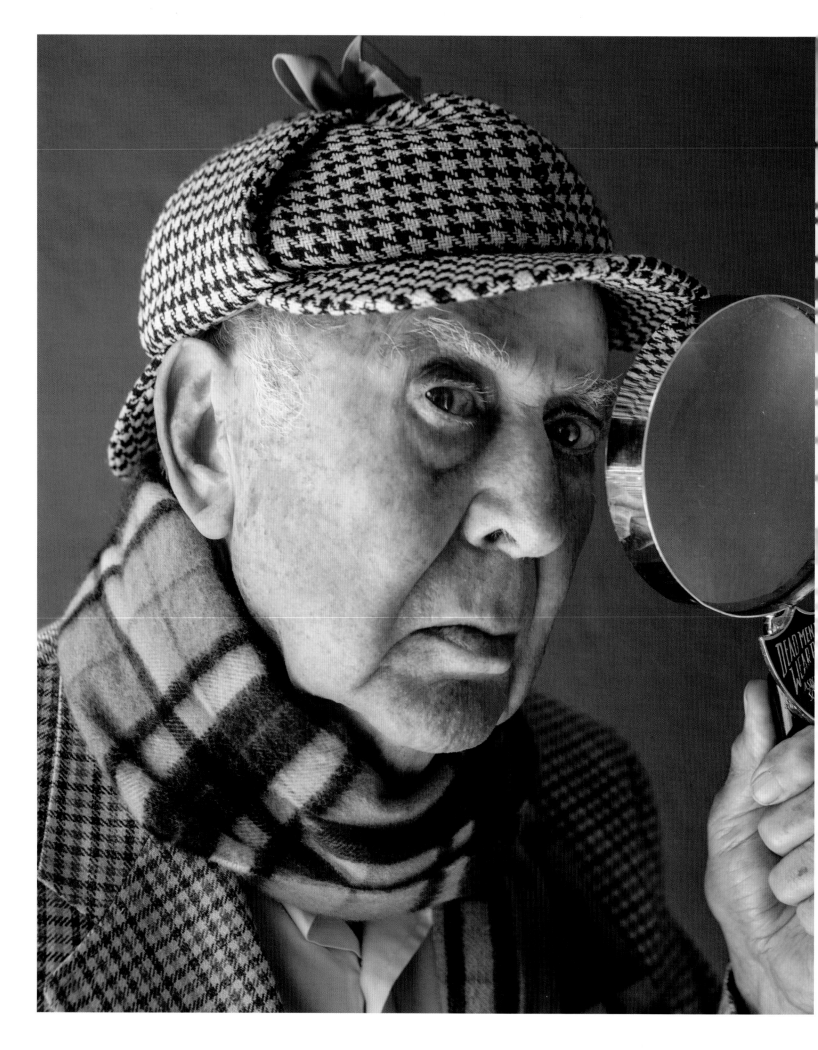

I'm a charming coward; I fight with words . . .

In comedy you tell it like it is and you know if you are being effective. In drama, you never know. When you go to a comedy and you don't hear anybody laughing, you know that you've failed.

CARL REINER

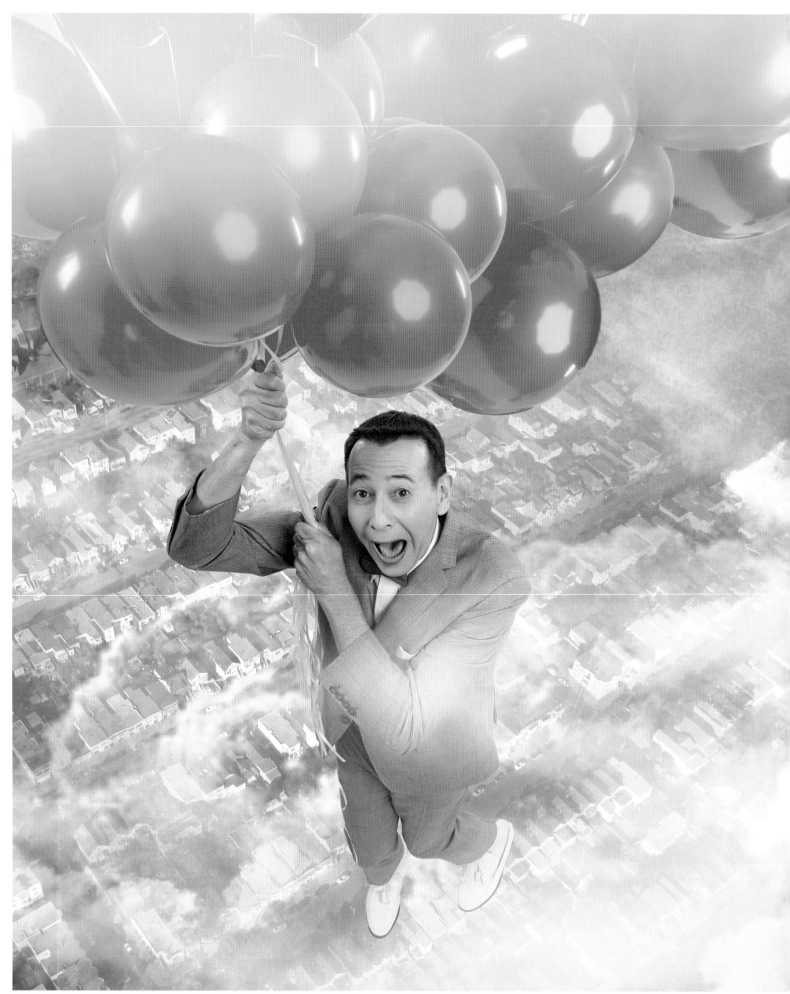

PAUL REUBENS

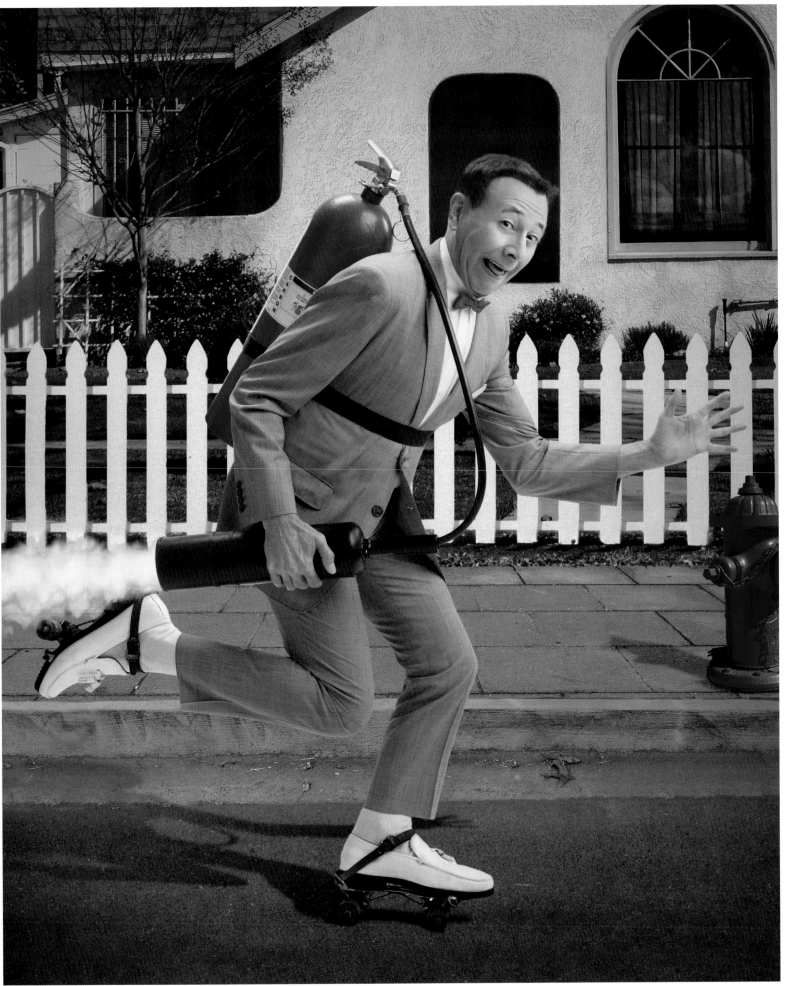

PAUL REUBENS

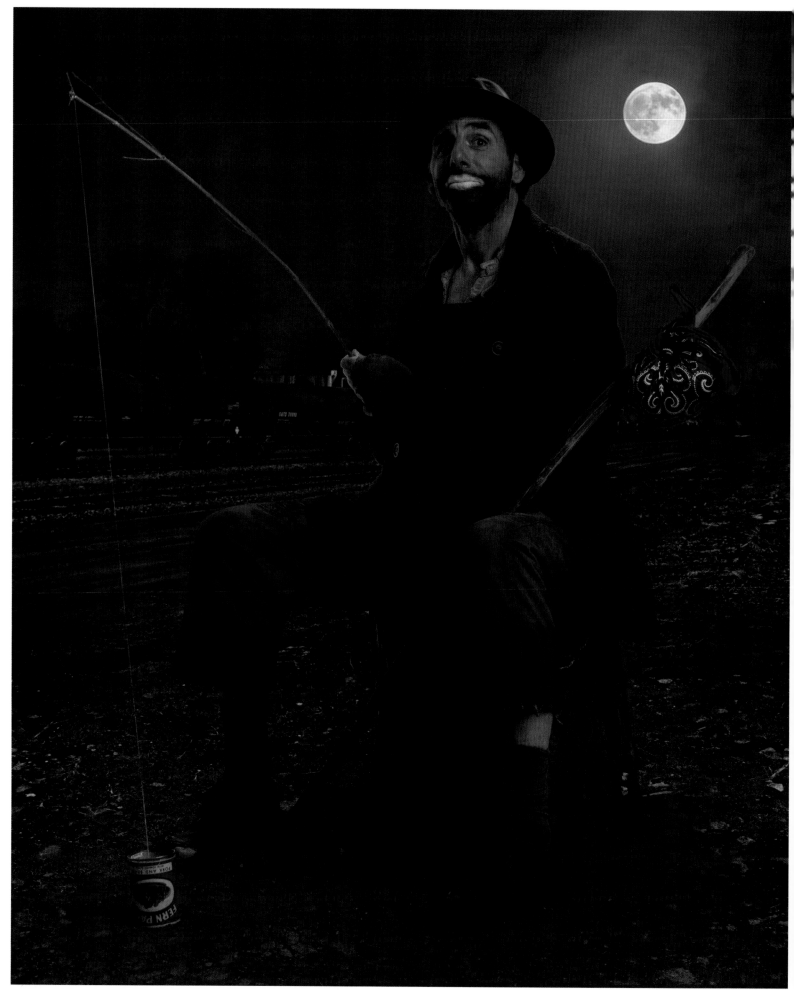

MICHAEL RICHARDS

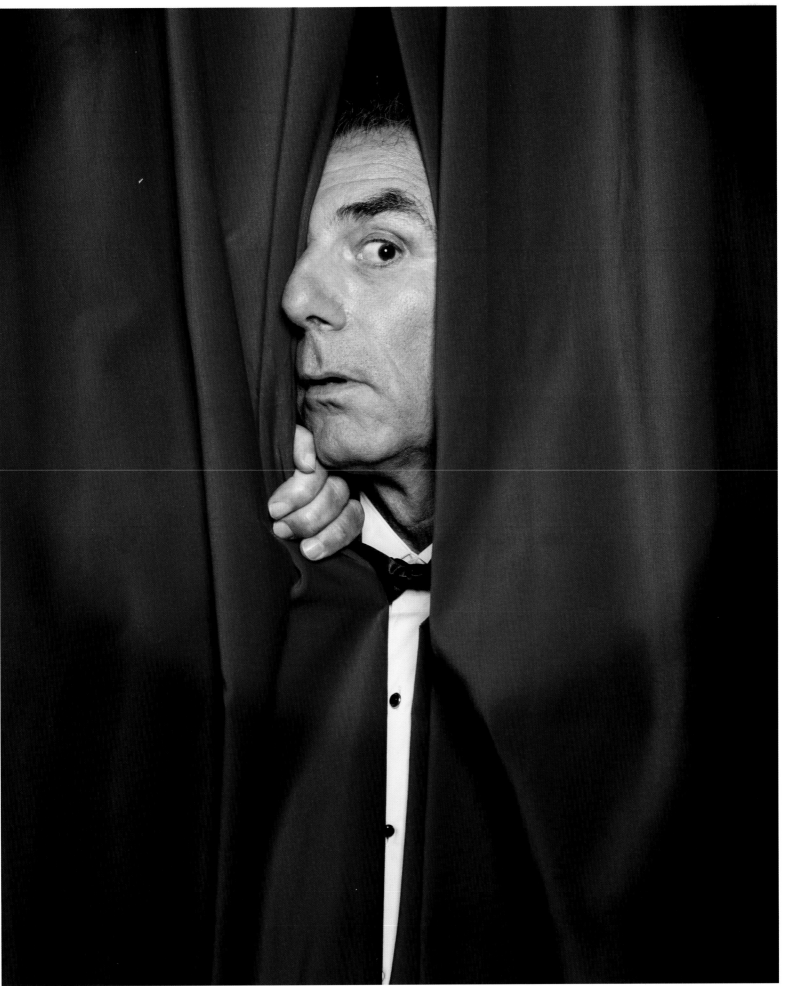

MICHAEL RICHARDS

You can't study comedy . . .

it's within you. It's a personality. My humor is an attitude.

DON RICKLES

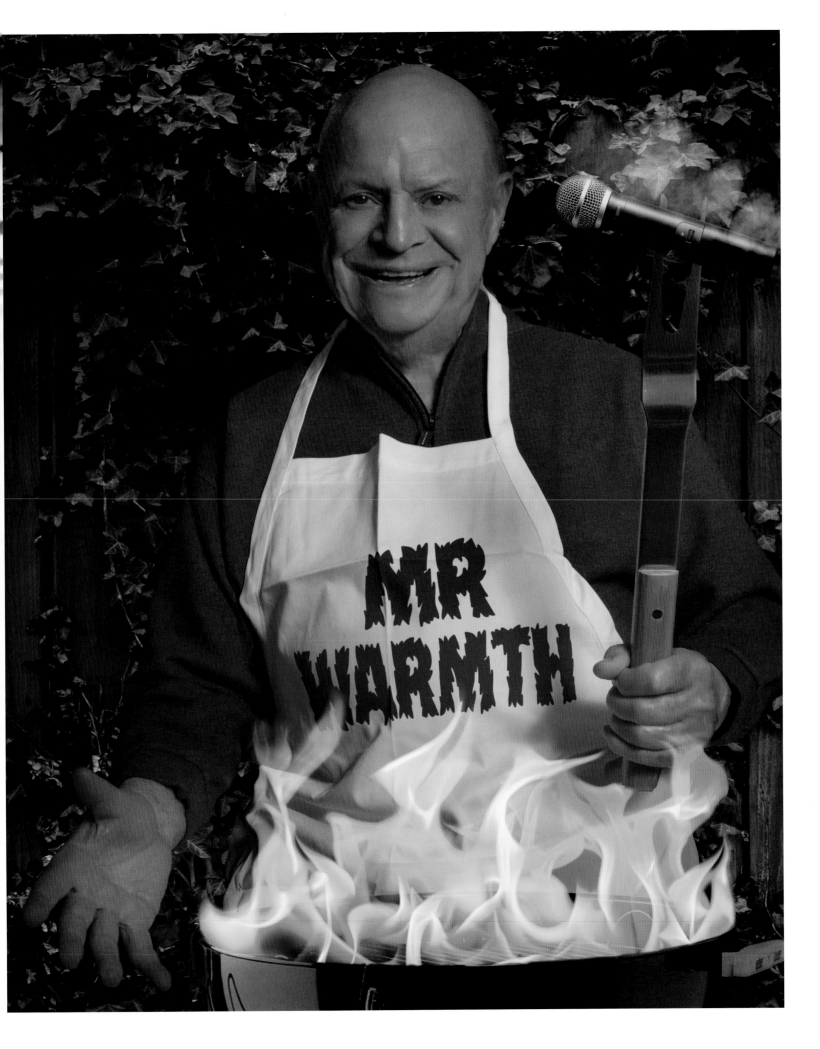

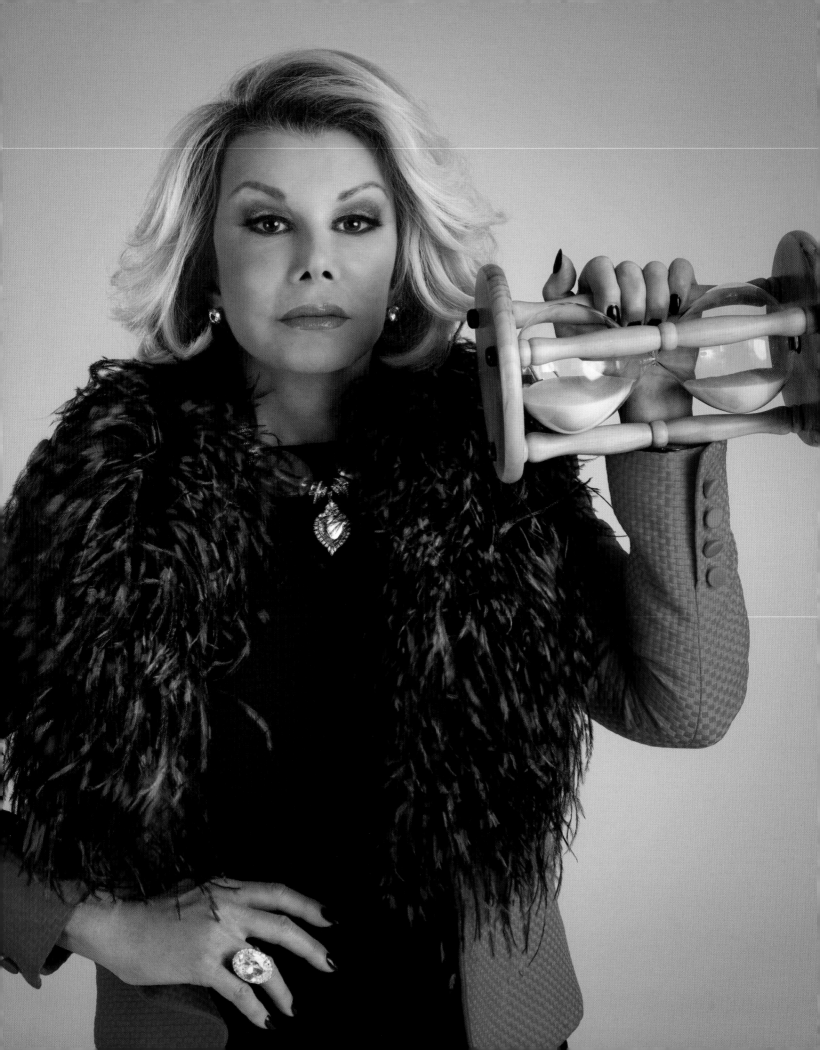

I succeeded by saying
what everyone else is thinking.

JOAN RIVERS

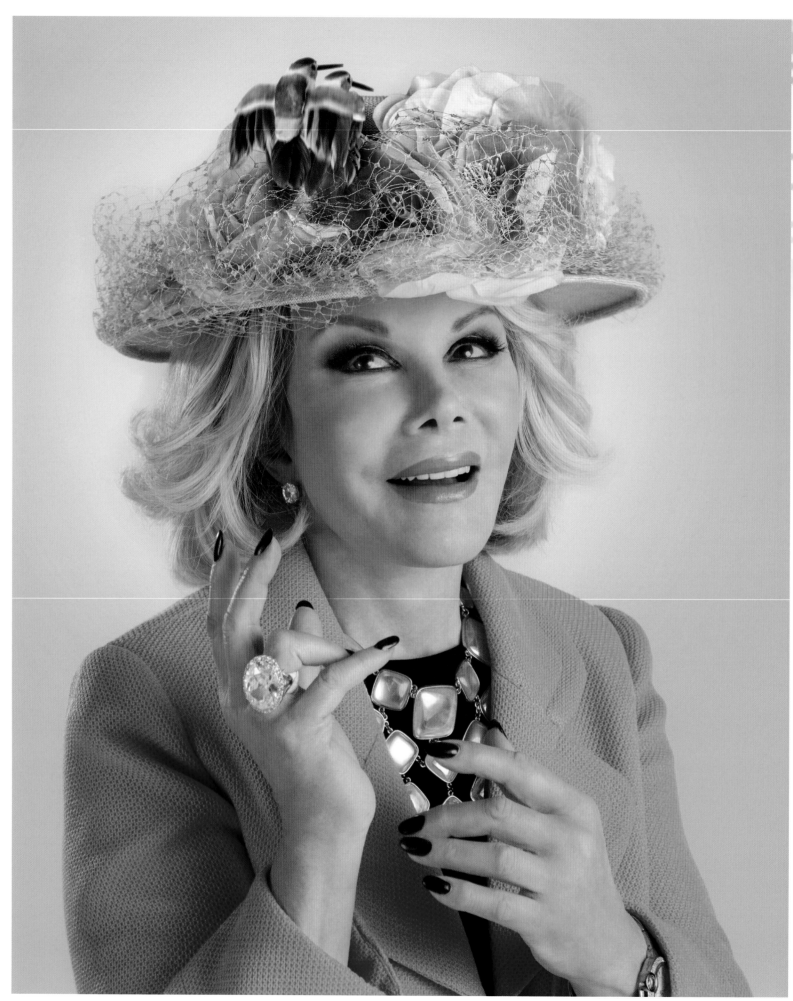

JOAN RIVERS

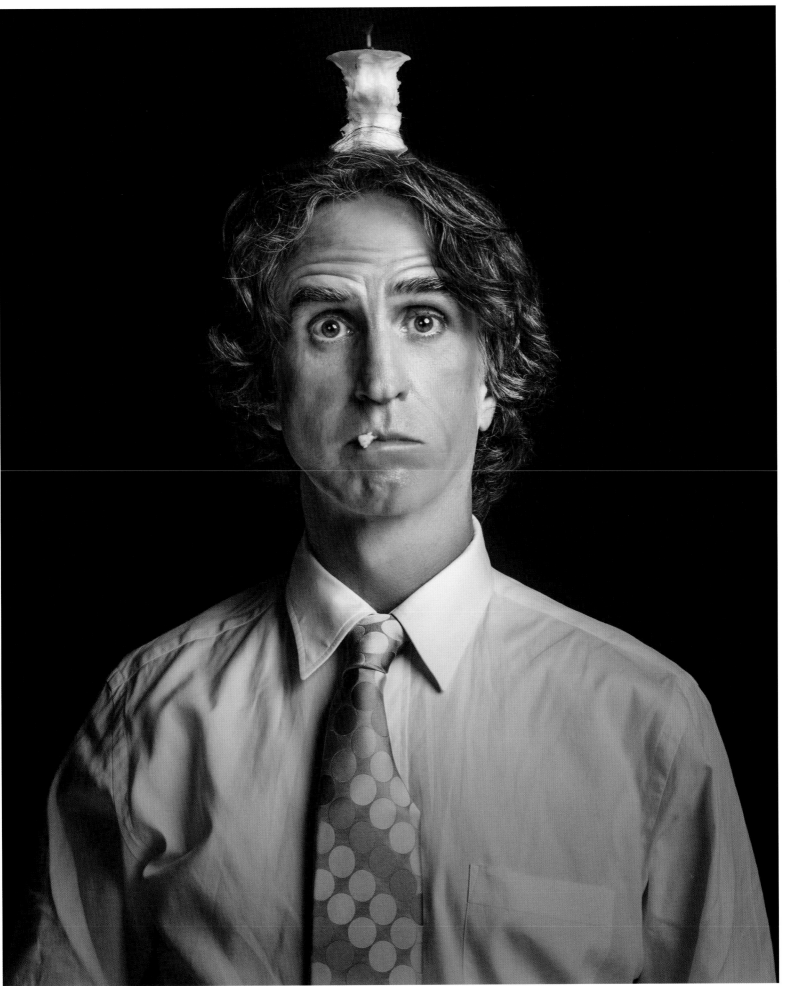

JAY ROACH

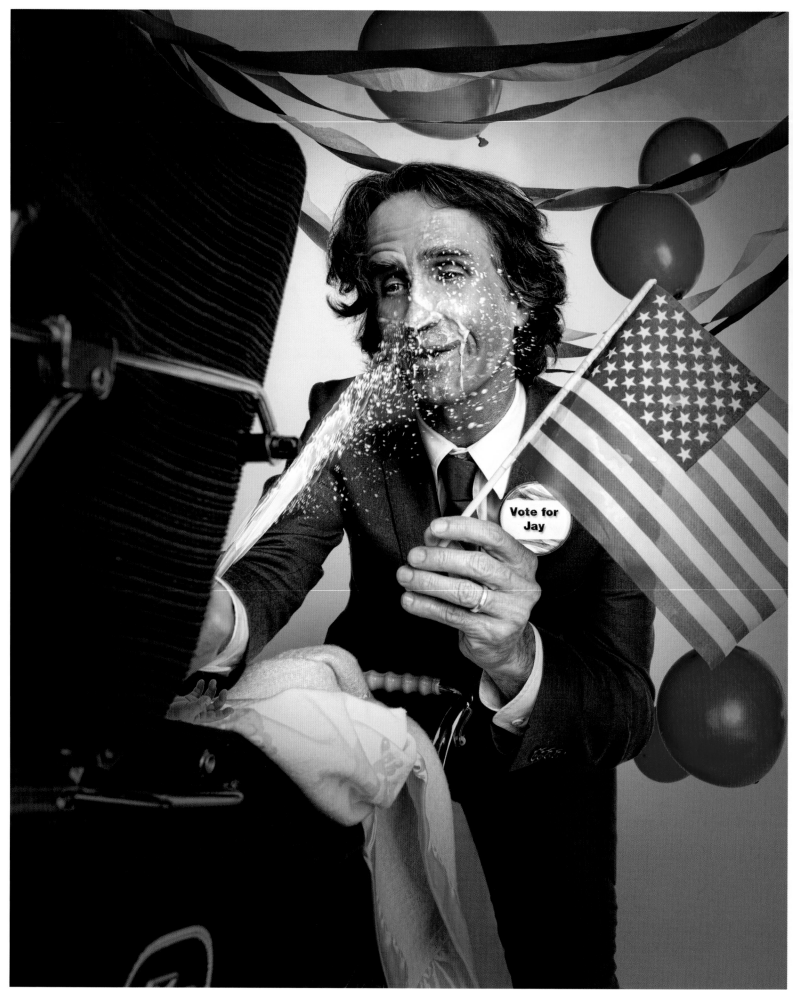

JAY ROACH

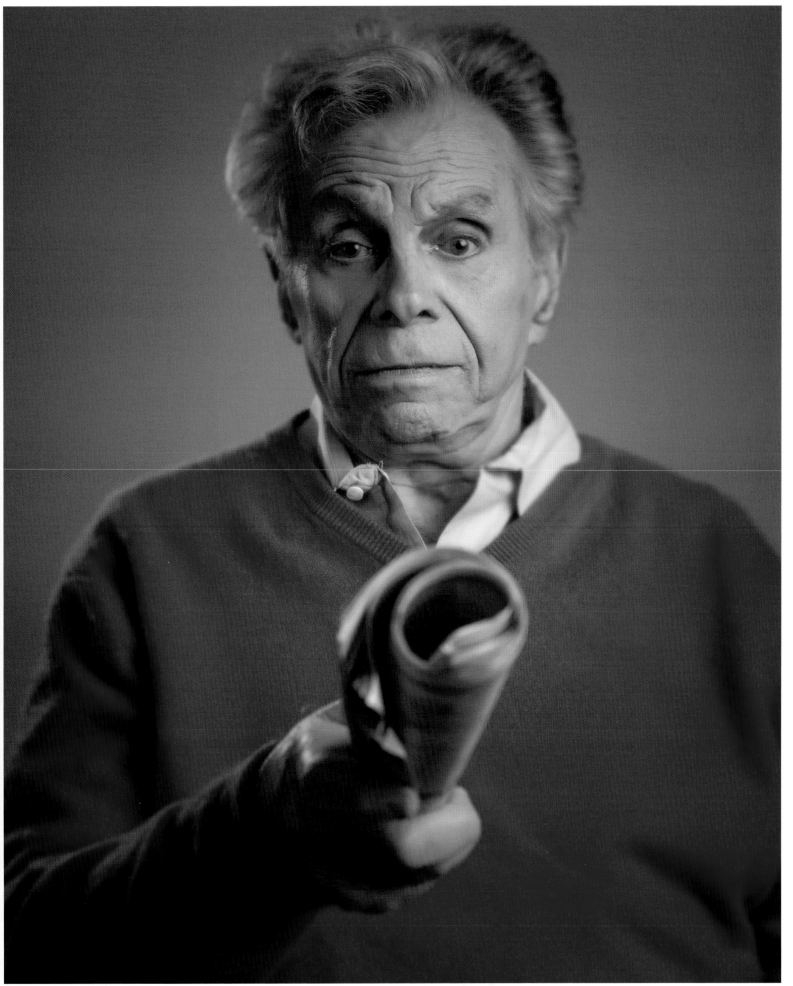

MORT SAHL

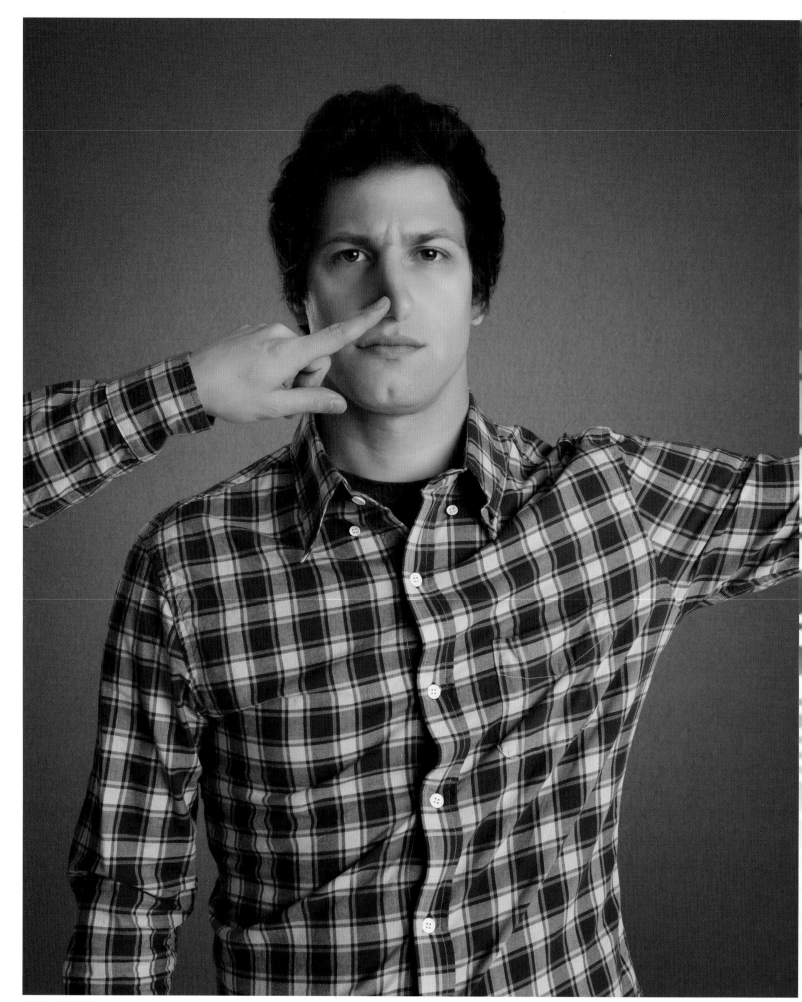

ANDY SAMBERG

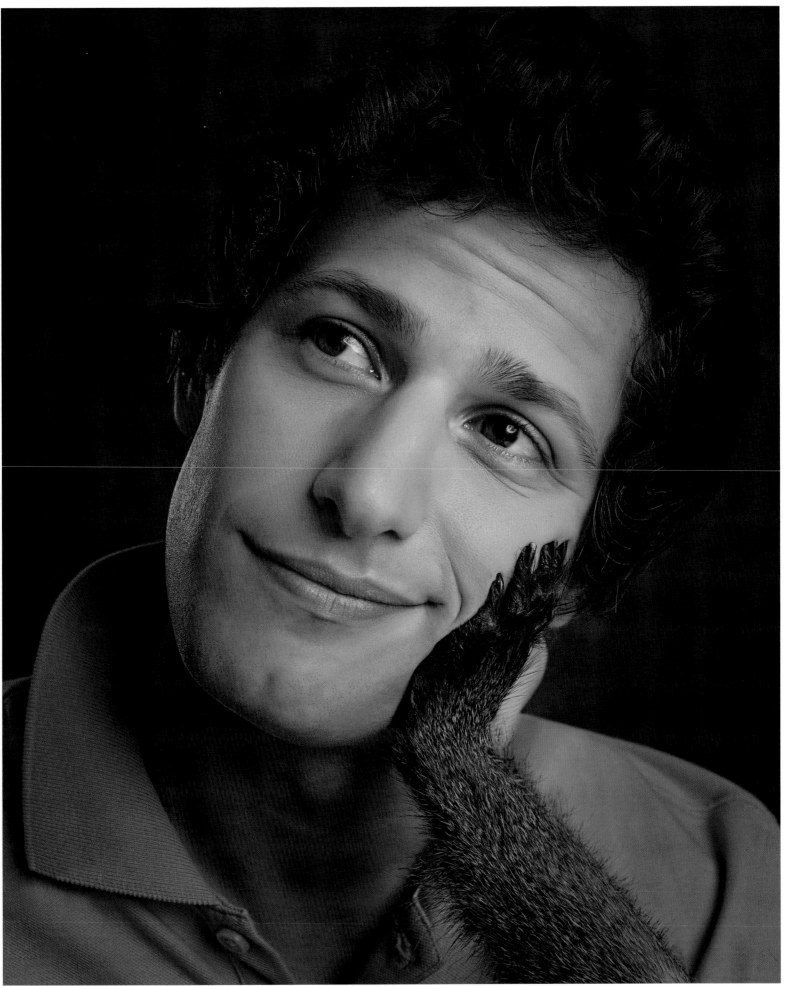

ANDY SAMBERG

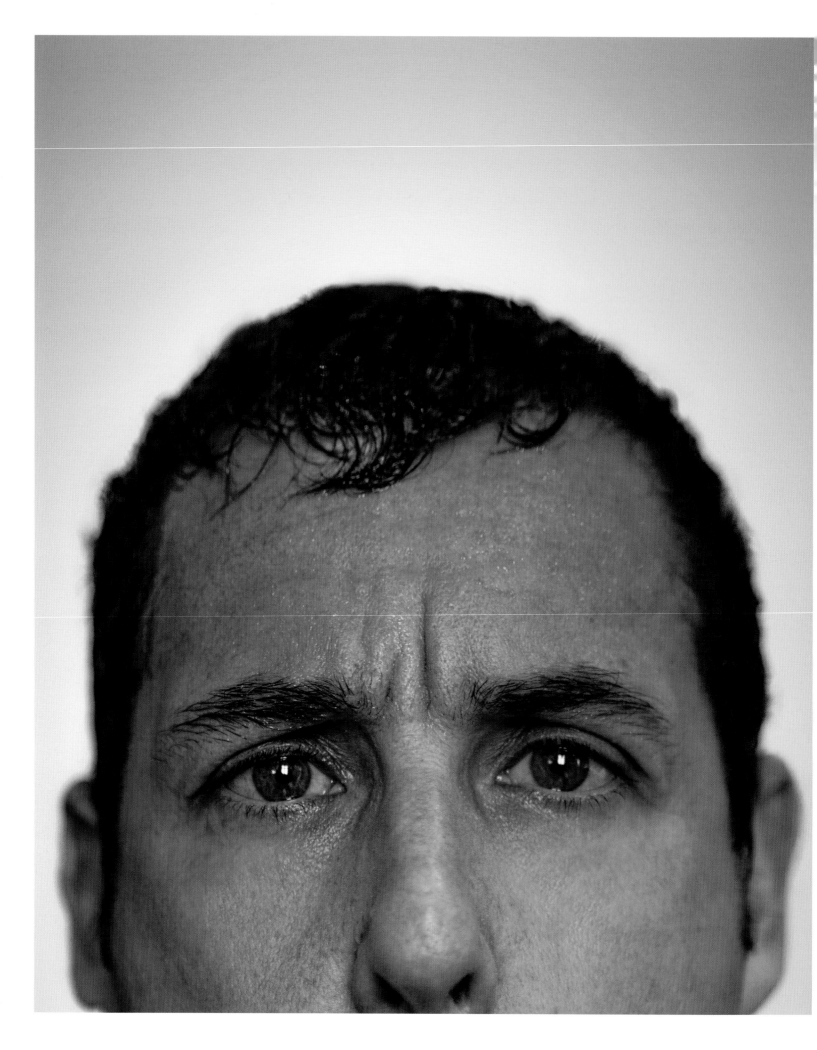

I've been called a moron since I was about four . . .

My father called me a moron. My grandfather said
I was a moron. And a lot of times when I'm driving,
I hear I'm a moron. I like being a moron.

ADAM SANDLER

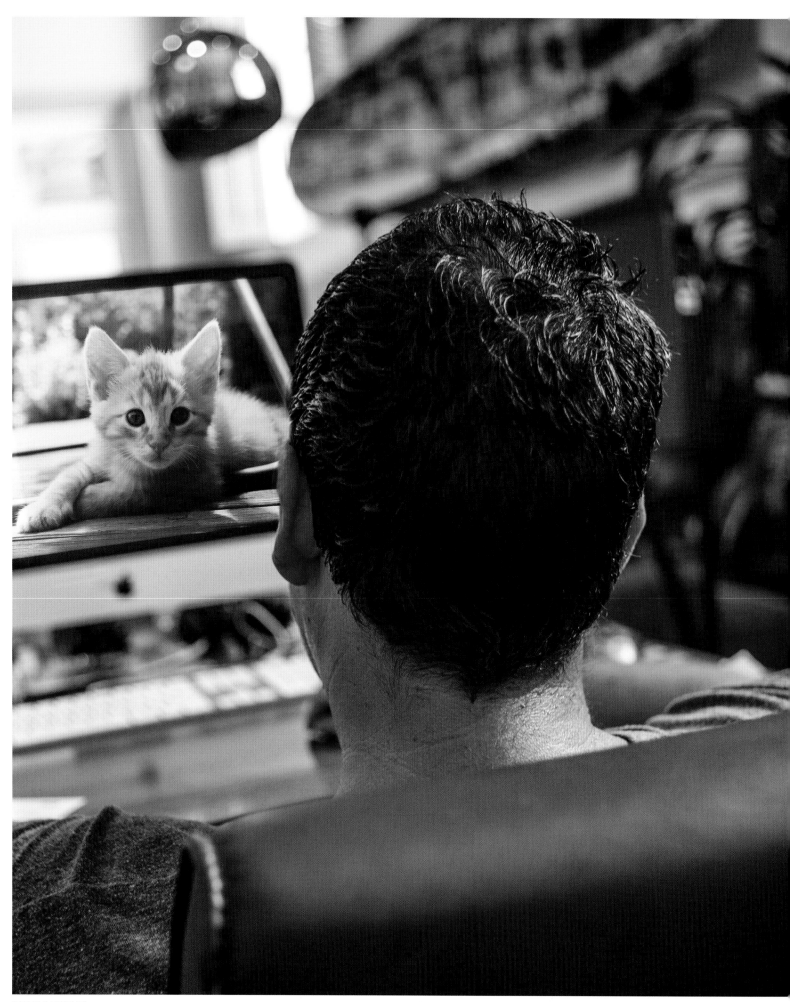

ADAM SANDLER

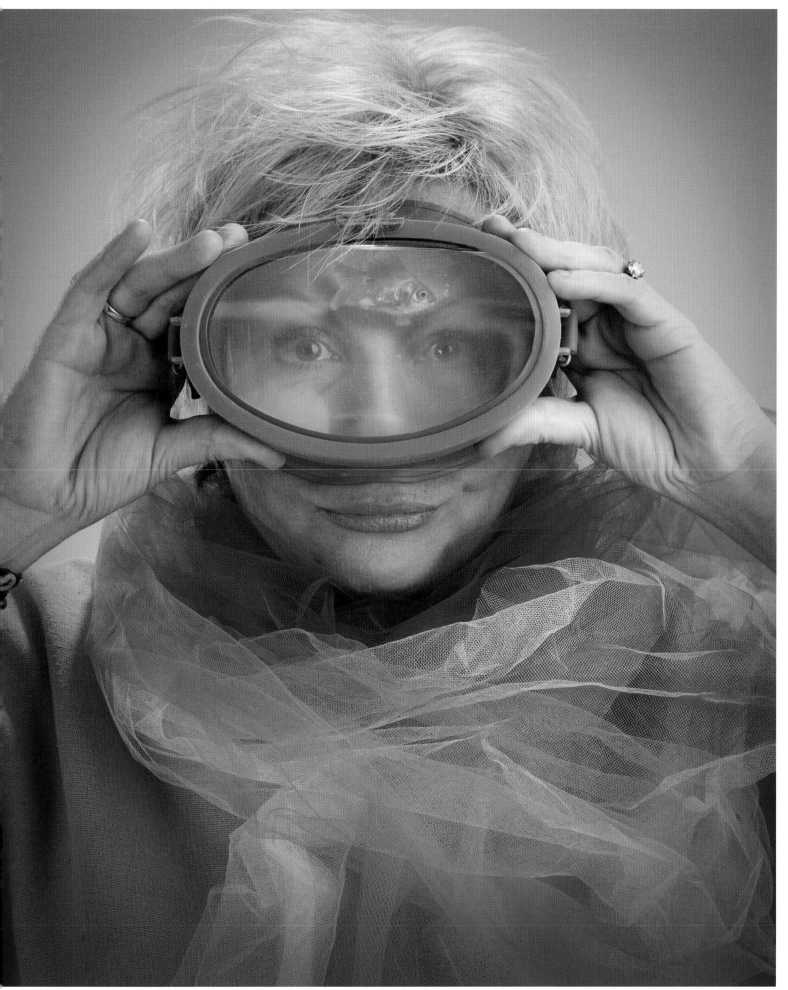

Everybody's trying to leave their mark on the world.

That's why there's graffiti and babies.

KRISTEN SCHAAL

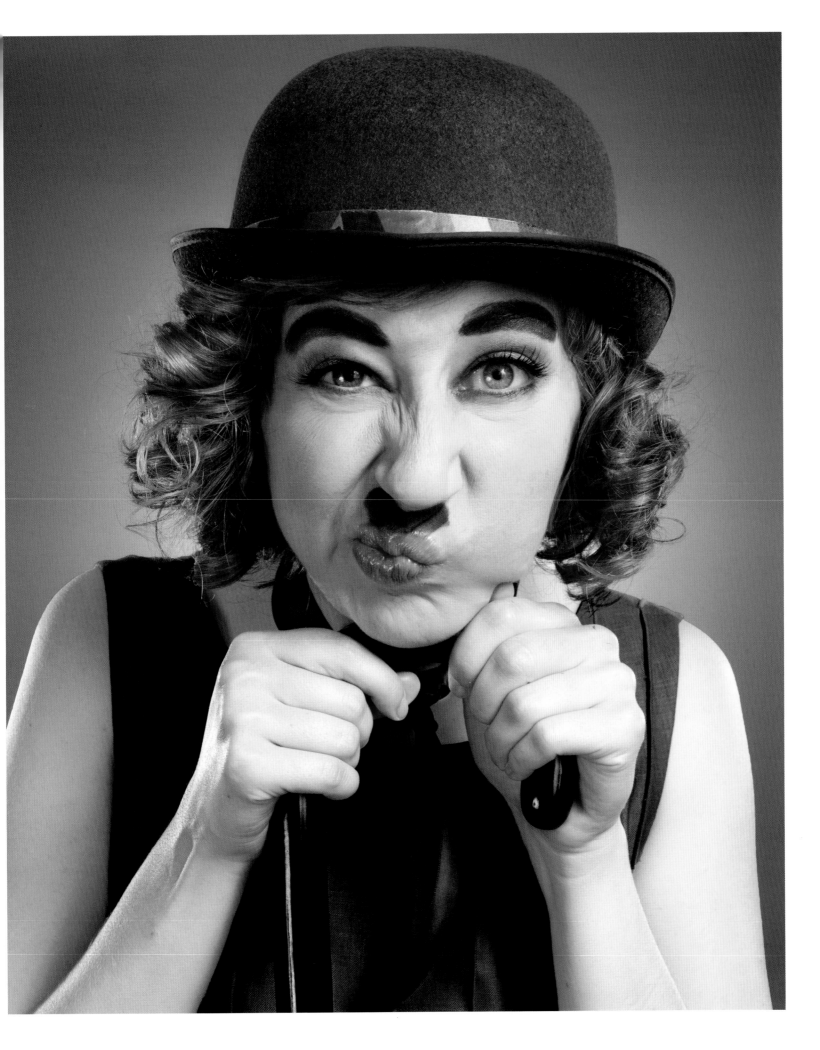

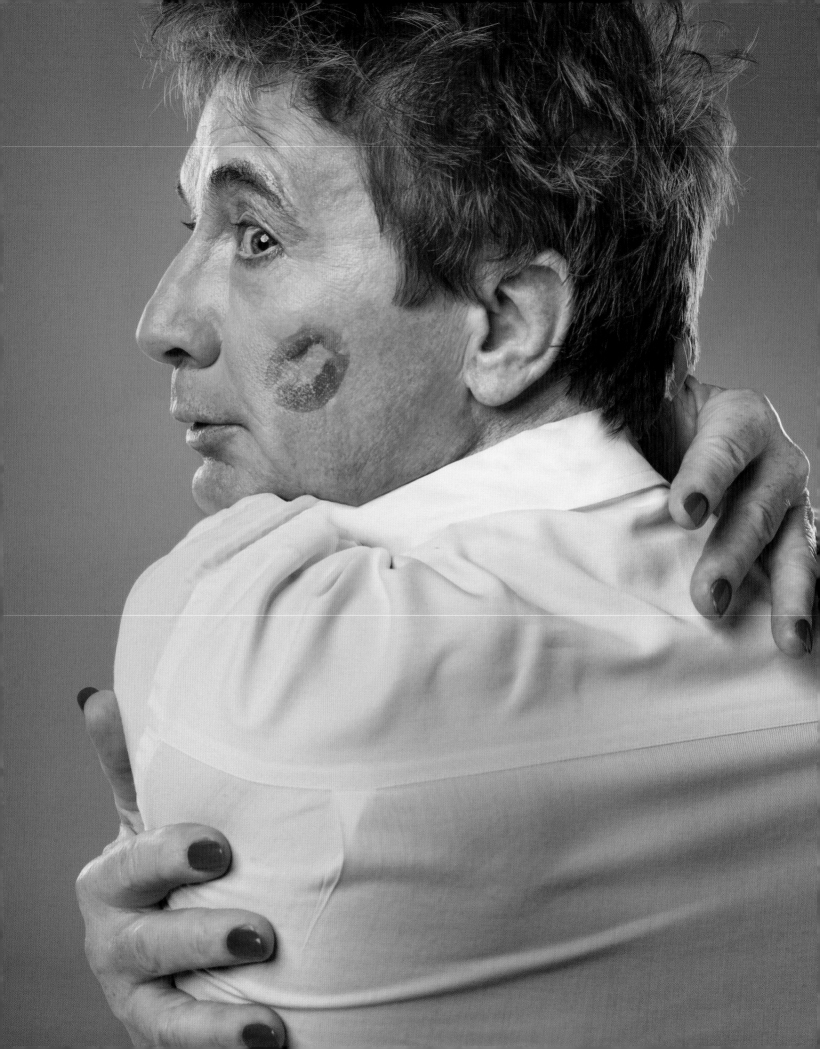

It's the bane of existence for anyone in comedy. "The photograph must be funny!"

So the people coordinating the shoot throw rubber chickens at you, twenty at a time. Or put a feathered hat on you. Or give you a clown nose. Of course, all of this makes you depressed, so you wind up looking more like you're promoting *A Long Day's Journey Into Night*.

MARTIN SHORT

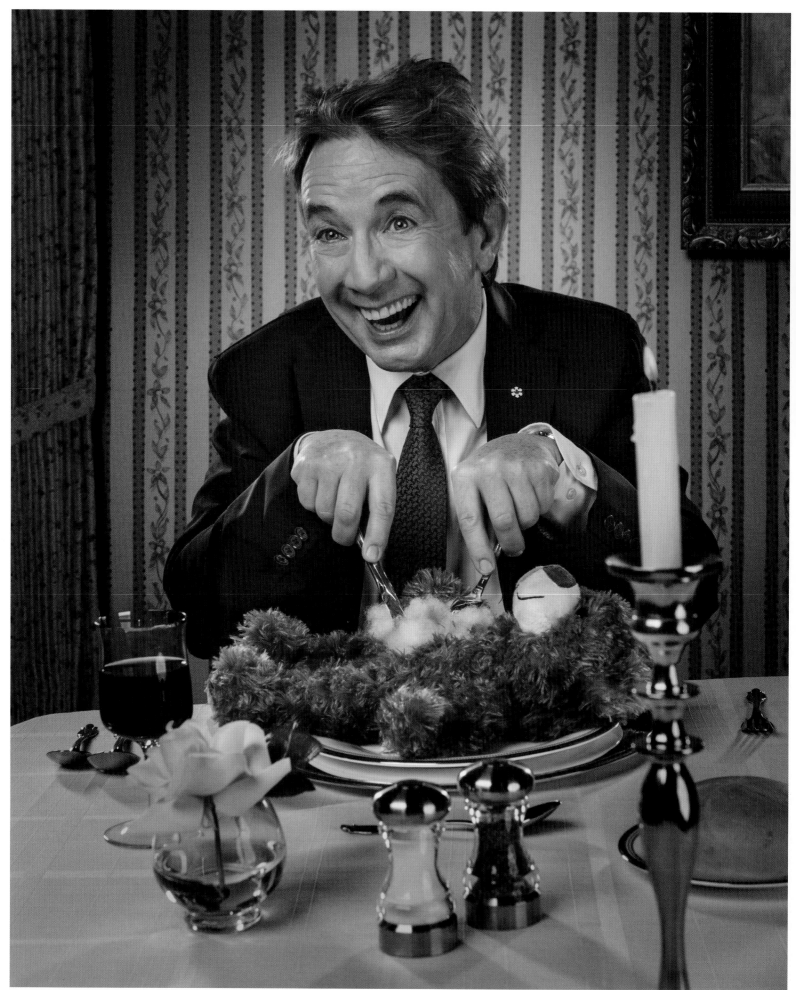

MARTIN SHORT

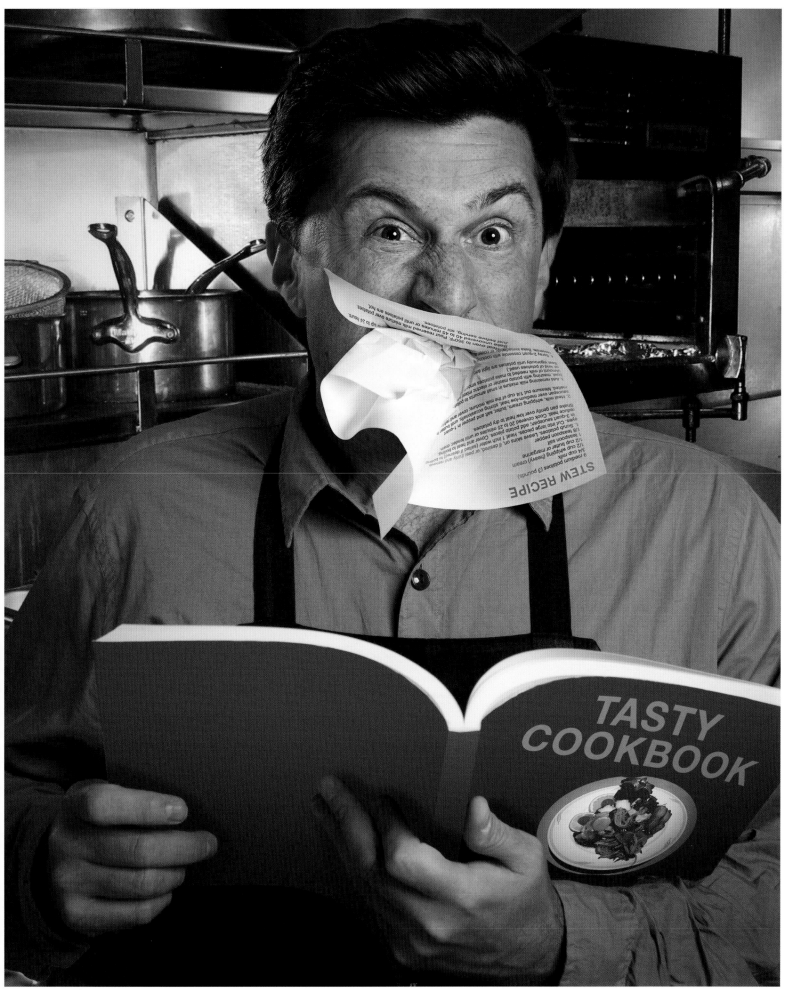

STEW RECIPE

3 medium potatoes (3 pounds)
3/4 cup milk
1/2 cup whipping (heavy) cream
1/2 cup butter or margarine
1 teaspoon salt
1/8 teaspoon pepper
1. Scrub potatoes; leave skins on, if desired, or peel potatoes and remove
eyes. Cut into large pieces. Heat 1 inch water (salted if desired) to boiling
in 3-quart saucepan. Cook covered 20 to 25 minutes or until tender; drain.
2. Heat milk, whipping cream, butter, salt and pepper in 1-quart
saucepan over medium-low heat. Cook covered over low heat to dry potatoes.
Shake pan gently over low heat for about 30 seconds.
reduce heat. Measure out 1/4 cup of the milk mixture; cover and refrigerate.
Add remaining milk mixture in small amounts to potatoes, mashing with a
amount of milk needed to make potatoes smooth.
treat, mashing with potato masher or electric mixer until
beat vigorously until potatoes are light and
(More or less amount of potatoes are used.)
Spray 2-quart casserole with cooking
texture. Bake uncovered 40 to 45 minutes or until potatoes are hot.
Heat oven to 350°F. Pour reserved milk mixture over potatoes
Refrigerate uncovered up to 24 hours,
Just before serving, stir potatoes.

In general there are a lot more funny men . . .

because men need to become funny in order to get women.

That or, I guess, being in a rock band.

SARAH SILVERMAN

When you don't know
what you're talking about . . .

it's hard to know when you're finished.

TOMMY SMOTHERS

DAVID STEINBERG

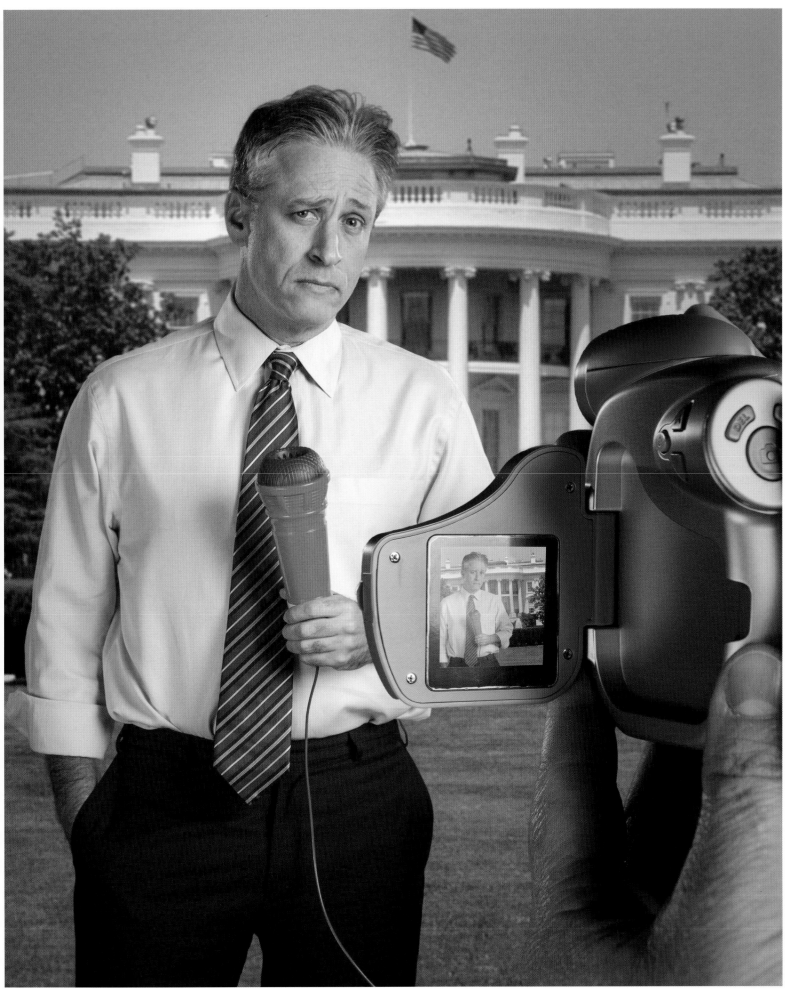

JON STEWART

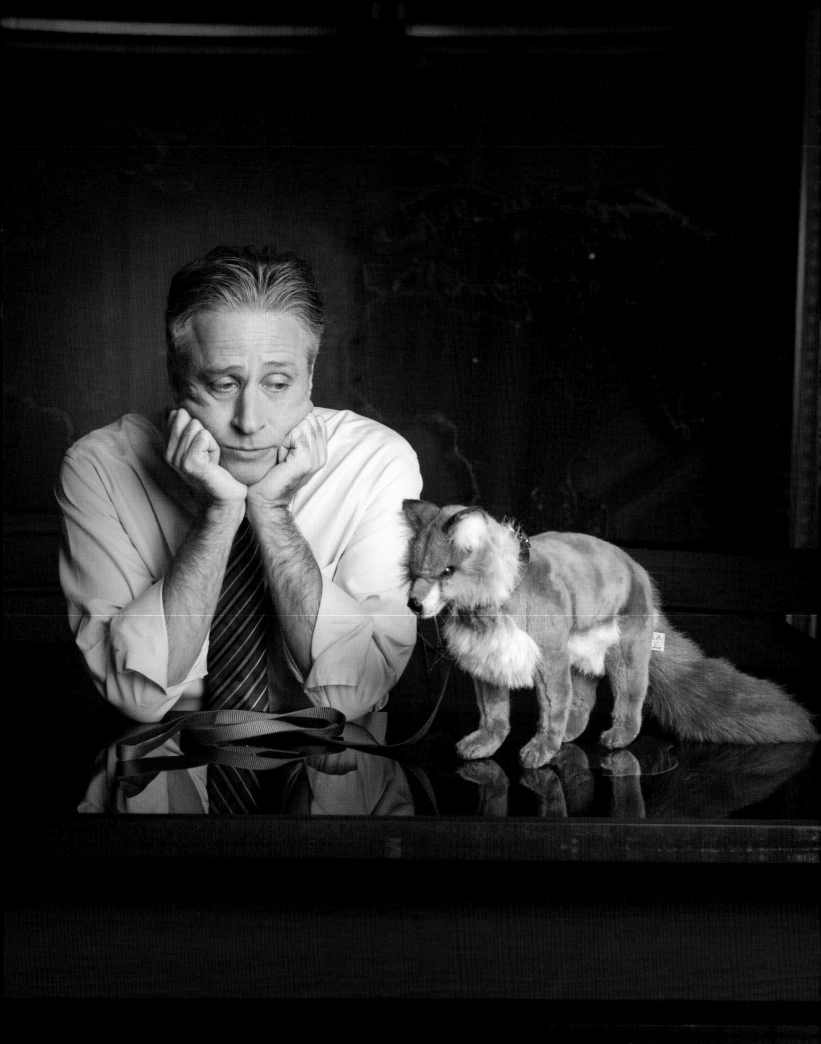

I have complete faith in the continued absurdity of whatever's going on.

I've always run by the hierarchy of "If not funny, interesting.
If not interesting, hot. If not hot, bizarre. If not bizarre, break something."

JON STEWART

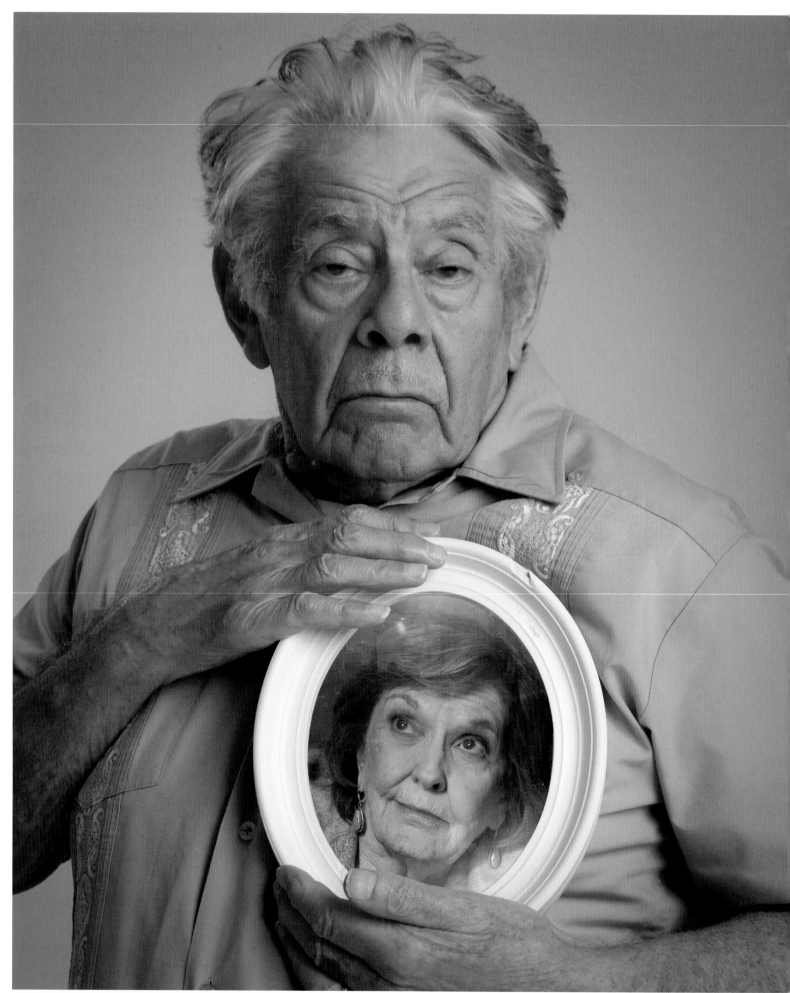

JERRY STILLER

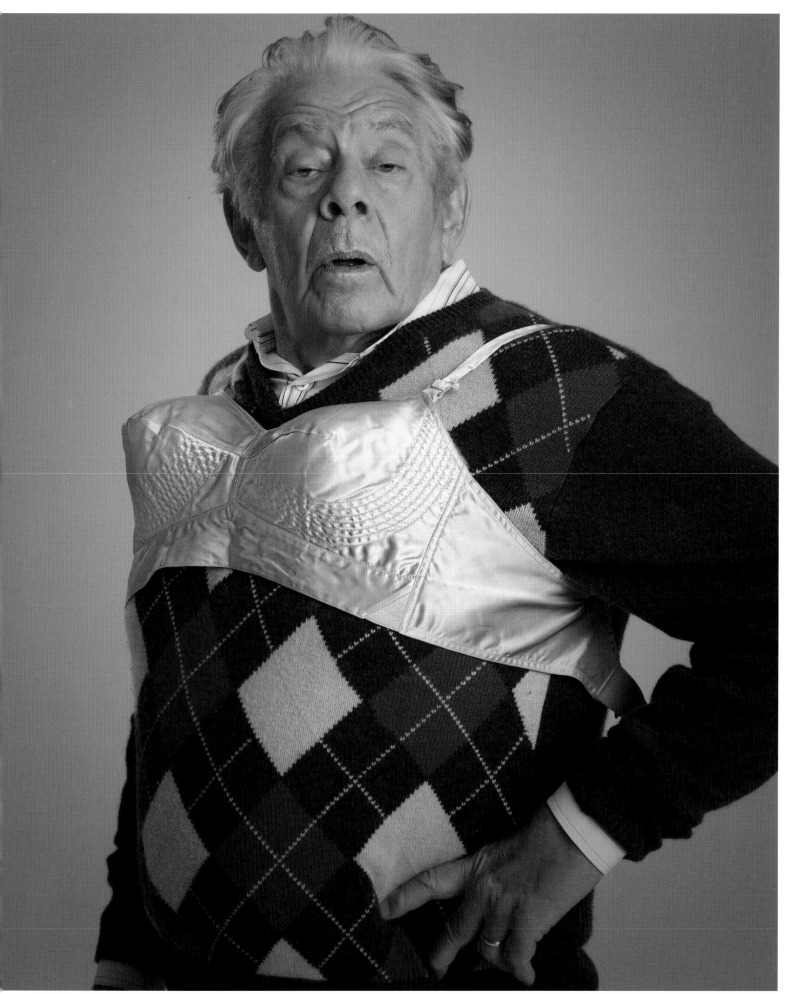

JERRY STILLER

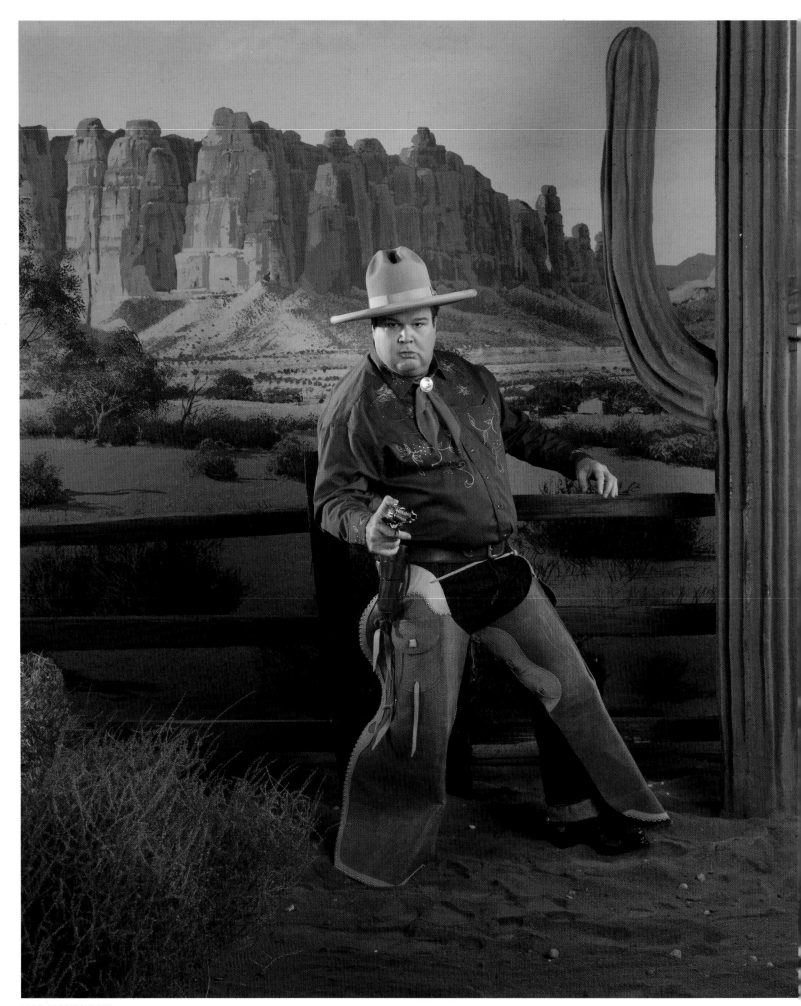

ERIC STONESTREET

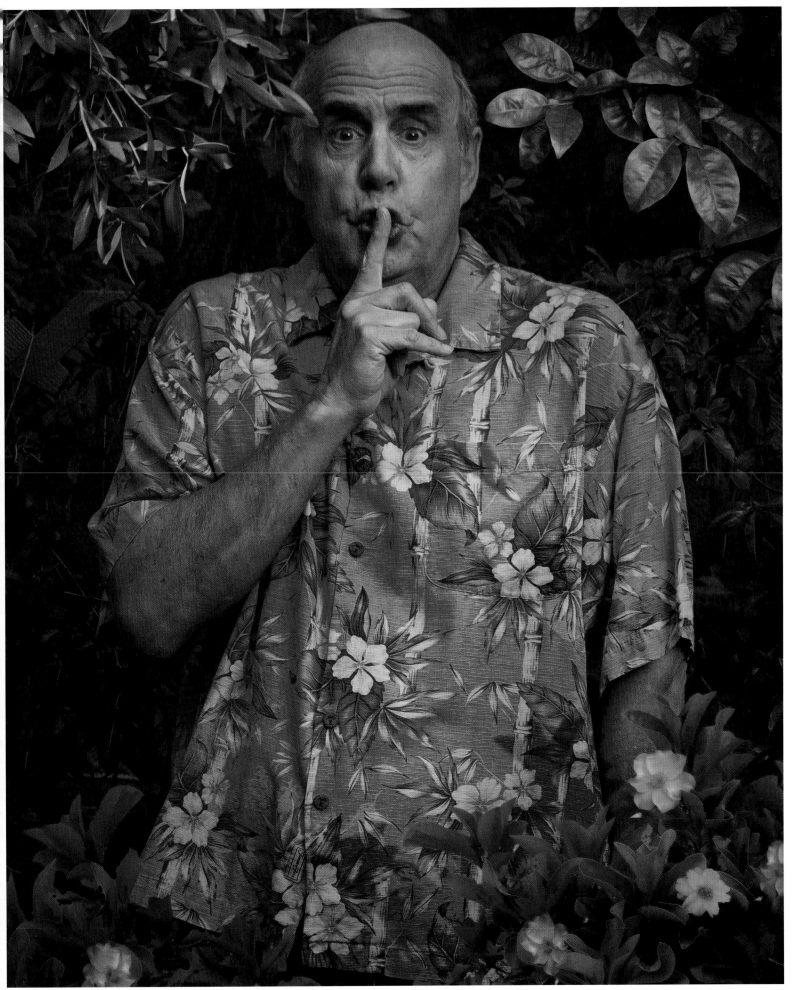

JEFFREY TAMBOR

My first agent called me "Hot Ticket" . . .

and I thought that was great. Until I realized he had no idea what my name was.

JEFFREY TAMBOR

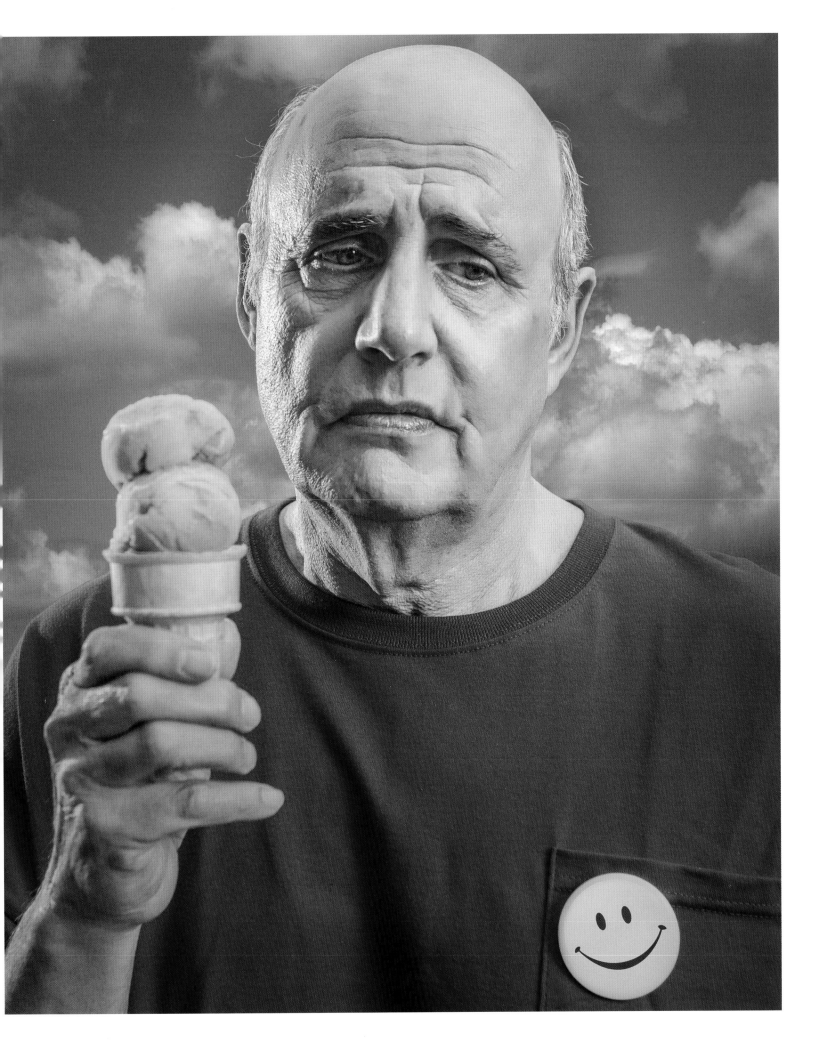

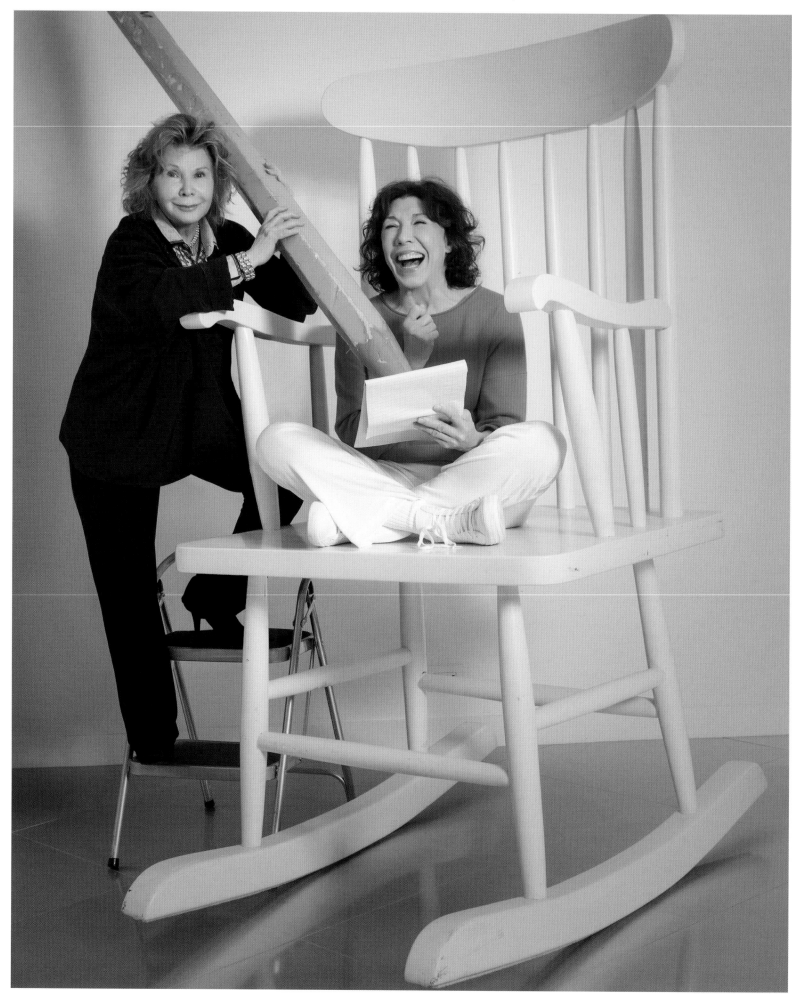

LILY TOMLIN AND JANE WAGNER

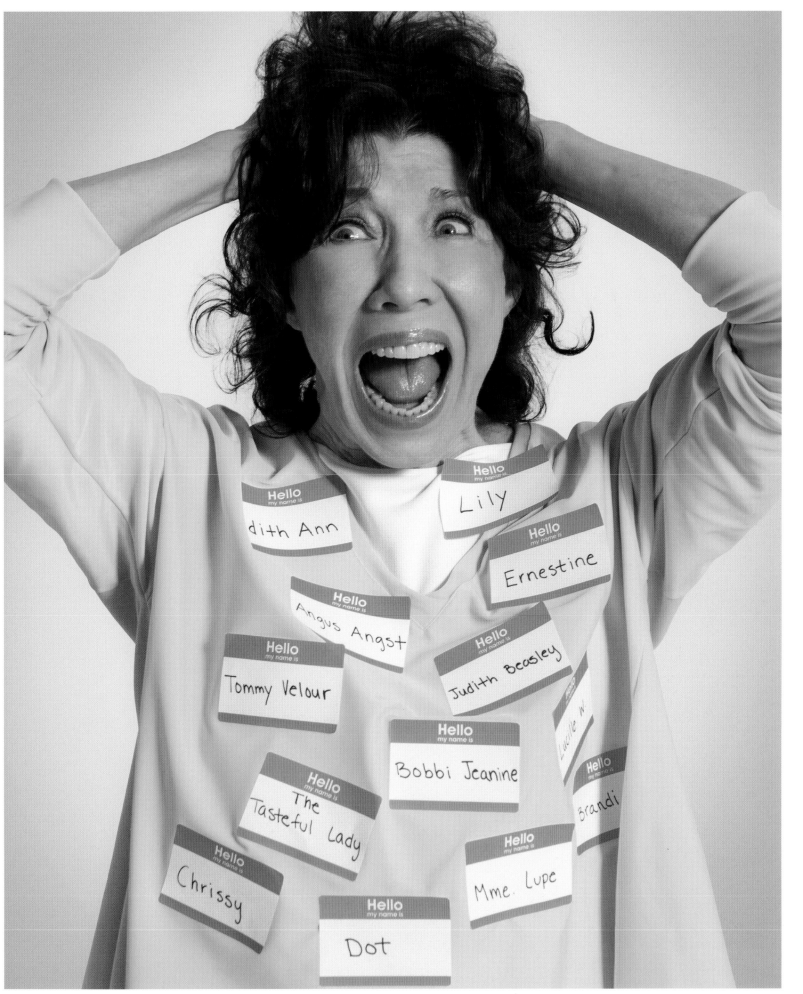

LILY TOMLIN

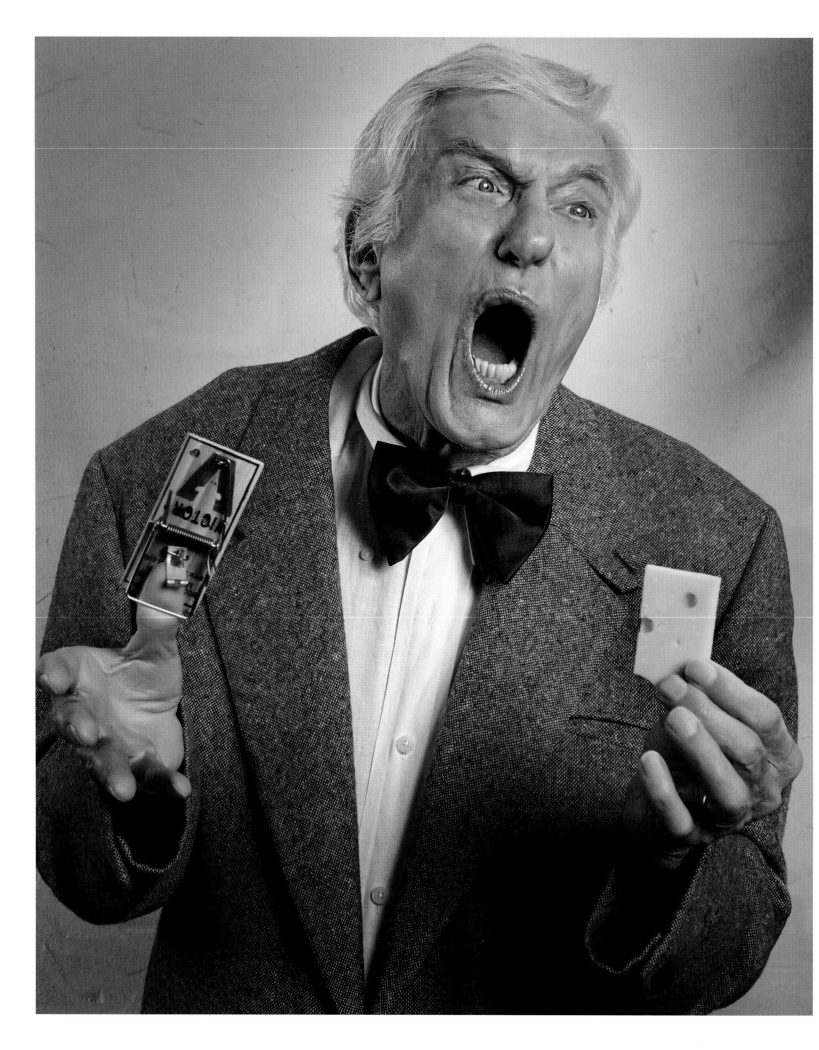

Women will never be as successful as men . . .

because they have no wives to advise them.

DICK VAN DYKE

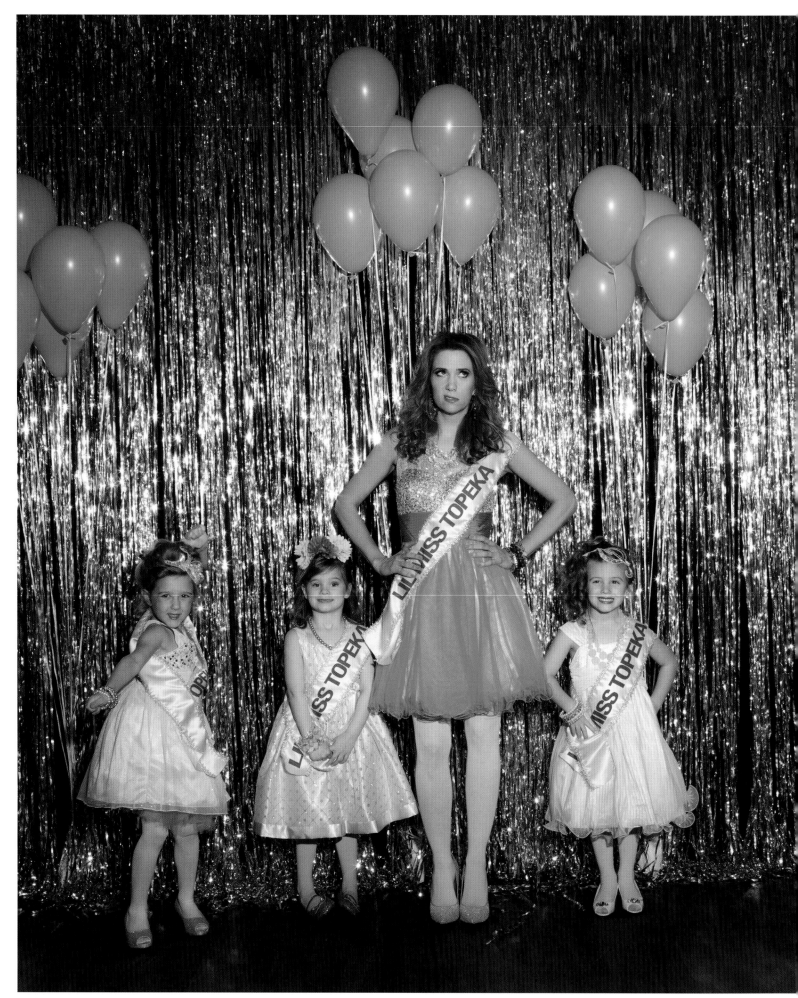

KRISTEN WIIG

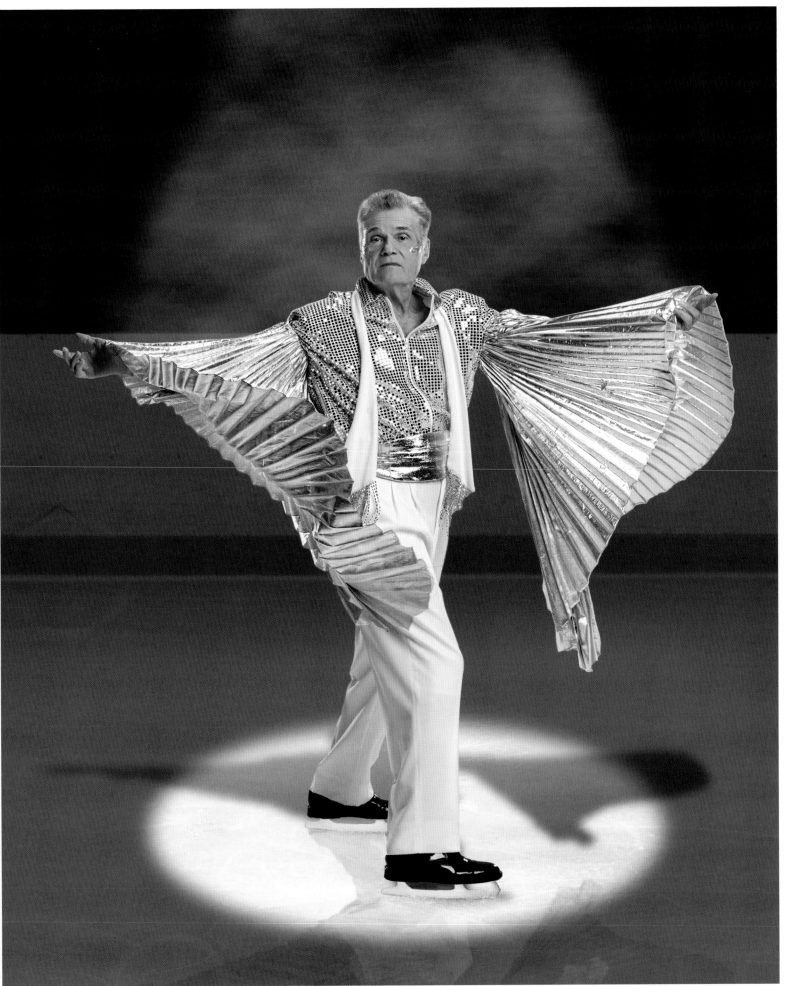

FRED WILLARD

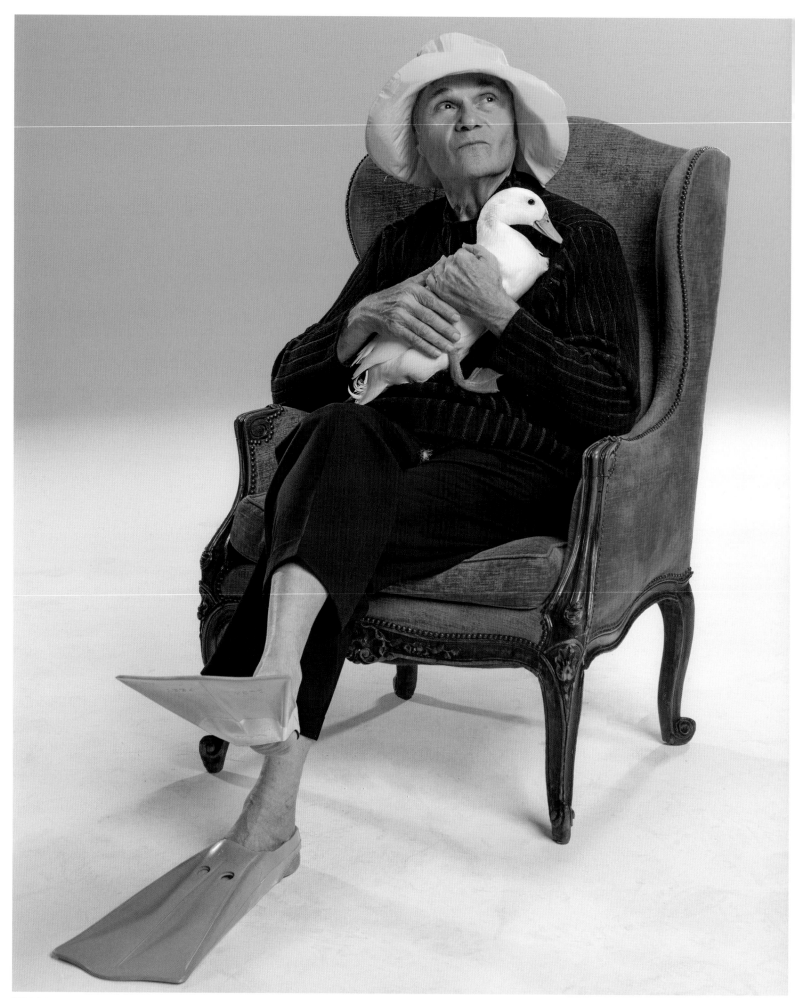

FRED WILLARD

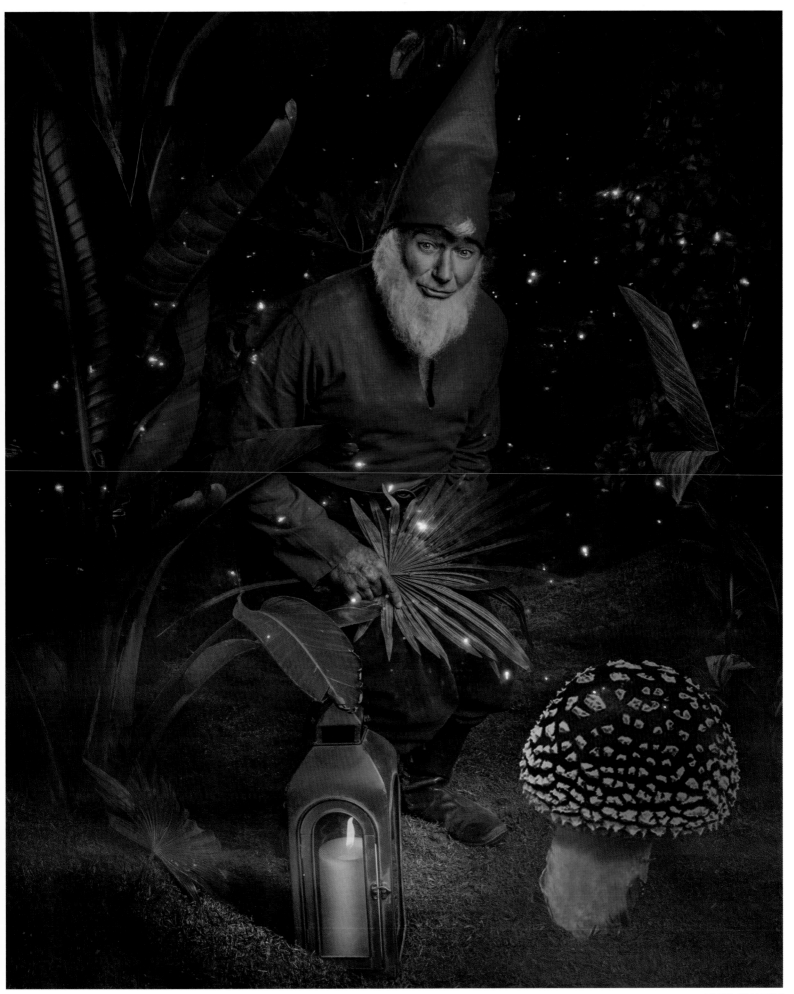

ROBIN WILLIAMS

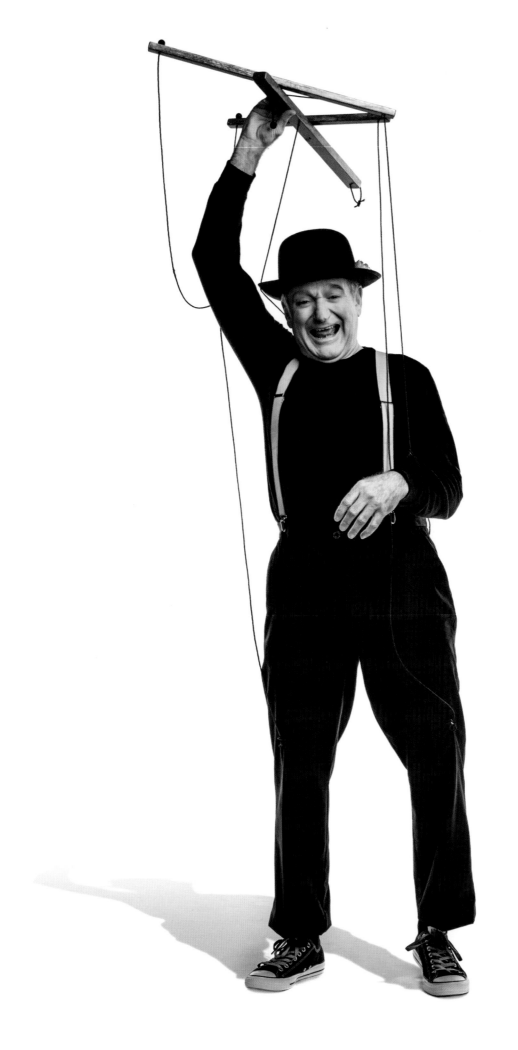

I want to thank my father . . .

the man, who when I said I wanted to be a comedian, said,
"Wonderful. Just have a back-up profession like welding."

ROBIN WILLIAMS

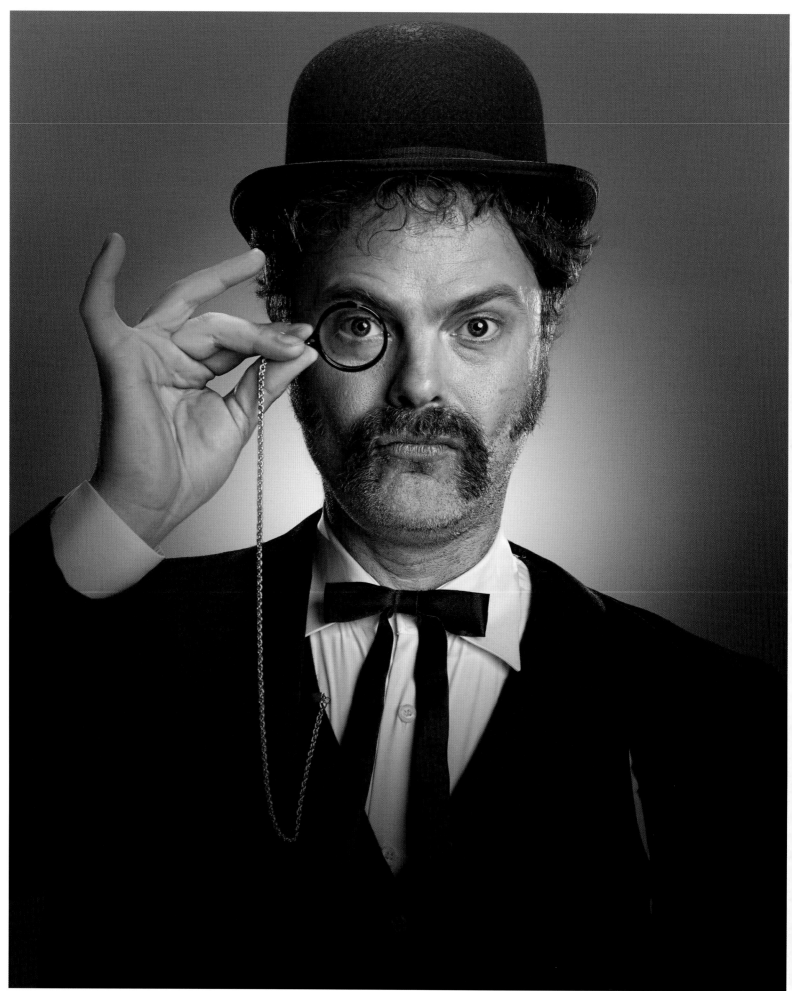

RAINN WILSON

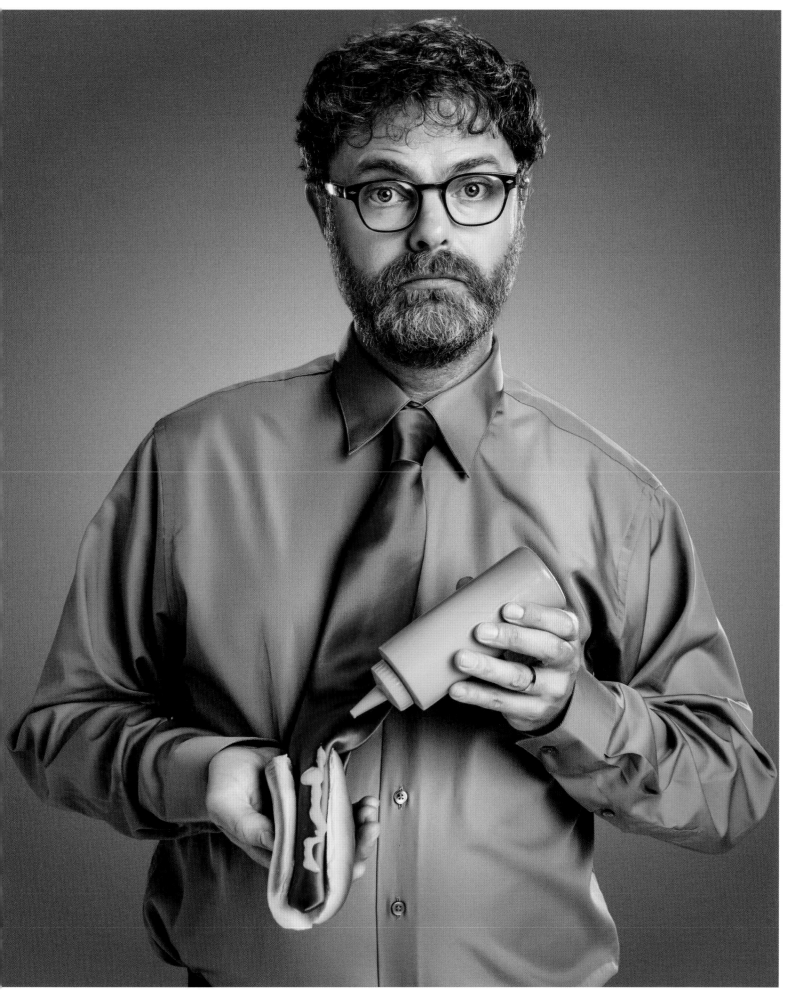

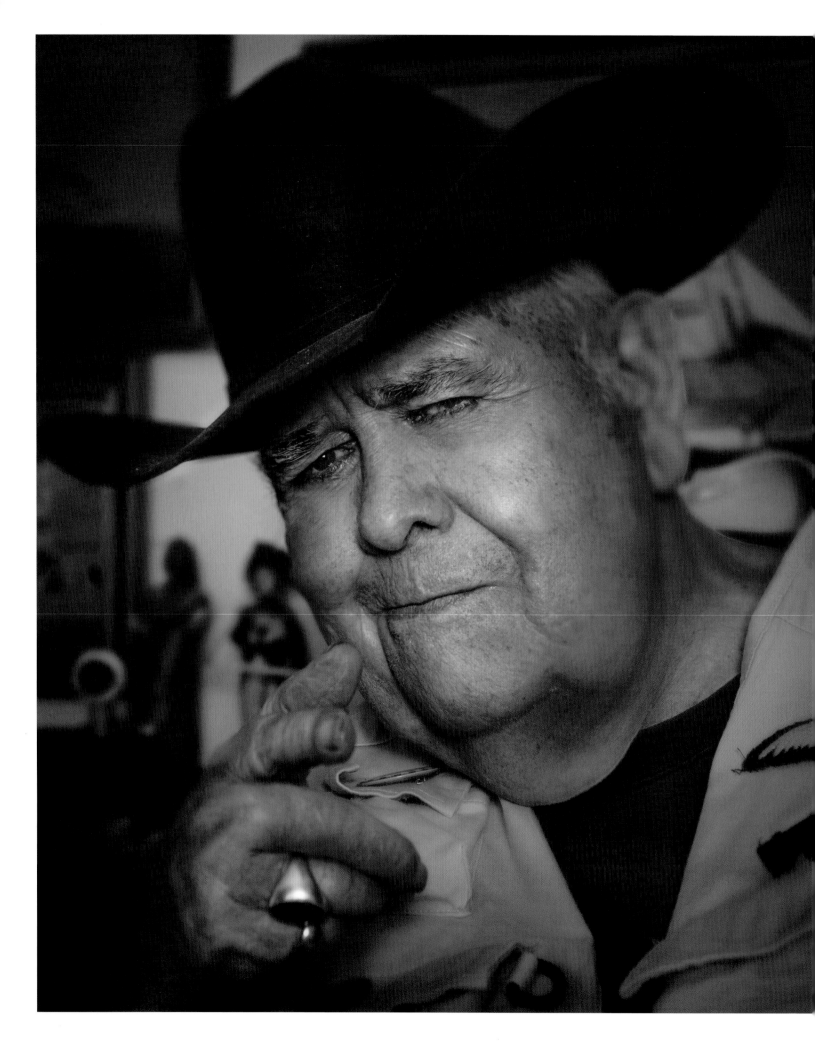

If your ship doesn't come in . . .

swim out to meet it.

JONATHAN WINTERS

I'm stranded . . .

all alone in the gas station of love,
and I have to use the self-service pump.

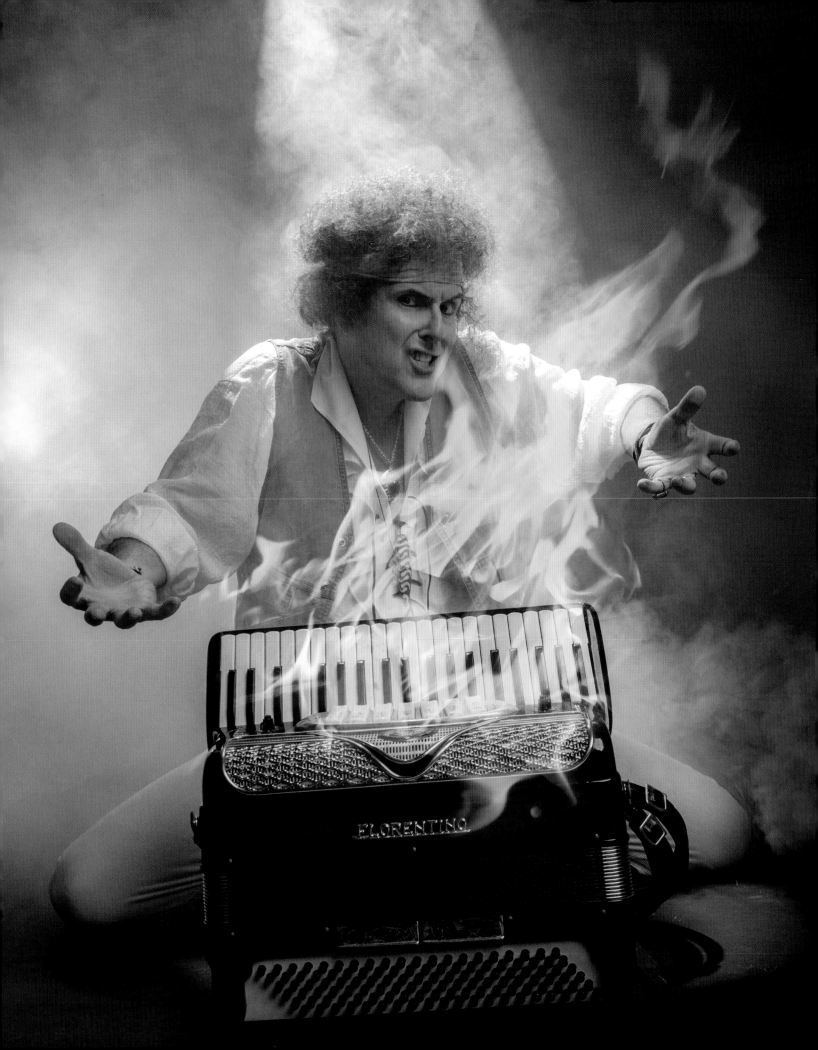

Blessed are the cracked . . .

for they shall let in the light.

–GROUCHO MARX

Biographies

MEL BROOKS
ACTOR, COMEDIAN, DIRECTOR, PRODUCER, WRITER
b. June 28, 1926, Brooklyn, New York

Mel Brooks is one of only fourteen entertainers who have received an Emmy, Grammy, Oscar, and Tony Award. As a writer for the variety television series *Your Show of Shows* in the 1950s, he met star and co-writer Carl Reiner. Together they developed "The 2000-Year-Old Man in the Year 2000" improvised comedy routine, recording five comedy albums, the fifth winning a Grammy Award for Best Spoken Comedy Album in 1998. Brooks wrote and directed his first film, *The Producers*, in 1968, winning an Oscar for Best Original Screenplay and later adapting the script into a Broadway musical that won twelve Tony Awards—a record for the most ever won by a musical. He has written, directed, and acted in a number of comedy films, including *Blazing Saddles*, *Young Frankenstein*, *High Anxiety*, *Spaceballs*, and *Robin Hood: Men in Tights*. He is a Kennedy Center honoree and in 2013 he was named as the recipient of the American Film Institute's forty-first Life Achievement Award.

TIM ALLEN
ACTOR, COMEDIAN, WRITER
b. June 13, 1953, Denver, Colorado

Tim Allen began performing as a stand-up comedian at the Comedy Castle in Detroit in 1979. His 1990 televised comedy special *Men are Pigs* was the basis for the sitcom *Home Improvement* in which Allen played the character Tim Taylor. It became one of the highest rated American television series of the 1990s, with Allen winning numerous awards including the People's Choice Award for Favorite Male Television Performer for eight years in a row and a Golden Globe for Best Performance by an Actor in a Television Series. In 1994 Allen achieved an unprecedented feat, having the number-one TV show, book, and film in the country, all during the same week. *Home Improvement* was the nation's highest rated TV show, the film *The Santa Clause*, in which he starred and won a People's Choice Award for Favorite Actor in a Comedy Motion Picture, was number one at the box office, and his book *Don't Stand Too Close to a Naked Man* was at the top of the *New York Times* Best Seller List. Some of Allen's other film credits include the animated *Toy Story* trilogy, in which he voices the character Buzz Lightyear, *Galaxy Quest* and *Wild Hogs*. In 2011 he returned to television, starring in the sitcom *Last Man Standing*.

BOB BALABAN
ACTOR, DIRECTOR, PRODUCER, WRITER
b. August 16, 1945, Chicago, Illinois

Bob Balaban's first film role was in *Midnight Cowboy* in 1969. Since then he has appeared in more than one hundred films, including Steven Spielberg's *Close Encounters of the Third Kind*; the Christopher Guest mockumentaries *Best in*

Show, *Waiting for Guffman*, *A Mighty Wind*, and *For Your Consideration*; Woody Allen's *Alice* and *Deconstructing Harry*; and Wes Anderson's *Moonrise Kingdom*. Also an experienced television actor, Balaban appeared in five episodes of the television sitcom *Seinfeld*. In 2001 Balaban created and produced the film *Gosford Park*, for which he received an Oscar nomination for Best Picture, and which won the Alexander Korda Award for the Outstanding British Film of the Year at the BAFTA Awards in 2002.

JASON BATEMAN
ACTOR
b. January 14, 1969, Rye, New York

Jason Bateman made his acting debut at age twelve in the television series *Little House on the Prairie*, but he is best known for his role as Michael Bluth in the television sitcom *Arrested Development*, for which he has won a number of awards including the Golden Globe for Best Performance by an Actor in a Television Series—Comedy or Musical in 2005. He has starred in numerous films including *The Break-Up*, *Hancock*, and *The Switch*.

MICHAEL IAN BLACK
ACTOR, COMEDIAN, DIRECTOR, WRITER
b. August 12, 1971, Chicago, Illinois

While at New York University, Michael Ian Black co-founded the sketch-comedy troupe The State, which was given its own television show of the same name by MTV in 1993. He developed his career as a comedian and actor on the television shows *Viva Variety*, *Ed*, *Stella*, and *Michael & Michael Have Issues*. In 2001 he acted in the comedy film *Wet Hot American Summer*. He wrote and directed the comedy *Wedding Daze*, and co-wrote *Run, Fat Boy, Run*. Black performs regularly as a stand-up comic and has released two full-length comedy albums on Comedy Central Records. He has also written a memoir, *You're Not Doing It Right*, a book of humorous essays, an exploration of American political culture, and four children's picture books.

CAROL BURNETT
ACTRESS, AUTHOR, COMEDIENNE
b. April 26, 1933, San Antonio, Texas

Carol Burnett is widely recognized for her work on stage and screen, most notably the long-running television series *The Carol Burnett Show*, which garnered twenty-five Emmy Awards. In addition to her television work, Burnett has appeared in numerous films, including *Annie, Noises Off*, and *Four Seasons*, and two animated features. On Broadway, she originated the role of Princess Winnifred in *Once Upon a Mattress* and starred in *Fade Out Fade In*, *Putting It Together*, and *Moon Over Buffalo*. Burnett has been honored with the Presidential Medal of Freedom, is a Kennedy Center honoree,

and has been inducted into the Television Academy Hall of Fame. She has also written two *New York Times* bestsellers, *This Time Together: Laughter and Reflection* and her autobiography, *One More Time*. Her most recent book is *Carrie and Me: A Mother-Daughter Love Story.*

STEVE CARELL
ACTOR, COMEDIAN, DIRECTOR, PRODUCER, WRITER
b. August 16, 1962, Concord, Massachusetts

Steve Carell was a comedian on the sketch-comedy television show *The Dana Carvey Show* and then a regular correspondent on *The Daily Show with Jon Stewart* from 1999 until 2005. His break-out acting roles were in *Bruce Almighty* and *Anchorman: The Legend of Ron Burgundy*. However, it was his starring role in the film *The 40-Year-Old Virgin*, which he also co-wrote and executive produced, that established him as a huge comedic talent, with Carell being nominated for a Writers Guild Award for Best Original Screenplay. In 2005 Carell began playing Michael Scott on the acclaimed television comedy show *The Office*, winning a Golden Globe for Best Actor in a Television Comedy Series and receiving both Golden Globe and Emmy Award nominations every year until his departure from the show in 2011.

JIM CARREY
ACTOR, COMEDIAN, PRODUCER, WRITER
b. January 17, 1962, Newmarket, Ontario, Canada

Jim Carrey is an award-winning actor who has been honored for both his comedic and dramatic work. He got his start in stand-up as a teenager performing at comedy clubs in Toronto. He quickly caught the attention of comedy legend Rodney Dangerfield who signed him as his opening act for his touring show. He eventually moved to Los Angeles and became a regular at The Comedy Store. Carrey's talents landed him a role on the sketch-comedy television series *In Living Color*. Soon after, he established himself as a major Hollywood actor, with starring roles in the comedy films *Ace Ventura: Pet Detective*, *Dumb and Dumber*, *The Mask*, *Liar Liar*, and *Bruce Almighty*, among others. Moving beyond the comedy genre, he starred in the dramas *The Truman Show*, *Man on the Moon*, and *Eternal Sunshine of the Spotless Mind*. His other film credits include the films *Me, Myself & Irene*, *The Cable Guy*, *How the Grinch Stole Christmas*, and the animated *Horton Hears A Who!* Carrey won a Golden Globe for Best Actor in a Motion Picture—Drama for his role in *The Truman Show*. He won his second Golden Globe, for Best Actor in a Motion Picture—Musical or Comedy, for his portrayal of comedian Andy Kaufman in *Man on the Moon*. Over the course of his career, Carrey has also been recognized numerous times by the MTV Movie Awards, People's Choice Awards, and Nickelodeon Kids' Choice Awards.

CHEVY CHASE
ACTOR, COMEDIAN, WRITER
b. October 8, 1943, New York, New York

Chevy Chase was one of the original cast of the iconic live-comedy television show *Saturday Night Live*, receiving two Emmy Awards in 1976 for both his writing and acting, and becoming known for his opener, "Good evening, I'm Chevy Chase and you're not." He also shared an Emmy Award for Outstanding Writing in a Comedy-Variety or Music Special with his co-writers for *The Paul Simon Special* that aired in 1977. His film credits include *Foul Play*, for which he received two Golden Globe nominations for Best Performance by an Actor in a Motion Picture—Comedy or Musical and New Star of the Year in 1979, four *National Lampoon's Vacation* films, *Caddyshack*, and *Three Amigos!* He received a star on the Hollywood Walk of Fame in 1994. In 2009 Chase began acting on the television comedy series *Community*.

ANDREW DICE CLAY
ACTOR, COMEDIAN
b. September 29, 1957, Brooklyn, New York

Courting a reputation for controversy and political incorrectness, Andrew Dice Clay developed his skills as a stand-up comedian in New York and Los Angeles before making his television-acting debut on an episode of the comedy show *M*A*S*H*. He became a film actor, incorporating the name "Dice" into his stage name after his character in the film *Making the Grade*, and playing the lead role in the 1990 comedy film *The Adventures of Ford Fairlane*. In 2011 he appeared as a version of himself on the comedy-drama television series *Entourage*. Clay has released eight bestselling DVDs and four comedy albums, and, along with being the only comedian to have sold out two nights in a row at Madison Square Garden, is also the only performer to have been banned by MTV.

JOHN CLEESE
ACTOR, COMEDIAN, PRODUCER, WRITER
b. October 27, 1939, Weston-super-Mare, Somerset, England

John Cleese was a founding member of Monty Python, the acclaimed comedy troupe that created the iconic sketch-comedy television series *Monty Python's Flying Circus*, which ran from 1969 to 1974, along with four films. In 1975, Cleese created the sitcom *Fawlty Towers* with Connie Booth. It was named the best British television series of all time by the British Film Institute in 2000, with Cleese previously winning a BAFTA Award for his role as Basil Fawlty in 1980. Cleese won a BAFTA Award and was nominated for a Golden Globe for his leading performance in the comedy film *A Fish Called Wanda* in 1988, also receiving an Oscar nomination for co-writing the screenplay. His other film credits include three *Shrek* films, two *James Bond* films, and two *Harry Potter* films. In 2005 he was voted number two out of three

hundred comedians on a British television program *The Comedians' Comedian*. A species of lemur, an animal Cleese has helped conserve, has been named after him.

BILLY CONNOLLY
ACTOR, COMEDIAN, MUSICIAN, PRESENTER
b. November 24, 1942, Glasgow, Scotland

Billy Connolly was a welder and then a folk singer before becoming a stand-up comedian. He has toured worldwide continuously for the last fifty years, performing to an audience of over 10,000,000. As a film actor, Connolly is best known for his role in *Mrs. Brown*, for which he received BAFTA and Screen Actors Guild Award nominations. His other film credits include *Gulliver's Travels*, *The Last Samurai*, *Quartet*, and *The Hobbit*. He has appeared on a number of travelogue television programs, such as *Billy Connolly's Route 66*. Connolly was made a Commander of the British Empire in 2003 and received BAFTA Scotland's Outstanding Contribution to Television and Film Award in 2012.

JENNIFER COOLIDGE
ACTOR
b. August 28, 1961, Boston, Massachusetts

Jennifer Coolidge was a company member of the sketch-comedy troupe The Groundlings, making her first television appearance on an episode of the award-winning sitcom *Seinfeld* and later playing main roles on the sitcoms *Joey* and *2 Broke Girls*. Her roles in comedy films include Stifler's mother in *American Pie*, Hilary Duff's stepmother in *A Cinderella Story*, and the manicurist Paulette in *Legally Blonde* and its sequel. She has appeared in three of Christopher Guest's mocku-mentaries: *Best in Show*, *A Mighty Wind*, and *For Your Consideration*, and was a voice actress on the animated film *Robots*. She was invited to join the Academy of Motion Picture Arts and Sciences in 2005.

DAVID CROSS
ACTOR, COMEDIAN, WRITER
b. April 4, 1964, Atlanta, Georgia

In 1993 David Cross won an Emmy Award for his work as a co-writer on *The Ben Stiller Show*. He co-created the sketch-comedy show *Mr. Show with Bob and David* with Bob Odenkirk in 1995, and received Emmy Award nominations for both its writing, and music and lyrics. He played Tobias Fünke on the television sitcom *Arrested Development*, and created, wrote, produced, and starred in *The Increasingly Poor Decisions of Todd Margaret*. He has appeared in a number of films including *Eternal Sunshine of the Spotless Mind*, *Year One*, and *Men in Black*. Cross has released three comedy albums, earning a Grammy Award nomination for Best Comedy Album in 2004. In 2009 he released a book, *I Drink For a Reason*, which went on to become a *New York Times* bestseller.

BILLY CRYSTAL
ACTOR, COMEDIAN, DIRECTOR, WRITER
b. March 14, 1948, New York, New York

Multiple Emmy Award–winning comedian, actor, and nine-time host of the Academy Awards, Billy Crystal first became known to television audiences as an actor in the hit 1970s sitcom *Soap*. He received Golden Globe nominations for his roles in the films *When Harry Met Sally* and *City Slickers*. He went on to write, direct, and star in *Mr. Saturday Night* and *Forget Paris*, earning a Golden Globe nomination for *Mr. Saturday Night*. In addition to appearing in many memorable films, Crystal has made his mark on Broadway with the Tony Award–winning *700 Sundays*, his autobiographical one-man play about his childhood on Long Island. Crystal has been recognized with many awards for his work, among them The Kennedy Center's Mark Twain Prize for American Humor. In 2012 Crystal starred alongside Bette Midler in *Parental Guidance* and in 2013 reprised his role as Mike Wazowski in Pixar's *Monsters University*, the prequel to *Monsters, Inc*. Also a successful author, he recently published his latest work, a humorous memoir on aging, entitled *Still Foolin' Em*.

RHYS DARBY
ACTOR, COMEDIAN, WRITER
b. March 21, 1974, Auckland, New Zealand

Rhys Darby is best known for playing the role of Murray Hewitt in the comedy television series *Flight of the Conchords*, which ran for two seasons and was nominated for ten Emmy Awards, including Outstanding Comedy Series. In 2008 he made his film-acting debut in the romantic comedy *Yes Man* starring Jim Carrey, and has since appeared in the films *Pirate Radio*, *Coming and Going*, and *Love Birds*. Darby has released three stand-up comedy DVDs and is the author of the loosely auto-biographical book *This Way to Spaceship*. He recently wrote and starred in his own eight-part mockumentary sitcom, *Short Poppies*, for Television New Zealand.

DAME EDNA EVERAGE
ACTOR, COMEDIAN, SINGER, TELEVISION HOST, WRITER
Birthdate unknown, Wagga Wagga, New South Wales, Australia

Former housewife Mrs. Norm Everage of Moonee Ponds, Melbourne, Australia, Dame Edna Everage is a self-proclaimed "gigastar," unmistakable for her greeting "Hello possums!" She began her stage career in the 1950s in Australia before moving to London and playing herself in the 1972 film *The Adventures of Barry McKenzie* and its sequel, making her debut in London's West End in the stage show *Housewife, Superstar* in 1976, and becoming a dame the same decade. During the 1980s and 1990s she became an internationally recognized television personality, receiving four BAFTA Award nominations for her television specials and her acclaimed talk show *The Dame Edna Experience*, which featured celebrity guests including Cher, Robin Williams, and Sean Connery. In 1991 Everage was awarded a Rose d'Or for her television special *A Night on Mt. Edna*, and in 2000 her Broadway show *Dame Edna: The Royal Tour* won a Special Tony Award. She is the author

of three books, including her autobiography *My Gorgeous Life*, and is the subject of *Handling Edna: The Unauthorised Biography* by her manager of almost six decades, Barry Humphries.

TINA FEY
ACTOR, COMEDIAN, PRODUCER, WRITER
b. May 18, 1970, Upper Darby, Pennsylvania

The youngest-ever winner of the Mark Twain Prize for American Humor, in 2010, Tina Fey was a performer and writer for the television show *Saturday Night Live* for nine years, becoming the show's first female head writer. She went on to write and star in the acclaimed television sitcom *30 Rock* (a show that loosely references Fey's experiences as a writer on *SNL*), which won the Emmy for Outstanding Comedy Series 2007 through 2009. She wrote and starred in the film *Mean Girls,* and her autobiography, *Bossypants*, published in 2011, topped the *New York Times* Best Seller List for five weeks.

ZACH GALIFIANAKIS
ACTOR, COMEDIAN, PIANIST
b. October 1, 1969, Wilkesboro, North Carolina

Zach Galifianakis developed his idiosyncratic stand-up comic style in comedy clubs in New York and then Los Angeles before appearing on his own late-night comedy show *Late World With Zach* in 2002. He has appeared on the televised comedy shows *Zach Galifianakis: Live at the Purple Onion* in 2005 and *The Comedians of Comedy: Live at the Troubadour* in 2007, as well as starred in a number of comedy films including *The Hangover*, for which he won the MTV Award for Best Comedic Performance. In 2008 he created *Between Two Ferns with Zach Galifianakis*, a series of slightly skewed interviews on the comedy website Funny or Die, where he interviews celebrities between two potted ferns.

JANEANE GAROFALO
ACTIVIST, ACTOR, COMEDIAN, WRITER
b. September 28, 1964, Newton, New Jersey

Janeane Garofalo made her television-acting debut on *The Ben Stiller Show* in 1992 before joining *The Larry Sanders Show* and receiving two Emmy Award nominations for an Outstanding Supporting Actress in a Comedy Series in 1996 and 1997. She became internationally famous during the 1990s for her roles in the films *Reality Bites*, *The Truth About Cats and Dogs*, and *The MatchMaker*. She was a co-host on Air America Radio's progressive *Majority Report* from 2004 to 2006, and is known for expressing her anti-war and liberal views. Her numerous television appearances include the sitcoms *Mad About You* and *Seinfeld*, and the dramas *Criminal Minds*, *24*, and *The West Wing*. Her stand-up comedy special *If You Will* was released on DVD in 2010.

RICKY GERVAIS
ACTOR, COMEDIAN, DIRECTOR, PRODUCER, WRITER
b. June 25, 1961, Reading, Berkshire, England

Creator and star of *The Office*, *Extras*, *The Ricky Gervais Show*, and *Derek*, Ricky Gervais has won three Golden Globes, two Primetime Emmys, and seven BAFTA Awards. *The Office* is the most successful British comedy of all time, shown in more than ninety countries with seven remakes. He has written, directed, produced, and starred in *Cemetery Junction* and *The Invention of Lying*, and starred in *Ghost Town*. Gervais has hosted the Golden Globes three times, was named in *Time* magazine's 100 Most Influential People in the World in 2010, and was awarded the "Sir Peter Ustinov Comedy Award" from the Banff World Television Festival in the same year.

"BOBCAT" GOLDTHWAIT
ACTOR, COMEDIAN, DIRECTOR, WRITER
b. May 26, 1962, Syracuse, New York

Robert Francis "Bobcat" Goldthwait gained notoriety as a stand-up comedian in the 1980s, performing numerous television specials including *An Evening with Bobcat Goldthwait—Share the Warmth*, *Bob Goldthwait—Is He Like That All the Time?*, and most recently his Showtime special *You Don't Look the Same Either*. He played the character Zed in three *Police Academy* films and also starred in the 1980s comedy films *One Crazy Summer*, *Burglar*, and *Hot to Trot*. He made guest appearances on a number of late-night talk shows, including *The Tonight Show with Jay Leno*, where he controversially set the guest chair alight in 1994. Goldthwait wrote and directed the dark-comedy films *Shakes the Clown*, which he also stars in, *Sleeping Dogs Lie*, which was nominated for the Grand Jury prize in the Dramatic Features category at the Sundance Film Festival, *World's Greatest Dad*, and his most recent movie *God Bless America*, which earned him *Esquire* magazine's "Director of the Year" title. Since 2004 Goldthwait has directed episodes of the television shows *The Man Show*, *Crank Yankers*, *Chappelle's Show*, *Important Things with Demetri Martin*, and *Jimmy Kimmel Live!*

TOM GREEN
ACTOR, COMEDIAN, RAPPER, TALK SHOW HOST, WRITER
b. July 30, 1971, Pembroke, Ontario, Canada

Tom Green began hosting *The Tom Green Show* on public-access television in 1994. A variety television show in which Green often played practical jokes on his parents, it was picked up by MTV in 1999. After being diagnosed with testicular cancer in 2000, he starred in the *The Tom Green Cancer Special*. Green became a film actor, appearing in films including *Road Trip* and *Charlie's Angels* before writing, directing, and starring in the 2001 comedy film *Freddy Got Fingered*. In 2003 after guest-hosting *The Late Show with David Letterman*, MTV gave him his own late-night talk show *The New Tom Green Show*. Then from 2006 to 2011 Green hosted his own Internet talk show *Tom Green's House Tonight*. He performs regularly as a stand-up comic and in 2012

starred in his own one-hour comedy special for *Showtime*. A rapper, Green has released a solo album and is part of the group The Keepin' It Real Crew.

KATHY GRIFFIN
ACTOR, COMEDIAN
b. November 4, 1960, Oak Park, Illinois

Kathy Griffin was a player in the improvisational comedy theater troupe The Groundlings, going on to appear as a guest actor on television series including *ER* and *Seinfeld* before playing Vicki Groener, the main character's sidekick, on the NBC sitcom *Suddenly Susan*. In 2005 she launched her television series *Kathy Griffin: My Life on the D-List*, which received six Emmy Award nominations for Outstanding Reality Program, winning twice, and for which Griffin has been nominated for the Producers Guild of America Television Producer of the Year Award in Non-fiction four times. Also a stand-up comedian, Griffin has appeared in numerous televised comedy specials, receiving three Emmy Award nominations for Outstanding Variety, Music, or Comedy Special. She has also released five Grammy Award–nominated comedy albums, with her first album, *For Your Consideration*, becoming the first ever comedy album by a woman to debut at number one on *Billboard* magazine's Top Comedy Albums chart. In 2009 she published *Official Book Club Selection: A Memoir According to Kathy Griffin*, which became a *New York Times* bestseller.

NEIL PATRICK HARRIS
ACTOR, DIRECTOR, MAGICIAN, SINGER
b. June 15, 1973, Albuquerque, New Mexico

Neil Patrick Harris became known for his leading role as a teen-prodigy doctor on the television show *Doogie Howser, M.D.*, for which he was nominated for a Golden Globe and won a People's Choice Award in 1990. He has appeared in numerous films including *Starship Troopers* and *The Proposition*, and is an accomplished Broadway actor, performing in the musicals *Rent*, *Assassins*, and *Cabaret*. He has been nominated for an Emmy Award multiple times for his supporting role as Barney Stinson in the sitcom *How I Met Your Mother*, and in 2010 he won an Emmy Award for his guest performance on the television series *Glee*.

TIM HEIDECKER AND ERIC WAREHEIM
ACTORS, COMEDIANS, DIRECTORS, WRITERS
b. February 3, 1976, Allentown, Pennsylvania (Tim);
b. April 7, 1976, Frederick, Maryland (Eric)

Comedy duo Tim Heidecker and Eric Wareheim met while studying film at Temple University in Philadelphia. Their first television show, *Tom Goes to the Mayor*, an animated comedy show which began as a web cartoon, was broadcast on the Cartoon Network's late-night Adult Swim programming segment. Their next program—*Tim and Eric Awesome Show*, *Great Job!*, an absurdist comedy show lasting fifteen minutes per episode, which they wrote, directed, and starred in—ran for five seasons and was followed by a spin-off program, *Check It Out! With Dr. Steve Brule*. In 2012 they released their first feature film, *Tim and Eric's Billion Dollar Movie*.

ED HELMS
ACTOR
b. January 24, 1974, Atlanta, Georgia

Ed Helms developed his skills as a stand-up comedian in New York comedy clubs before he was hired as a correspondent for the acclaimed late-night comedy television program *The Daily Show with Jon Stewart*, where he remained for four years. In 2006 he joined the cast of the award-winning U.S. version of the sitcom *The Office*, in the role of Andy Bernard. Along with numerous acting and voice-acting roles in comedy television programs such as *Arrested Development* and *Family Guy*, he has appeared in over twenty films, playing starring roles in *The Hangover* trilogy, *Jeff, Who Lives At Home*, and as a voice actor in the animated film of the Dr. Seuss story *The Lorax*.

JOHN HODGMAN
ACTOR, AUTHOR
b. June 3, 1971, Brookline, Massachusetts

Dubbed one of the *New York Observer*'s "Power Punks," John Hodgman worked as a literary agent in New York before publishing his first book in 2005, a satirical almanac titled *The Areas of My Expertise*. After promoting the book on *The Daily Show with Jon Stewart*, he made regular appearances as the show's "resident expert." As well as publishing the books *More Information Than You Require* and *That Is All*, he is a regular contributor to the *New York Times Magazine*, *McSweeney's*, and *The Paris Review*. He narrates stories on Public Radio International's *This American Life*, and has played small acting roles in a number of films and television shows, also acting as the personification of a PC computer in Apple's "Get a Mac" advertising campaign.

DAVID KOECHNER
ACTOR, COMEDIAN, MUSICIAN, WRITER
b. August 24, 1962, Tipton, Missouri

David Koechner was a regular performer on the late-night comedy shows *Saturday Night Live* and *Late Night with Conan O'Brien*. With actor Dave "Gruber" Allen he created the musical-comedy act *The Naked Trucker and T-Bones Show*, which they regularly perform in LA nightclubs and was later made into an eight-episode television show and released as a comedy album in 2007. Koechner's extensive television acting roles include a recurring role as Todd Packer on the acclaimed comedy show *The Office*. Also a film actor, in 2005 he was nominated for a shared MTV Movie Award for Best On-Screen Team for his acting in *Anchorman: The Legend of Ron Burgundy*.

MARTIN LAWRENCE
ACTOR, COMEDIAN, DIRECTOR, PRODUCER, WRITER
b. April 16, 1965, Frankfurt, Hesse, Germany

Born to American parents in Germany, Martin Lawrence grew up in Maryland. After appearing on the talent-spotting show *Star Search*, he was cast in the television sitcom *What's Happening Now!!*, which ran until 1988. His debut film role was in *Do the Right Thing* directed by Spike Lee. In 1992 he became the host of the comedy show *Def Comedy Jam*, also appearing as the main character on the sitcom *Martin*, which ran until 1997 and for which he won a NAACP Image Award for Outstanding Lead Actor in a Comedy Series in 1995 and 1996. Lawrence has starred in a number of commercially successful films, including *Bad Boys*, *Nothing to Lose,* and the *Big Momma's House* trilogy of films, that have grossed more than $100 million in ticket sales.

CLORIS LEACHMAN
ACTOR
b. April 30, 1926, Des Moines, Iowa

Cloris Leachman has won nine Emmy Awards for performance— more than any other actor or actress. She trained at the Actors Studio in New York, and began acting in films in 1947, winning an Oscar for Best Supporting Actress for her 1971 performance in *The Last Picture Show*. In the 1970s she played the character Phyllis Lindstrom on *The Mary Tyler Moore Show*, winning a Golden Globe for her performance in the spin-off series, *Phyllis*. She won two Emmy Awards for Outstanding Guest Actress in a Comedy Series for her role in the television sitcom *Malcolm in the Middle* and an Emmy nomination for Outstanding Supporting Actress in a Miniseries or TV Movie for her performance in *Mrs. Harris*. She was inducted into the Television Academy Hall of Fame in 2011.

DENIS LEARY
ACTOR, COMEDIAN, DIRECTOR, PRODUCER, WRITER
b. August 18, 1957, Worcester, Massachusetts

Denis Leary is the son of Irish immigrant parents John and Nora Leary—who firmly believed he was up to no good for most of his first twenty-five years on this planet. Once he turned things around and started to get nominated for Emmys and Golden Globes and writing bestselling books and starring in movies, they changed their minds. A little. Denis is also the founder of The Leary Firefighters Foundation, which provides much needed equipment and training facilities and funding to fire departments all over America. He plans on using that fact to get into heaven.

JAY LENO
ACTOR, COMEDIAN, TELEVISION HOST, WRITER
b. April 28, 1950, New Rochelle, New York

Prior to becoming one of America's best-known talk show hosts, Jay Leno was a writer for the television sitcom *Good Times* during the 1970s, and also acted in films such as *American Hot Wax*. As a touring comedian he performed around 300 gigs per year, often opening for singers like Tom Jones. In 1977 he made his first appearance on *The Tonight Show Starring Johnny Carson*, became a permanent guest host in the 1980s, and eventually took over as host in 1992. *The Tonight Show with Jay Leno* won an Emmy Award for Outstanding Variety, Music, or Comedy Series in 1995 and has been nominated a further nine times, with Leno twice being nominated for his individual performance. He won the People's Choice Award for Favorite Late Night Talk Show Host in 2006. His web series, *Jay Leno's Garage*, won an Emmy Award in 2011.

EUGENE LEVY
ACTOR, WRITER
b. December 17, 1946, Hamilton, Ontario, Canada

Eugene Levy was a member of Second City in Toronto, the improvisational comedy theater troupe that in 1976 launched the television sketch-comedy show *Second City Television*, for which he and his co-writers won two Emmys for Outstanding Writing in a Variety or Music Program. With Christopher Guest he has written and also starred in the mockumentaries *Waiting for Guffman*, *Best in Show*, and *A Mighty Wind*, winning both a Satellite Award and a New York Film Critics' Circle Award for his role as supporting actor in the latter. He has appeared in all eight of the *American Pie* films. In 2011 he was made a member of the Order of Canada for his contributions as a comic actor and writer, and for his dedication to charitable causes.

GEORGE LOPEZ
ACTOR, COMEDIAN, TELEVISION HOST, WRITER
b. April 23, 1961, Mission Hills, California

After working the comedy circuit in Los Angeles for two decades and being hired for small film and television roles, George Lopez became famous playing the highly rated lead role on the sitcom *George Lopez*, which ran from 2002 to 2007 and which he also produced and wrote. From 2009 to 2011 he hosted the late-night talk show *Lopez Tonight*. He has recorded three comedy albums, earning Grammy Award nominations for *El Mas Chingon* and *Team Leader*. *Time* magazine named him one of the "Twenty-Five Most Influential Hispanics in America" in 2005. Known for his charity work, he was named an honorary mayor of Los Angeles for his fundraising work for earthquake victims in El Salvador and Guatemala and was the recipient of Harvard University's 2004 Artist of the Year and Humanitarian Award.

JON LOVITZ
ACTOR, COMEDIAN, SINGER
b. July 21, 1957, Los Angeles, California

A performer with the comedy troupe The Groundlings in the 1980s, Jon Lovitz became a cast member on the comedy showcase *Saturday Night Live* in 1985, and was nominated for two Emmy Awards for his individual performances during his five years with the program. A character actor, Lovitz's film and television credits are extensive and include voice-acting

on animated television series such as *The Simpsons* and *The Critic*, on which he voiced the main character Jay Sherman. Also a singer who has performed at Carnegie Hall, Lovitz sang the duet "Well, Did You Evah!" with British rock star Robbie Williams at the Royal Albert Hall, and has sung the American national anthem at the U.S. Open and at Dodger Stadium.

MATT LUCAS
ACTOR, COMEDIAN, SINGER, WRITER
b. March 5, 1974, London, England

Matt Lucas gained notoriety in the 1990s for playing giant baby George Dawes on the surreal panel show *Shooting Stars*, created by comedians Vic Reeves and Bob Mortimer. However, Lucas is best known as a performer on the character-based comedy television series *Little Britain*, which he created with his long-time collaborator David Walliams. Originally a radio show on BBC Radio 4, the television series first aired in 2003, winning three BAFTA Awards and multiple British Comedy Awards, including Best Stage Comedy for the stage adaptation which played to sold-out theaters. The duo went on to create the BAFTA Award–nominated comedy television series *Come Fly with Me*. Lucas's other television-acting roles include a television adaptation of *The Wind in the Willows* and Australian sitcom *Kath and Kim*. He has also appeared in a number of musicals, playing the thief Thénardier in the stage musical *Les Misérables*. Lucas's film credits include Tim Burton's *Alice in Wonderland*, in which he played Tweedledee and Tweedledum, and the commercially successful comedy film *Bridesmaids*.

JOANNA LUMLEY
ACTRESS, HUMAN RIGHTS ACTIVIST, MODEL, PRODUCER, TELEVISION PRESENTER, WRITER
b. May 1, 1946, Srinagar, Kashmir, India

Joanna Lumley was educated in the U.K. before becoming a photographic model and then a house model for fashion designer Jean Muir. Her first major television role was in 1976, as Purdey on the television series *The New Avengers* for which she received a Special BAFTA Award in 2000. She went on to act in a number of television programs, including *Sapphire & Steel*, before appearing in one of her best-known roles, for which she won two BAFTA Awards, as Patsy in the comedy series *Absolutely Fabulous*. She also appeared on the television series *Sensitive Skin* and the films *James and the Giant Peach*, *Ella Enchanted*, and *Corpse Bride*. As well as presenting a number of television travelogues, she has written five books. In 2011 she was nominated for a Tony Award for her acting in the play *La Bête*. A human rights campaigner, she is considered a national treasure of Nepal for her support of the Gurkha Justice Campaign. She was made an Officer of the British Empire in 1995 and received a Special Recognition Award at the National Television Awards in 2013.

JANE LYNCH
ACTOR, COMEDIAN, SINGER
b. July 14, 1960, Dolton, Illinois

Jane Lynch has become best known for her role as Sue Sylvester, the coach of the cheerleading squad on the television series *Glee*, for which she has won both an Emmy and a Golden Globe as supporting actor. Prior to that, she was already well known for her roles in Christopher Guest's mockumentaries, including *Best in Show*, *A Mighty Wind*, and *For Your Consideration*, and her other film roles including those in *Talladega Nights: The Ballad of Ricky Bobby* and *The 40-Year-Old Virgin*. Lynch was a recurring character on the sitcom *Two and a Half Men*, earning an Emmy Award nomination for her role as a guest actor, and wrote and starred in the award-winning play *Oh, Sister, My Sister!*

MARC MARON
COMEDIAN, RADIO AND PODCAST HOST
b. September 27, 1963, Jersey City, New Jersey

Pursuing his childhood dream of becoming a stand-up comic, Marc Maron has performed at comedy venues in Los Angeles, New York, and across the United States. He has appeared on HBO, *The Late Show with David Letterman*, *Real Time*, *The Late Late Show with Craig Ferguson* and *John Oliver's New York Stand-Up Show*, and has made more appearances on the talk show *Late Night with Conan O'Brien* than any other comedian. He was a presenter on the Air America radio shows *Morning Sedition* and *The Marc Maron Show*. In 2009 he created *WTF with Marc Maron*, a podcast recorded in Maron's garage in which he interviews comedians and celebrities and which won the award for Best Comedy Podcast at the Comedy Central Comedy Awards in 2012. Maron also created and starred in the IFC series, *Maron*. He is the author of the books *The Jerusalem Syndrome* and *Attempting Normal*.

STEVE MARTIN
ACTOR, AUTHOR, COMEDIAN, MUSICIAN
b. August 14, 1945, Waco, Texas

Steve Martin was twenty-three years old when he won an Emmy Award for his work as a co-writer on the television show *The Smothers Brothers Comedy Hour*, and rose to prominence as a stand-up comedian, regularly appearing on *The Tonight Show Starring Johnny Carson*. His comedy albums *Let's Get Small* and *A Wild and Crazy Guy*, released in the late 1970s, both went platinum and won Grammy Awards. Following his first major film role in *The Jerk* in 1979, which he also co-wrote, he has appeared in over fifty films, including *Father of the Bride*, *Parenthood*, and *Roxanne*, writing the screenplays for a number of them. He was awarded the Mark Twain Prize for American Humor in 2005 and was a recipient of the 2007 Kennedy Center Honors. Martin is also a Grammy Award–winning musician who has released three critically acclaimed bluegrass albums.

JACKIE MASON
ACTOR, COMEDIAN, RADIO HOST, WRITER
b. June 9, 1934, Sheboygan, Wisconsin

Jackie Mason was a rabbi before becoming a comedian and appearing regularly on the variety television program *The Ed Sullivan Show* in the 1960s. His comedy show *The World According to Me*, which went on Broadway in 1986, won a Special Tony Award, and his comedy special *Jackie Mason on Broadway* won an Emmy Award for outstanding writing. He went on to create another eight comedy shows and has performed in several Royal Command Performances. Mason has been a voice actor on the animated television series *The Simpsons*, winning an Emmy Award for his performance in 1992, and has written and starred in the films *One Angry Man* and *Jackie Goldberg: Private Dick*. With attorney Raoul Felder he has hosted the current-events television show *Crossing the Line*, the BBC radio show *The Mason-Felder Report*, and also written three books.

ADAM MCKAY
ACTOR, DIRECTOR, PRODUCER, WRITER
b. April 17, 1968, Philadelphia, Pennsylvania

Adam McKay started his career in Chicago as an improviser at Second City and as a founding member of Upright Citizens Brigade. From there he was hired as a writer, then head writer for the Emmy Award–winning live-television comedy show *Saturday Night Live*, occasionally appearing on the show as a heckling audience member. In 2004 he directed his first feature film, *Anchorman: The Legend of Ron Burgundy*, which he co-wrote with comedian and former *SNL* cast member Will Ferrell. Over the years the duo has made a number of comedy films, including *Talladega Nights: The Ballad of Ricky Bobby*, *The Other Guys*, and *Step Brothers*. They also produce the comedy television series *Eastbound & Down*. In 2009 McKay directed the Broadway comedy play *You're Welcome America: A Final Night with George W. Bush* which was nominated for three Tony Awards. Adam is also a frequent contributor to the *Huffington Post* and founder of ProtestTunes.com, a clearinghouse for activist music.

STEPHEN MERCHANT
ACTOR, COMEDIAN, DIRECTOR, RADIO HOST, WRITER
b. November 24, 1974, Bristol, England

Stephen Merchant met Ricky Gervais, his future collaborator on the comedy television shows *The Office* and *Extras*, when he was hired as Gervais's assistant at London-based radio station Xfm in 1997. The concept for the comedy-drama *The Office* stemmed from a short film Merchant made with Gervais while on a production course at the BBC. *The Office* went on air in 2001 and won a plethora of awards, including an Emmy, a Golden Globe, three BAFTA Awards, and two British Comedy Awards, with Merchant and Gervais sharing the British Comedy Award for Writer of the Year in 2004. For his performance in the duo's next sitcom, *Extras*, Merchant was honored with a British Comedy Award for Best TV Comedy Actor in 2006, with the show itself winning

a Golden Globe in 2008. Merchant was one of the presenters of the *The Ricky Gervais Show*, which became the most downloaded podcast in the world.

BETTE MIDLER
ACTOR, COMEDIAN, PRODUCER, SINGER-SONGWRITER, WRITER
b. December 1, 1945, Honolulu, Hawaii

Bette Midler performed on Broadway and at the Continental Baths in New York before winning a Grammy Award for her first album *The Divine Miss M* in 1973, followed by a Special Tony Award in 1974. She made her film-acting debut in the 1979 film *The Rose*, winning a Golden Globe and being nominated for an Oscar for her leading role. She starred in a string of films during the 1980s and 1990s, winning two Golden Globes for her performances in *For the Boys*, for which she also received an Oscar nomination, and *Gypsy*. She played herself in the popular television sitcom *Bette* and received an Emmy Award nomination for her 2011 stage show *Bette Midler: The Showgirl Must Go On*. She has released thirteen studio albums, selling over 30 million worldwide. In 2012 she was awarded the Sammy Cahn Lifetime Achievement Award by the Songwriters Hall of Fame.

TIM MINCHIN
ACTOR, COMEDIAN, COMPOSER, MUSICIAN, SONGWRITER, WRITER
b. October 7, 1975, Northampton, England

Born to Australian parents, Tim Minchin won the Directors' Choice Award at the Melbourne International Comedy Festival in 2005 for his musical-comedy show *Darkside*, then the Perrier Award for Best Newcomer at the Edinburgh Festival Fringe. He has performed his live shows, in which he combines original song, piano performance, and stand-up comedy, to sell-out audiences internationally, winning Best Alternative Comedian at the U.S. Comedy Arts Festival in 2007. He has performed with the Heritage Orchestra at the Royal Albert Hall in London and with the Sydney Symphony Orchestra at the Sydney Opera House. With the Royal Shakespeare Company he wrote the music and lyrics for *Matilda The Musical*, an adaptation of the Roald Dahl book, which began playing in London's West End in 2011 and won numerous awards including an unprecedented seven Olivier awards. Minchin has played Judas in the Andrew Lloyd Webber musical *Jesus Christ Superstar* and has also played a recurring role on the comedy television series *Californication*.

EUGENE MIRMAN
ACTOR, COMEDIAN, WRITER
b. July 24, 1974, Moscow, Russia

Eugene Mirman graduated from Hampshire College in Western Massachusetts with a Bachelor of Arts in Comedy. His first comedy album *The Absurd Nightclub Comedy of Eugene Mirman* was voted one of the best albums of 2004 by *The A.V. Club* and *Time Out New York*, leading to his own televised comedy

special. As well as performing stand-up routines in comedy clubs, he has frequently appeared at rock clubs, opening for bands such as Modest Mouse. He played the role of Eugene on the comedy series *Flight of the Conchords*, the Russian comedian/hitman Yvgeny Mirminsky on the comedy television series *Delocated*, and voices Gene in the animated sitcom *Bob's Burgers*. In 2009 the newsweekly *Village Voice* named him "Best Stand-Up Comedian."

TRACY MORGAN
ACTOR, COMEDIAN
b. November 10, 1968, The Bronx, New York

Tracy Morgan performed comedy on the streets of New York before making his television debut on the sitcom *Martin* and appearing in films such as Chris Rock's *Head of State*. In 1996 he joined the cast of the award-winning comedy show *Saturday Night Live*, performing on the show for eight seasons. After appearing in the eponymously named *Tracy Morgan Show*, which ran for one season, he took on the role of Tracy Jordon in the television comedy series *30 Rock*, receiving two NAACP Image Award nominations and an Emmy Award nomination for his role as a supporting actor in a comedy series. His autobiography *I Am the New Black* was published in 2009.

EDDIE MURPHY
ACTOR, COMEDIAN, DIRECTOR, MUSICIAN, SINGER, WRITER
b. April 3, 1961, Brooklyn, New York

One of the most commercially successful film actors of the 1980s, Eddie Murphy was a cast member on the acclaimed television show *Saturday Night Live* from 1980 to 1984. In 1982 he released *Eddie Murphy*, the first of five comedy albums, and also appeared in his first feature film, *48 Hrs.*, receiving his first Golden Globe nomination for New Star of the Year. He went on to play the lead roles in the films *Trading Places*, *Beverly Hills Cop*, and *The Nutty Professor*, receiving Golden Globe nominations for Best Actor for all three. In 2007 he played James "Thunder" Early in the film version of the Broadway musical *Dreamgirls*, winning a Golden Globe, a Screen Actors Guild Award, and a Broadcast Film Critics Association Award, as well as receiving an Oscar nomination for his role as supporting actor. His other film credits include the high-grossing animated *Shrek* trilogy in which he voices the role of Donkey, and for which he received a BAFTA Award nomination for his role as a supporting actor. He was invited to join the Academy of Motion Picture Arts and Sciences in 2007 and has been ranked number ten on Comedy Central's 100 Greatest Stand-Ups of All Time.

MIKE MYERS
ACTOR, COMEDIAN, PRODUCER, SINGER, WRITER
b. May 25, 1963, Scarborough, Ontario, Canada

Mike Myers was a writer for the show *Saturday Night Live*, receiving an Emmy Award nomination for his acting and winning one for his role as a co-writer. He then brought his SNL character Wayne Campbell to the big screen in the film *Wayne's World*, which he wrote and starred in. Following *Wayne's World 2*, Myers wrote, produced, and starred in the film *Austin Powers: International Man of Mystery*, the first of a trilogy, with the character Austin Powers developing a cult following. The trilogy became the highest grossing comedy franchise ever, with Myers winning numerous awards, including American Comedy Award for Funniest Actor in a Motion Picture for *Austin Powers: The Spy Who Shagged Me*. Myers's next major role was as the voice of the ogre Shrek in the Oscar Award–winning animated film trilogy of the same name. Myers has stars on both Hollywood and Canada's Walks of Fame and received the Lucille Ball Legacy of Laughter Award in 2008.

BOB NEWHART
ACTOR, COMEDIAN
b. September 5, 1929, Oak Park, Illinois

Originally an accountant, Bob Newhart won multiple Grammy Awards for his first comedy album, *The Button-Down Mind of Bob Newhart*, which became the first comedy album to reach number one on *Billboard* magazine's charts, establishing him as one of the top twenty–bestselling comedy artists of all time. He also received a Grammy Award for Best New Artist of 1960, then won a second Grammy Award for his next album *The Button-Down Mind Strikes Back!* The following year he received Emmy and Peabody Awards for his televised variety show. He developed a successful television career, receiving Golden Globe and Emmy Award nominations for his lead roles on the television sitcom *The Bob Newhart Show* in the 1970s, followed by *Newhart* in the 1980s, and later for his role as a guest actor on the drama television series *ER*. In 1993 Newhart was inducted into the Academy of Television Arts and Sciences Hall of Fame, and in 2002 he won the Mark Twain Prize for American Humor. He has also written a *New York Times* bestseller *I Shouldn't Even Be Doing This*.

B. J. NOVAK
ACTOR, COMEDIAN, DIRECTOR, WRITER
b. July 31, 1979, Newton, Massachusetts

A Harvard graduate, Benjamin Joseph (B. J.) Novak moved to Los Angeles in 2001 and began performing stand-up in clubs. Before long he was making appearances on television shows, including the Comedy Central showcase *Premium Blend* and *Late Night with Conan O'Brien*. *Variety* magazine named him one of the "Ten Comedians to Watch" in 2003, and the same year he became one of the pranksters on Ashton Kutcher's hidden-camera MTV series *Punk'd*. In 2004 he joined the television series *The Office* in dual capacities as an actor and writer, playing Ryan Howard and eventually becoming an executive producer of the show. He has since appeared in films including *Knocked Up*, *Reign Over Me*, *Inglourious Basterds*, *The Internship*, and the forthcoming *Saving Mr. Banks*. He continues to perform stand-up.

CONAN O'BRIEN
COMEDIAN, PRODUCER, TELEVISION HOST, WRITER
b. April 18, 1963, Brookline, Massachusetts

Conan O'Brien was hired as a writer on the live-comedy television show *Saturday Night Live* in 1988, sharing an Emmy Award with his other co-writers in 1989 for Outstanding Writing in a Comedy or Variety Series. He was a writer on the animated sitcom *The Simpsons* for two years before replacing David Letterman on the talk show *Late Night* in 1993. During *Late Night With Conan O'Brien*'s sixteen-year run, O'Brien and his co-writers were nominated for the Emmy Award for Outstanding Writing for a Variety, Music, or Comedy Program for thirteen consecutive years, winning the award in 2007. The show also won five Writers Guild Awards for Best Writing in a Comedy/Variety Series. In 2010, O'Brien became the host of the late-night talk show *Conan* on TBS.

CATHERINE O'HARA
ACTOR, COMEDIAN, WRITER
b. March 4, 1954, Toronto, Ontario, Canada

Catherine O'Hara was a performer and writer on the award-winning comedy television series *Second City Television* in the 1970s. She has acted in numerous films, including *After Hours*, *Orange County*, and *Home Alone*, one of the highest grossing comedy films of all time. In 2001 she received an American Comedy Award for Funniest Supporting Actress in a Motion Picture for her role in Christopher Guest's mockumentary film *Best in Show*. O'Hara has done voice work for a number of animated films including *The Nightmare Before Christmas* and *Where the Wild Things Are*. In 2000 she won a Genie Award for Best Performance by an Actress in a Supporting Role for *The Life Before This*, and in 2010 she was nominated for an Emmy Award for Outstanding Supporting Actress for her role in *Temple Grandin*.

BOB ODENKIRK
ACTOR, COMEDIAN, DIRECTOR, PRODUCER, WRITER
b. October 22, 1962, Berwyn, Illinois

Bob Odenkirk was a writer on the Emmy Award–winning comedy show *Saturday Night Live* and then *The Ben Stiller Show*, winning an Emmy Award for his co-writing on the program in 1993. With his *Ben Stiller Show* co-writer, David Cross, he formed a comedy duo, creating the television comedy series *Mr. Show with Bob and David* in 1995, which received three Emmy Award nominations during its four-season run for both its writing, and its music and lyrics. Also an actor, Odenkirk has appeared on the television programs *The Larry Sanders Show* and *Breaking Bad*. He has directed the films *Melvin Goes to Dinner*, *Let's Go to Prison*, and *The Brothers Solomon*.

NICK OFFERMAN
ACTOR, CARPENTER, WRITER
b. June 26, 1970, Minooka, Illinois

Nick Offerman is best known for his role as the popular character Ron Swanson in the sitcom *Parks and Recreation*, which went on air in 2009. His film acting credits include *Somebody Up There Likes Me*, *The Men Who Stare at Goats*, *21 Jump Street*, and *Casa de Mi Padre*. For his role in *Parks and Recreation* he won a Television Critics' Association Award for Individual Achievement in a Comedy in 2011, and he has also been nominated for the Critics' Choice Television Award for his role as a supporting actor in a comedy series. When not acting, he can be found in his woodworking shop building canoes, tables, and other items by hand.

JOHN OLIVER
ACTOR, COMEDIAN, TELEVISION AND RADIO HOST, WRITER
b. April 23, 1977, Birmingham, England

John Oliver performed comedy with the Cambridge Footlights Dramatic Club at Cambridge University before becoming a successful stand-up comedian in the U.K., with three radio series, a string of television appearances and sold-out Edinburgh Festival solo shows to his name. In 2006 he joined *The Daily Show with Jon Stewart* as a correspondent, winning Emmy and Writers Guild of America Awards for his role as a co-writer on the show. In 2007 he won the Breakout Award at the Aspen Comedy Festival. He has hosted the satirical comedy podcast *The Bugle: Audio Newspaper for a Visual World* with British comedian Andy Zaltzman since 2007, and hosts the stand-up comedy television series *John Oliver's New York Stand-up Show*.

PATTON OSWALT
ACTOR, COMEDIAN, WRITER
b. January 27, 1969, Portsmouth, Virginia

Patton Oswalt has acted in over sixty films and television programs and has played the role of Spencer Olchin on the sitcom *King of Queens*. Also a comedian, he has released four comedy albums, one receiving a Grammy Award nomination for Best Comedy Album. In 2004 he organized the Comedians of Comedy stand-up tour, which became the subject of a documentary film of the same name and a television series. His significant film credits include the animated film *Ratatouille*, *Big Fan*, for which he received a Gotham Independent Film Award nomination for Breakthrough Actor, and *Young Adult*, for which he received a Critics' Choice Movie Award nomination for Best Supporting Actor. Oswalt's book *Zombie Spaceship Wasteland* was a *New York Times* bestseller.

MICHAEL PALIN
ACTOR, COMEDIAN, TELEVISION PRESENTER, WRITER
b. May 5, 1943, Sheffield, South Yorkshire, England

Michael Palin attended Oxford University, where he met his future writing partner Terry Jones. Together the pair wrote sketch comedy for various television shows including the

satirical series *The Frost Report* and the children's program *Do Not Adjust Your Set*, which they also acted in. He was a co-founder of Monty Python, whose television program *Monty Python's Flying Circus* and four films established them as one of the world's most famous comedy groups. Palin won a BAFTA Award for Best Light Entertainment Series for his next show *Ripping Yarns*, and then went on to develop a career as a television presenter on travel documentaries, beginning with the BBC series *Great Railway Journeys of the World*, and wrote eight accompanying books. Continuing to act in films and television, Palin won a BAFTA Award in 1989 for his supporting actor role in *A Fish Called Wanda*. Palin was made a Commander of the British Empire for his services to television in 2000 and received a Special Award for Television Craft from BAFTA in 2005. He is a former president of the Royal Geographical Society.

CARL REINER
ACTOR, COMEDIAN, DIRECTOR, PRODUCER, WRITER
b. March 20, 1922, The Bronx, New York

After performing as a comedian in Maurice Evans's Special Entertainment Unit during the Second World War, Carl Reiner acted in Broadway musicals. In the 1950s he appeared on the television variety show *Your Show of Shows* and then *Caesar's Hour*, winning two Emmy Awards for Best Supporting Actor for the latter. With Mel Brooks he recorded five comedy albums, including the *The 2000-Year-Old Man in the Year 2000*, which won a Grammy Award for Best Spoken Comedy Album in 1998. In 1961 he created the television sitcom *The Dick Van Dyke Show*, which ran for five seasons and for which he won five Emmy Awards for his roles as writer and producer. He directed numerous films including *The Jerk*, *Fatal Instinct*, and *That Old Feeling*. He was inducted into the Television Academy Hall of Fame in 1999 and won the Mark Twain Prize for American Humor in 2000. He is the author of several novels, children's books, and two memoirs, *My Anecdotal Life* and *I Remember Me*.

PAUL REUBENS
ACTOR, COMEDIAN, PRODUCER, WRITER
b. August 27, 1952, Peekskill, New York

Paul Reubens created Pee-wee Herman during the time he was an early member of the Los Angeles improvisation company The Groundlings. In 1981 *The Pee-wee Herman Show* became a hit on stage at the famed Roxy Theatre on Sunset Strip, and in 1985 *Pee-wee's Big Adventure* was released. His legendary Saturday morning children's television program *Pee-wee's Playhouse* followed the next year, winning twenty-two Emmy Awards during its five-year reign on Saturday mornings. Pee-wee Herman was made a United States Marine, has his own star on the Hollywood Walk of Fame, as well as being bestowed with the title "Honorary Muppet." Paul Reubens, outside his famous alter ego, has appeared in numerous films and television programs. He is also a writer, director, and producer who has won multiple Emmys and, among many other accolades, received the *Ernie Kovacs Award*. In 2010 a new version of *The Pee-wee Herman Show* played to sold-out audiences at the Stephen Sondheim Theater

on Broadway. That production became a television special for HBO, winning three Emmy Award nominations. In 2012, set-pieces and puppets from *Pee-wee's Playhouse* were part of the Museum of Modern Art show *Century of the Child* and the Smithsonian Museum plans to display other Pee-wee Herman iconic artefacts in an installation on pop culture.

MICHAEL RICHARDS
ACTOR, COMEDIAN, WRITER
b. July 24, 1949, Culver City, California

Michael Richards starred in high school plays, won honors as a National Forensic League champ, and worked as an ambulance attendant. Trained as a medic in the U.S. Army during the Vietnam War, Michael also wrote and directed plays on drug abuse and race relations for the Army's V-Corp Training Roadshow. After his tour, he attended CalArts as a theater major and studied with Allan Kaprow ("Happenings"). As a performance artist in comedy clubs in the late 1970s and 1980s, Michael went on to star in ABC's *Fridays*, a live, late-night sketch-comedy show. Also a trained theater actor under the tutelage of Stella Adler, Michael starred in regional stage productions, Off-Broadway, and in London's West End. Throughout the 1980s he starred in numerous television shows, comedy specials, and motion pictures. Best known for his role as Cosmo Kramer on the comedy series *Seinfeld*, Michael won three Emmy Awards for Outstanding Supporting Actor in a Comedy Series and three Screen Actors Guild Awards for his iconic performance. He currently co-stars in the TVLand comedy series *Kirstie*.

DON RICKLES
COMEDIAN, ACTOR
b. May 8, 1926, Queens, New York

Don Rickles made a name for himself in the 1950s as a comic who responded to his hecklers. During the 1960s Rickles took on acting roles in films such as *Run Silent, Run Deep*, and in sitcoms including *Get Smart*, *The Addams Family*, and *Gilligan's Island*. He became a regular guest on the talk show *The Tonight Show Starring Johnny Carson*, appearing over 100 times and receiving the nicknames The Merchant of Venom and Mr. Warmth by Carson. His first live comedy album, *Hello Dummy!*, achieved a ranking of fifty-four on *Billboard* magazine's Hot 100 list. At singer Frank Sinatra's invitation, he performed at President Reagan's second inaugural ball. His film credits include *Kelly's Heroes*, *Casino*, and the *Toy Story* films, in which he played Mr. Potato Head. He is the subject of the 2007 documentary film *Mr. Warmth: The Don Rickles Project*, that won an Emmy Award for Outstanding Variety, Musical, or Comedy Special and for which Rickles was awarded an Emmy for Outstanding Individual Performance. He received the Johnny Carson Award for Comedic Excellence at the 2012 Comedy Awards.

JOAN RIVERS
ACTRESS, COMEDIENNE, DIRECTOR, TELEVISION HOST, WRITER
b. June 8, 1933, Brooklyn, New York

Joan Rivers is an internationally renowned comedienne, actress, and Emmy Award–winning talk show host who broke the glass ceiling of late-night television when she became the first woman with her own talk show: *The Late Show Starring Joan Rivers*. She has also appeared on stage in Neil Simon's *Broadway Bound*, and in 1994 co-wrote and starred in *Sally Marr . . . and Her Escorts* for which she received a Tony Award nomination for her performance. Joan, along with her daughter Melissa Rivers, created *Live from the Red Carpet* on E!, and hosted the show from 1996 to 2004. Joan currently hosts E!'s popular franchise, *Fashion Police*. Alongside Melissa, Joan co-stars in the WEtv reality series, *Joan and Melissa: Joan Knows Best?* Joan is the author of eleven books, three of which are *New York Times* bestsellers, including *I Hate Everyone . . . Starting with Me*, and was the subject of the critically acclaimed documentary film, *Joan Rivers: A Piece of Work*. Her most recent project is her Internet talk show, *In Bed with Joan.*

JAY ROACH
DIRECTOR, PRODUCER, SCREENWRITER
b. June 14, 1957, Albuquerque, New Mexico

Jay Roach's directorial breakthrough was on the commercially successful *Austin Powers* trilogy. His next major directorial role was on the 2000 film *Meet the Parents*, which won the People's Choice Award for Favorite Comedy Motion Picture, and *Meet the Fockers*, which broke all-time domestic and worldwide box office records for live action comedy in 2004. In 2008 he directed and executive produced the HBO film *Recount* about the 2000 U.S. presidential election and subsequent vote recount in Florida. It won two Emmy Awards for Best TV Movie or Miniseries, Best Directing in a TV Movie or Miniseries, and a Directors Guild of America Award. He repeated his success in 2012, winning the Directors Guild Award, as well as the Emmy Awards in the same categories for the HBO film *Game Change*, about the 2008 Sarah Palin/ John McCain political campaign. The film became one of the most highly viewed films in HBO's history and received twelve Emmy Award nominations, three Golden Globes, and a Peabody Award. Roach has also directed the comedy films *Dinner for Schmucks* and *The Campaign*, and produced *Borat* and *Bruno* starring Sacha Baron Cohen.

MORT SAHL
ACTOR, COMEDIAN, TEACHER, WRITER
b. May 11, 1927, Montreal, Quebec, Canada

Crowned as leading the new breed of modern comedians by *Time* magazine in 1960, Mort Sahl was the first entertainer ever to appear on its cover. Before comedy clubs existed, Sahl began performing at the hungry i music club in San Francisco in the early 1950s. He differed from other comedians, appearing in casual clothing rather than a suit, skewing popular politicians such as Eisenhower, Joe McCarthy, and JFK. Sahl's approach was energetic, tangential, and deep and wide in both social and political scopes, inspiring Woody Allen and George Carlin among others. A 1955 performance with Dave Brubeck was recorded and released (without Sahl's permission), selling as *Mort Sahl at Sunset*, and was recently recognized by the Library of Congress as the first stand-up comedy record album. When Kennedy was assassinated in 1963, Sahl regularly targeted the government's official Warren Commission Report during his routines, resulting in the loss of the entertainment and mass media industry's support, but he maintained audience popularity with college tours and through a bestselling book, *Heartland*. Sahl is one of the longest active performing social satirists, spanning sixty years and eleven presidents.

ANDY SAMBERG
ACTOR, COMEDIAN, WRITER
b. August 18, 1978, Berkeley, California

Andy Samberg is a member of the comedy trio The Lonely Island with Jorma Taccone and Akiva Schaffer whom he met at junior high school. Their comedy videos, which they began creating in 2000, gained an Internet following, eventually leading to the group being hired as writers, and Samberg also as a performer, on acclaimed television show *Saturday Night Live*. During Samberg's time on *SNL* he received six Emmy Award nominations for Outstanding Original Music and Lyrics, winning in 2007 for the song "Dick in a Box," performed on the show by Justin Timberlake. Samberg's other television credits include hosting the 2009 MTV Movie Awards, guest-acting roles on series such as *Parks and Recreation*, and as a cast member in the British sitcom *Cuckoo*. He has also appeared in films such as *That's My Boy*, playing opposite Adam Sandler, *Celeste and Jesse Forever*, and the animated films *Cloudy with a Chance of Meatballs* and *Hotel Transylvania.*

ADAM SANDLER
ACTOR, COMEDIAN, PRODUCER, WRITER
b. September 9, 1966, Brooklyn, New York

After making his television debut on the sitcom *The Cosby Show* in 1987, Adam Sandler pursued his childhood ambition to become a stand-up comedian, and was eventually hired as a writer and then a performer on the sketch-comedy show *Saturday Night Live*. He has released five top-selling comedy albums, two going double-platinum, receiving Grammy Award nominations for three of them. He developed a highly successful career as an actor, appearing in comedy films such as *Happy Gilmore*, *The Waterboy*, and *The Wedding Singer*, with a number of his films achieving box-office sales exceeding $100 million. In 2000 he was nominated for a Golden Globe for his lead role in the 2000 film *Punch-Drunk Love*. His production company Happy Madison has produced numerous films, such as *Deuce Bigalow: Male Gigolo*, as well as the television series *Rules of Engagement*. Sandler was inducted into the Academy of Motion Picture Arts and Sciences in 2010 and was named Favorite Comedic Movie Actor at the 2013 People's Choice Awards.

JENNIFER SAUNDERS
ACTRESS, COMEDIAN, WRITER
b. July 6, 1958, Sleaford, Lincolnshire, England

Jennifer Saunders is best known as half of the comedy duo French & Saunders and for playing Edina Monsoon on the television sitcom *Absolutely Fabulous*. She studied at the Central School of Speech and Drama in London in the 1970s, where she met her future collaborator, Dawn French. They teamed up and began performing at London club The Comic Strip, making their television debut on the series *The Comic Strip Presents . . .* in 1982. In 1987 the BBC sketch show *French & Saunders* went on air and became a huge success, quickly establishing the comedians as household names and running until 2007. In 1992 Saunders created the internationally successful sitcom *Absolutely Fabulous*. It won numerous awards including an International Emmy and four BAFTA Awards. Saunders also wrote and starred in the sitcoms *Jam & Jerusalem* and *The Life and Times of Vivienne Vyle* and wrote the script for the Spice Girls musical *Viva Forever*. In 2009 French and Saunders received the prestigious BAFTA Academy Fellowship Award in recognition of their outstanding body of work.

KRISTEN SCHAAL
ACTOR, COMEDIAN, WRITER
b. January 24, 1978, Longmont, Colorado

Kristen Schaal has won a string of awards for her stand-up comedy performances, including the Andy Kaufman Award at the New York Comedy Festival in 2005, Best Alternative Comic at the U.S. Comedy Arts Festival in 2006, and the 2006 Nightlife Award for Best Female Stand-Up. Her recurring role in the comedy series *Flight of the Conchords*, in which she plays Mel, was her first major acting role, and she has subsequently appeared on numerous television programs including *30 Rock*, *Bob's Burgers*, and as a correspondent on *The Daily Show with Jon Stewart*. She has also appeared in a number of films, including *The Muppets*. She has been a writer on the animated comedy series *South Park*, and with her husband, Rich Blomquist, wrote the book *The Sexy Book of Sexy Sex*.

MARTIN SHORT
ACTOR, COMEDIAN, PRODUCER, SINGER, WRITER
b. March 26, 1950, Hamilton, Ontario, Canada

Martin Short was a writer and performer on the sketch-comedy program *Second City Television*, winning an Emmy Award for his co-writing and also creating the popular character Ed Grimley. He then worked for a year on *Saturday Night Live* before starring alongside Steve Martin and Chevy Chase in the 1986 comedy film *Three Amigos!* and going on to play supporting roles in films such as *Father of the Bride*. Also a Broadway actor, Short won an Outer Critics' Circle Award in 1993 for his performance in *The Goodbye Girl*, and winning both a Tony Award and an Outer Critics' Circle Award for his performance in the lead role in *Little Me* in 1999. He received Emmy Award nominations for his acting roles in the drama series *Damages*, the miniseries *Merlin*, and his own comedy series *Primetime Glick*. Short is an officer of the Order of Canada and was inducted into Canada's Walk of Fame in 2000.

MICHAEL SHOWALTER
ACTOR, COMEDIAN, DIRECTOR, PRODUCER, WRITER
b. June 17, 1970, Princeton, New Jersey

Michael Showalter was a founding member of the sketch-comedy troupe The State, which became an MTV show of the same name and was nominated for a CableACE Award in 1995. He then formed the comedy trio Stella with former State members Michael Ian Black and David Wain, and together they created the television series *Stella* in 2005. Showalter co-wrote and starred in the comedy film *Wet Hot American Summer*, then wrote, directed, and starred in the romantic comedy *The Baxter*. In 2009 he teamed up with Black again to create the comedy television series *Michael & Michael Have Issues*, in which they played fictionalized versions of themselves. Showalter's comedy album *Sandwiches and Cats* was released in November 2007, and he published his comedic memoir *Mr. Funny Pants* in 2011.

SARAH SILVERMAN
ACTOR, COMEDIAN, WRITER
b. December 1, 1970, Manchester, New Hampshire

After attending New York University, Sarah Silverman joined *Saturday Night Live* as a writer and feature performer in 1993 and has not stopped working since. She released the film of her stand-up show *Sarah Silverman: Jesus is Magic* in 2004 to critical acclaim at the Toronto Film Festival. In 2008 she won a Primetime Emmy for Outstanding Original Music and Lyrics for the song "I'm Fucking Matt Damon." Silverman's television sitcom *The Sarah Silverman Program*, in which Silverman plays a fictionalized version of herself, earned her an Emmy Award nomination for Outstanding Lead Actress in a Comedy Series and a Writers Guild Award for best new series. She earned another Emmy nomination for her guest role on the television series *Monk*, and has also recently starred in the films *Wreck-It Ralph* and *Take this Waltz*. Her book *The Bedwetter: Stories of Courage, Redemption, and Pee* was a *New York Times* bestseller and the audio book was nominated for a Grammy Award.

TOMMY SMOTHERS
COMEDIAN, COMPOSER, MUSICIAN
b. February 2, 1937, New York, New York

Tommy Smothers is one half of the musical-comedy duo The Smothers Brothers, with his younger brother Dick. They began their act in San Francisco in 1959 and after a fifty-two-year career retired in 2011. *The Smothers Brothers Comedy Hour* (1967–1969) on CBS became one of the most top-rated and controversial shows of the 1960s. It pushed the boundaries with its political satire on issues such as the Vietnam War, racial tolerance, and censorship, eventually leading to the program's demise. In April 1969 CBS fired the brothers and cancelled the show the year it won an Emmy for Outstanding Writing

in Comedy or Variety. During their career they produced twelve top-selling comedy albums, performed national concert tours, and made many network guest appearances. Tom and his brother share a star on the Hollywood Walk of Fame, and in 2010 were inducted into the Television Academy Hall of Fame.

DAVID STEINBERG
COMEDIAN, DIRECTOR, WRITER
b. August 9, 1942, Winnipeg, Manitoba, Canada

Described by the *New York Times* as a "comic institution himself," David Steinberg appeared on *The Tonight Show Starring Johnny Carson* 140 times and was the youngest person to ever guest-host. During the 1970s he released four comedy albums, two receiving Grammy Award nominations, and starred in two network television shows. He turned to directing, working on many successful television sitcoms including *Friends*, *Designing Women*, and *Newhart*, and received several Directors Guild of America and Emmy Award nominations for his work on the sitcoms *Seinfeld*, *Mad About You*, and *Curb Your Enthusiasm*. He has also directed feature films including *Paternity*, *Going Berserk*, and *The Wrong Guy*. He is the star and executive producer of the comedy documentary series *Inside Comedy*.

JON STEWART
ACTOR, COMEDIAN, PRODUCER, TELEVISION HOST, WRITER
b. November 28, 1962, New York, New York

Jon Stewart began his career as a stand-up comedian, then hosted several television shows before becoming the anchor and executive producer of *The Daily Show with Jon Stewart* in 1999. During his time on the satirical late-night talk show, which screens four nights per week, he has interviewed politicians including presidents Barack Obama and Bill Clinton as well as popular celebrities and bestselling authors. The show has been nominated for forty-four Emmy Awards, has won eighteen, and has twice been awarded the Peabody Award for excellence in broadcasting for its coverage of the American presidential elections. Stewart has published three *New York Times* bestsellers including *America (The Book): A Citizen's Guide to Democracy Inaction* and *Earth (The Book): A Visitor's Guide to the Human Race*, which have both won Grammy Awards as audio books. In 2005 Stewart was named to *Time* magazine's inaugural list of the world's 100 most influential people.

JERRY STILLER
ACTOR, COMEDIAN, WRITER
b. June 8, 1927, Brooklyn, New York

Jerry Stiller is best known for playing the role of Frank Costanza on the award-winning sitcom *Seinfeld*. He and his wife Anne Meara were a comedy double act in the 1960s and 1970s, performing on variety television programs, such as *The Ed Sullivan Show*, as well as radio commercials, the five-minute sketch-comedy show *Take Five with Stiller and Meara*, and the sitcom *The Stiller and Meara Show* in 1986. For his role playing

father of George Costanza in *Seinfeld*, Stiller won the American Comedy Award for Funniest Male Guest Appearance in a television series and also received an Emmy Award nomination for Outstanding Guest Actor in a Comedy Series. Stiller next played the role of Arthur Spooner on the sitcom *King of Queens*, which ran from 1998 to 2007. With his son, actor Ben Stiller, he appeared in the 2001 comedy film *Zoolander*. He shares a star with Meara on the Hollywood Walk of Fame.

ERIC STONESTREET
ACTOR
b. September 9, 1971, Kansas City, Kansas

Eric Stonestreet plays the role of Cameron Tucker in the Emmy Award-winning sitcom *Modern Family*. He studied and performed improvisation and theater at the Second City Training Center and iO in Chicago before moving to Los Angeles and playing numerous roles in television series such as *CSI: Crime Scene Investigation*, *ER*, *Malcolm in the Middle*, and *The West Wing*. His film credits include *Almost Famous*, *Girls will be Girls*, and *The Island*. For his role playing Cameron Tucker on *Modern Family* he has been nominated for three Golden Globe and three Emmy Awards, winning two Emmy Awards for Outstanding Supporting Actor in a Comedy Series.

JEFFREY TAMBOR
ACTOR, DIRECTOR
b. July 8, 1944, San Francisco, California

Best known for his roles on the award-winning sitcoms *The Larry Sanders Show* and *Arrested Development*, Jeffrey Tambor began his acting career in the 1970s and has appeared in scores of films and television programs including the comedy films *City Slickers* and *The Hangover*, and the television series *Three's Company, Law and Order: Special Victims Unit*, and *Bob's Burgers*. In 1992 he began playing Hank Kingsley on *The Larry Sanders Show*, receiving four Emmy Award nominations for Outstanding Supporting Actor in a Comedy Series during the program's six-season run. For his role playing George Bluth, Sr. on *Arrested Development*, he has twice been nominated in the same category, winning a Golden Satellite Award for Best Performance by an Actor in a Supporting Role in a Series, Comedy, or Musical in 2004. In 2011 he received the Del Close Lifetime Achievement Award at the Los Angeles Improv Comedy Festival.

LILY TOMLIN
ACTOR, COMEDIAN, PRODUCER
b. September 1, 1939, Detroit, Michigan

JANE WAGNER
DIRECTOR, PRODUCER, WRITER
b. Morristown, Tennessee

Lily Tomlin rose to prominence in the television program *Rowan and Martin's Laugh-In* in 1969, developing her classic comic characters, six-year-old Edith Ann and telephone operator Ernestine. Jane Wagner also rose to prominence in 1969 for her teleplay, *J.T.*, for which she won a Peabody Award.

Tomlin and Wagner formed a creative alliance in the early 1970s and went on to co-produce eight television specials, winning six Emmy Awards and a Writer's Guild award. In the 1990s, Wagner wrote three animated Edith Ann television specials voiced by Tomlin for which the team won a second Peabody Award. Tomlin won a Grammy Award for her first comedy album, *This is a Recording*, and Wagner wrote and produced three subsequent Grammy-nominated albums starring many of Tomlin's most famous characters. The film *The Incredible Shrinking Woman* was written by Wagner and starred Tomlin. Tomlin has also starred in over twenty movies, including *Nashville*, *Nine to Five*, *All of Me*, *Big Business*, and *A Prairie Home Companion*. Tomlin and Wagner together created two sell-out Broadway shows, *Appearing Nitely* and *The Search for Signs of Intelligent Life in the Universe*, both written by Wagner, for which Tomlin won two Tony Awards and for which Wagner was singled out by the New York Drama Critics' Circle for a Special Award as the author. Tomlin and Wagner have earned four Peabody Awards, and Tomlin was awarded the Mark Twain Prize for American Humor in 2003. Most recently, Wagner wrote and Tomlin narrated HBO's documentary *An Apology to Elephants*.

DICK VAN DYKE
ACTOR, COMEDIAN, DANCER, PRODUCER, SINGER, WRITER
b. December 13, 1925, West Plains, Missouri

Dick Van Dyke established his reputation as a talented actor in the 1960 Broadway musical *Bye Bye Birdie*, winning a Tony Award for his performance. He then played the starring role in the sitcom *The Dick Van Dyke Show*, which ran from 1961 to 1966 and for which he won three Emmy Awards, going on to win a fourth Emmy Award for his next comedy show *Van Dyke and Company* in 1977. He earned Emmy Award nominations for his performances in the television film *The Morning After* and the sitcom *Golden Girls*, before playing Dr. Mark Sloan in *Diagnosis: Murder*, which he also executive produced. Van Dyke's major film roles include the 1964 Disney film *Mary Poppins* for which he earned a Golden Globe nomination for his acting and shared a Grammy Award, with Julie Andrews, for his performance on the soundtrack. His other film credits include *Chitty Chitty Bang Bang*, *Dick Tracy*, and *Night at the Museum*. Among his many accolades, he was honoured with a star on the Hollywood Walk of Fame in 1993 and the Screen Actors Guild Life Achievement Award in 2013.

KRISTEN WIIG
ACTOR, COMEDIAN, PRODUCER, WRITER
b. August 22, 1973, Canandaigua, New York

A former player in The Groundlings theater troupe, Kristen Wiig was a cast member on the sketch-comedy show *Saturday Night Live* from 2005 to 2012, during which time she received four Emmy Award nominations for Outstanding Supporting Actress in a Comedy Series. She turned to film acting, appearing in films including *Knocked Up*, *Forgetting Sarah Marshall*, *Whip It!*, *Adventureland*, and the animated comedy *Despicable Me*. Wiig co-wrote and starred in the 2011 comedy film *Bridesmaids*, earning a Golden Globe nomination for her

acting and both Oscar and BAFTA Award nominations for co-writing the screenplay with Annie Mumolo. A huge commercial success, it grossed over $280 million worldwide and won the Critics' Choice Movie Award for Best Comedy. She has also made guest appearances on the sitcoms *30 Rock* and *Flight of the Conchords*. In 2012 she was named to *Time* magazine's list of the world's 100 most influential people.

FRED WILLARD
ACTOR, COMEDIAN, WRITER
b. September 18, 1939, Shaker Heights, Ohio

Fred Willard's extensive acting career encompasses roles in more than seventy films and seventy television shows. He co-founded the comedy group Ace Trucking Company, which made regular appearances on *This is Tom Jones* in the late 1960s and early 1970s. He has played roles in comedy series including *Get Smart*, *Fernwood 2 Night*, *Everybody Loves Raymond*, for which he received three Emmy Award nominations for his guest acting role, and *Modern Family*, which earned him another guest-actor Emmy Award nomination. Willard has made over 100 appearances on *The Tonight Show with Jay Leno*, often as the character Willard J. Fredericks. After starring alongside Christopher Guest in the 1984 film *This is Spinal Tap*, he reunited with the director in 1996, subsequently appearing in Guest's mockumentary films *Waiting for Guffman*, *Best in Show*, for which he earned an American Comedy Award for his role as a supporting actor, *A Mighty Wind*, and *For Your Consideration*. His other film credits include *Anchorman: The Legend of Ron Burgundy*, *WALL-E*, and *Austin Powers: The Spy Who Shagged Me*.

ROBIN WILLIAMS
ACTOR, COMEDIAN, VOICE ACTOR
b. July 21, 1951, Chicago, Illinois

Robin Williams's appearance as an alien called Mork on an episode of the sitcom *Happy Days* was so successful that it resulted in the creation of the television show *Mork and Mindy* in 1978, propelling Williams into stardom and winning him his first Golden Globe in 1979. Williams developed a successful career as both a stand-up comedian, winning four Grammy Awards for his comedy albums, and a feature-film actor, garnering numerous award nominations for his roles in films including *Good Morning Vietnam*, *Dead Poet's Society*, and *Good Will Hunting*, for which he won an Oscar for Best Supporting Actor. He has appeared as a voice actor on a number of animated children's films including as the genie in Disney's *Aladdin*, where he improvised many of his lines.

RAINN WILSON
ACTOR, COMEDIAN, DIRECTOR, WRITER
b. January 20, 1966, Seattle, Washington

Rainn Wilson studied acting at New York University. His first recurring television role was in the drama series *Six Feet Under*, in which he played mortician intern Arthur Martin.

In 2005 he began playing eccentric salesman Dwight Schrute on the acclaimed NBC sitcom *The Office* and was nominated for the Emmy Award for Outstanding Supporting Actor in a Comedy Series three years in a row. Wilson has also directed several episodes for the series. His film credits include *Almost Famous*, *Baadasssss!*, *My Super Ex-Girlfriend*, and the animated film *Monsters vs. Aliens*. In 2008 Wilson co-created the philosophical website SoulPancake, publishing an accompanying book, *SoulPancake: Chew on Life's Big Questions*, which became a *New York Times* bestseller, and which was also developed into *Oprah and Rainn Wilson Present SoulPancake*, a weekly feature on the Oprah Winfrey Network's *Super Soul Sunday* series.

JONATHAN WINTERS
ACTOR, ARTIST, COMEDIAN, WRITER
b. November 11, 1925, Dayton, Ohio
d. April 11, 2013

Ranked the eighteenth best stand-up comedian of all time by television channel Comedy Central in 2004, Jonathan Winters became famous for his improvised comedic characters, such as elderly Maude Frickert, on television shows including *The Jack Paar Show* and *The Tonight Show* during the 1950s and 1960s. He was nominated for a Golden Globe for his acting in the 1963 comedy film *It's a Mad, Mad, Mad, Mad World*, and went on to appear in numerous television programs including sitcoms *Mork & Mindy* and *Davis Rules* for which he won an Emmy Award for Outstanding Supporting Actor in a Comedy Series in 1991. Also a voice actor, he played the role of Papa Smurf in the animated films *The Smurfs* and *The Smurfs 2*. As well as starring in five comedy television specials, Winters released twelve comedy albums, receiving twelve Grammy Award nominations and winning the Grammy Award for Best Spoken Comedy Album in 1995 for *Crank Calls*. He was the second-ever recipient of the Mark Twain Prize for American Humor in 1999.

"WEIRD AL" YANKOVIC
ACTOR, COMEDIAN, DIRECTOR, PRODUCER,
SINGER-SONGWRITER, WRITER
b. October 23, 1959, Downey, Los Angeles, California

Alfred Matthew "Weird Al" Yankovic's parodies of popular songs have made him a pop-culture icon and he has sold more than 12 million albums. While still at college, Yankovic began sending his homemade tapes to radio DJ Dr. Demento who played Yankovic's single "My Bologna," a parody of The Knack's "My Sharona," on his show. He has been nominated for fourteen Grammy Awards, winning Best Comedy Recording in 1984 for "Eat It," a parody of the Michael Jackson song "Beat It," then Best Concept Music Video in 1988 for "Fat," a parody of Michael Jackson's "Bad," and finally Best Comedy Album for *Poodle Hat* in 2003. His thirteenth studio album, *Alpocalypse*, released in 2011, debuted at number nine on *Billboard* magazine's list of top 200 albums. In addition to his own ground-breaking music videos, he has also directed music videos for bands such as Hanson and The Black Crowes. His film and television credits include the 1989 film *UHF*, which is regarded as a cult classic, and the television series *The Weird Al Show*. Yankovic also wrote the *New York Times* bestselling children's book *When I Grow Up*.

Acknowledgments

A special thanks to my super team at Matt Hoyle Photography, Kyley Cheever and Erin Andrews, for pulling such a seemingly insurmountable project together and turning it into this amazing collection of comedic icons—I appreciate their dedication, stamina, and determination to get the job done. Special thanks also to my lovely wife, Anthea, who played accountant, manager, psychiatrist, and loan shark and had the faith in me that 131 shoots would eventually turn into something special.

PRODUCER

Kyley Cheever

CO-PRODUCER

Erin Andrews

PRODUCTION DESIGNER

Lauren Fitzsimmons: Jason Bateman, Chevy Chase, Andrew Dice Clay, Jennifer Coolidge, Billy Crystal, Rhys Darby, "Bobcat" Goldthwait, Neil Patrick Harris, Ed Helms, Cloris Leachman, Jon Lovitz, Jane Lynch, Marc Maron, Steve Martin, Bette Midler, B. J. Novak, Conan O'Brien, Catherine O'Hara, Bob Odenkirk, Paul Reubens, Michael Richards, Jay Roach, Sarah Silverman, David Steinberg, Eric Stonestreet, Jeffrey Tambor, Kristen Wiig, Fred Willard, Rainn Wilson, "Weird Al" Yankovic

HAIR

Amanda Abizaid: Tim Allen

Riad Azar: Kathy Griffin

Candice Birns: Jason Bateman, Billy Crystal, Ed Helms, Cloris Leachman, Jon Lovitz, B. J. Novak, Catherine O'Hara, Michael Richards, Eric Stonestreet, Rainn Wilson

Alex Polillo: Kristen Wiig

Raymond Rosario: Joan Rivers

Cher Savery: Joanna Lumley

Jeff Swander: Conan O'Brien

Byron Williams: Bette Midler

Marlene Williams: Lily Tomlin

Sachi Worrall: Carol Burnett

Natalie Wozniak: Jennifer Coolidge, Marc Maron, Kristen Wiig extras, Fred Willard

MAKE UP

Anna Branson: Jason Bateman, Billy Crystal, Ed Helms, Cloris Leachman, Jon Lovitz, B. J. Novak, Catherine O'Hara, Nick Offerman, Michael Richards, Sarah Silverman, Eric Stonestreet, Kristen Wiig extras, Rainn Wilson

Kerry Lou Brehm: Tracy Morgan

Wendy Brown: Dame Edna Everage

Christine Cant: Jennifer Saunders

Debra Coleman: Lily Tomlin

Adele Fass: Joan Rivers

Toby Fleischman: Jane Lynch

Tracey Levy: Kristen Wiig

Cheri Minns: Robin Williams

Noel Nichols: Jennifer Coolidge

Mira Parmar: Joanna Lumley

Deborah T. Pullmann: Conan O'Brien

Marja Webster: Carol Burnett

Wendy Weiss: Tim Allen

Mynxii White: Marc Maron, Fred Willard

Byron Williams: Bette Midler

Elizabeth Yoon: Kathy Griffin

GROOMING

Amanda Abizaid: Matt Lucas

Anna Branson: Chevy Chase, Andrew Dice Clay, Rhys Darby, "Bobcat" Goldthwait, Neil Patrick Harris, Tim Heidecker and Eric Wareheim, David Koechner, Steve Martin, Stephen Merchant, Bob Odenkirk, Patton Oswalt, Carl Reiner, Jay Roach, Jeffrey Tambor

Margie Bresciani: Michael Showalter

Bill Corso: Jim Carrey

Kumi Craig: Mike Myers

Susan Donoghue: Jerry Stiller

Alexis Ellen: Zach Galifianakis, Eugene Levy, Adam McKay, Bob Newhart, Martin Short

Carola Gonzalez: George Lopez

Sarah Hyde: Mort Sahl

Linda Johansson: John Cleese, Michael Palin

Amy Komorowski: Denis Leary, Andy Samberg

Losi for Martial Vivot Salon: Ricky Gervais

Mira Parmar: Tim Minchin

Spring Super: David Cross

Tomiko Taft: Jonathan Winters

Cristina Waltz: Paul Reubens

STYLISTS

Bruce Brumage: Conan O'Brien

Ann Closs-Farley: Paul Reubens

Michelle Cruz: George Lopez

Sharron Daly: John Cleese, Michael Palin

Cary Fetman: Joan Rivers

Scott Free: Bob Odenkirk, Kristen Wiig

Jennifer Greene: Bob Balaban, Jim Carrey, David Cross, Janeane Garofalo, Ricky Gervais, Kathy Griffin, Mike Myers, Jerry Stiller

Doreen Hoff: Jason Bateman, Tina Fey, Neil Patrick Harris, Jane Lynch, Steve Martin, B. J. Novak, Catherine O'Hara, Eric Stonestreet

Sasa Jalali: Bette Midler

Bob Mackie: Carol Burnett

Danny O'Neill: Robin Williams

Sam Spector: Denis Leary

Callan Stokes: Chevy Chase, Billy Crystal, Tim Heidecker and Eric Wareheim, Ed Helms, David Koechner, Cloris Leachman, Jay Leno, Eugene Levy, Jon Lovitz, Adam McKay, Stephen Merchant, Bob Newhart, Conan O'Brien, Patton Oswalt, Michael Richards, Jay Roach, Martin Short, Jeffrey Tambor, Rainn Wilson, "Weird Al" Yankovic

Alice Timms: Joanna Lumley, Tim Minchin, Michael Palin, Jennifer Saunders

ART DEPARTMENT

Jordan Baker Caldwell: Conan O'Brien

Sharron Daly: John Cleese, Joanna Lumley, Tim Minchin, Michael Palin, Jennifer Saunders

Susan Donner: Andrew Dice Clay, Jennifer Coolidge, Rhys Darby, "Bobcat" Goldthwait, Marc Maron, Bette Midler, Bob Odenkirk, Paul Reubens, Kristen Wiig

Kelsi Ephraim: Ed Helms, Conan O'Brien, "Weird Al" Yankovic

Carey Gallagher: Tim Allen, Jim Carrey, Andrew Dice Clay, Jennifer Coolidge, Rhys Darby, Marc Maron, Bette Midler, Bob Odenkirk, Paul Reubens, Kristen Wiig, Fred Willard

Brian Goodwin: Tina Fey

Sean House: Robin WIlliams

Jennifer Hwang: Conan O'Brien, Ed Helms, Rainn Wilson, "Weird Al" Yankovic

Dave Jones: Tina Fey

Carly Lujan: Carol Burnett, Chevy Chase, Martin Short

Carli Maloney: Ed Helms, Conan O'Brien, "Weird Al" Yankovic

Wade Morrison: Jason Bateman, Neil Patrick Harris, Tim Heidecker and Eric Wareheim, Eugene Levy, George Lopez, Jane Lynch, Steve Martin, Adam McKay, Stephen Merchant, Bob Newhart, B. J. Novak, Conan O'Brien, Catherine O'Hara, Patton Oswalt, Eric Stonestreet, Rainn Wilson, "Weird Al" Yankovic

Patrick Muller: Ed Helms

Yuri Okahana: Adam McKay, Stephen Merchant, Bob Newhart

Anna Oldham Cooper: John Cleese

Tricia Peck: Jennifer Coolidge, Steve Martin, Bob Odenkirk, Paul Reubens, Kristen Wiig, Fred Willard

Nathalie Ruiz: Chevy Chase, Martin Short

Jennifer Williams: Carol Burnett, Ed Helms, David Koechner, Cloris Leachman, Jon Lovitz, Steve Martin, Jay Roach, Martin Short, "Weird Al" Yankovic

Grace Yun: Tina Fey

SPECIAL THANKS

Bill Barretta, Rebecca Cabbage, Kristen Kish, Debbie McClellan, Joel Norton, Tyson Smyer, Marcel Vocino, Marian Walsh, Samantha White, Steve Whitmire: Kermit the Frog puppeteer, The Rex Agency, The Wall Group, Zenobia

L.A. Lighting Director: Jonathan Folds

First Photo Assistants: Robert Morris, Nick Tooman

Studios: 32ten, Edge, Headshot London, Siren, Smashbox, Smudge

Photo Assistants: Logan Barrier, Ben Peter Catchpole, Chris Chudleigh, Corey Deguia, Adele Godfrey, Catriona Gray, Joe Gunawan, Samantha Isom, Dave Jones, Michael Kinsey, Aleksandra Kocela, Marc Oliver Le Blanc, Wayne Lennon, Scott Leon, Douglas Markland, Mallory Morrison, Derek Olson, Nico Oved, Adrian Rozas, Justin Schaefers, Quinn Starr, Meri Stoutenburg

Extras:
Jason Bateman: Dan Lew, Samantha Slopes

Jennifer Coolidge: Nick Tooman, Natalie Wozniak

Andrew Dice Clay: Kelly Cunningham

David Cross: Andrew Fofoutakis

Neil Patrick Harris: Wall-E

Tim Heidecker and Eric Wareheim: Raegan Revord

George Lopez: Ezequias Virgen Lopez

Stephen Merchant: Stefanie Henderson, David Namminga

Bob Newhart: Wade Morrison

Conan O'Brien: Spencer Peck

Catherine O'Hara: Higgins, Graham Mackie

Kristen Wiig: Paige Fields, Amelia Lewinson, Jordyn Wooddy

Vendors: Ahern Entertainment, Astek Wallcovering, Black & White Catering, Carlo Manzi, Cinema Vehicle Services, Citron Catering, City Kitchen, Corner Bakery Cafe, Cornucopia Catering, Culinary Delight, Dangling Carrot Creative, DTC Lighting and Grip, Dyer Co., EC2 Costumes, Eclectic Encore, Evolution, Fillmore & Western, Freyer Lights, Green Sets, History for Hire, Hollywood Paws, Hollywood Studio Gallery, IDF Studio Scenery, Isolated Ground, ISS Props, JC Backings, Limoncello Catering, Linoleum City, Louise's Trattoria Catering, Ocean Leisure, Omega Cinema Props, Orchard Supply Hardware, Prop Hire and Deliver, Ray Marston Wig, Ready to Roll, Robert Barone/Moviefleet, Rosebrand, SirReel, Special Effects Unlimited, Steel Deck, Stuart Learmonth, Superhire, Valentino's Costume, Western Costume, Whitehouse Dish

Matt Hoyle Photography wishes to offer the gift of laughter
to an audience that needs it the most and, with this book,
is proud to support Save the Children.

First published in the United States in 2013 by Chronicle Books LLC.

Photographs copyright © 2013 Matt Hoyle.
Compilation copyright © 2013 PQ Blackwell Limited.
Introduction copyright © 2013 Mel Brooks.

Produced and originated by PQ Blackwell Limited
116 Symonds Street, Auckland, New Zealand
www.pqblackwell.com

Library of Congress Cataloging-in-Publication Data available.

ISBN: 978-1-4521-2538-1

The quotations that appear in this book have been used with
permission of the copyright holders. Every effort has been made
to trace the copyright holders and the publisher apologizes for any
unintentional omissions. We would be pleased to hear from any not
acknowledged here and undertake to make all reasonable efforts to
include the appropriate acknowledgment in any subsequent editions.
The quote on page 185 has been widely attributed to Groucho Marx
although at the time of printing, the publisher was unable to completely
and accurately verify him as being the source of the quote.

Manufactured in China

10 9 8 7 6 5 4 3 2 1

Chronicle Books LLC
680 2nd Street
San Francisco, California 94107
www.chroniclebooks.com

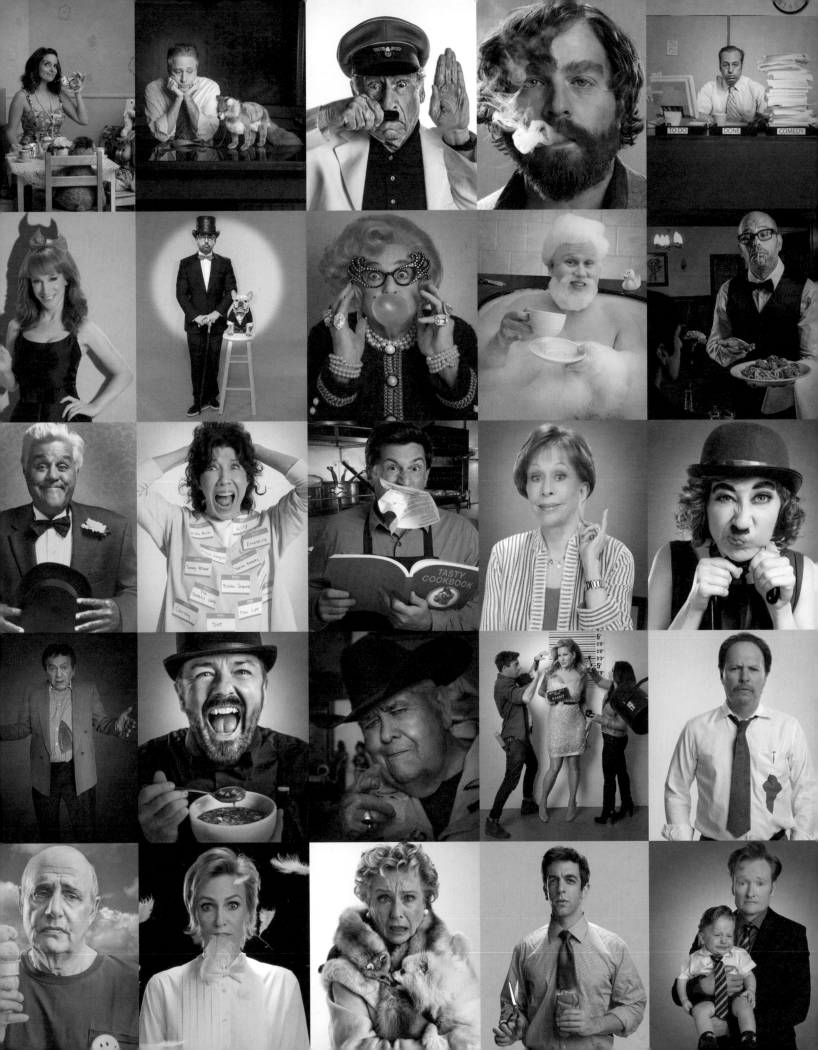

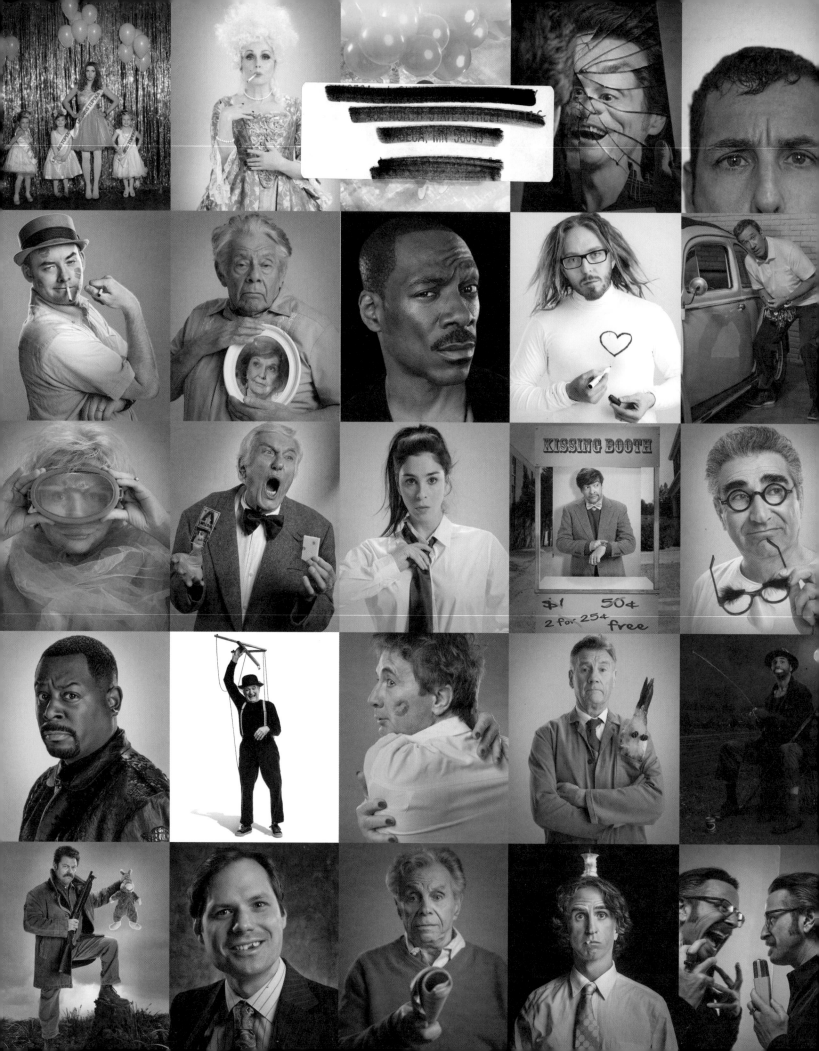